YOUCEN DRAN

YOU CAN DRAW-ALL YOU NEED IS A PENCIL AND SOME PAPER.

Once you're comfortable with the basics, try other materials and work on your techniques. Even if your first drawing isn't a masterpiece, don't worry! The more you draw, the better you'll become. Look long and hard at whatever it is you want to draw, too. The more you look, the more you'll see!

Follow the steps to try the projects in this book, and then vary them how you like. Maybe try ink instead of paint, orange instead of blue, swirls instead of lines. It's up to you!

PICK UP A PENCIL, OPEN TO ANY PAGE, AND GET DRAWING!

This edition published by Parragon Books Ltd in 2016 and distributed by

Parragon Inc. 440 Park Avenue South, 13th Floor New York, NY 10016 www.parragon.com

Copyright © Parragon Books Ltd 2013–2016

All rights reserved. No part of this publication may be reproduced, stored in a retrieval system, or transmitted, in any form or by any means, electronic, mechanical, photocopying, recording, or otherwise, without the prior permission of the copyright holder.

ISBN 978-1-4748-5685-0

Printed in China

CONTENTS

Materials	2
Techniques	5
Portraits)
Hedgehog 12	
Hot-Air Balloons 14	
Fashion Girls 18)
Grizzly Bear	5
Race Car)
Profile	
Penguin's 24	N. Carlo
Electric Guitar 26	
Rose	5
Fashion Boys 30)
Meerkats ,	
T-Shirts 34	34
Pirate Ship 36	
Main Street 38	The second
Statue of Liberty 40	AND LONG
Quad Bike 42	
Mega Dessert	
Ninja	
Mustaches	
Alien Invasion 50	ALL AND A
Giraffe Face	いたのないと
Pop Star 54	States and
Line Designs	

Geometric Patterns	110
T. rex	112
Motorcycle Stunt Rider	
Wild Hats	
Haunted House	
Manga Girl	
Urban Bridge	
Cartoon Wild Animals	
Jetpack	
Monster Plant	128
World's Tallest Hamburger	1.712.00
Circular Patterns	132
Zombie	134
Candy Machine	
Shark!	
Skyscrapers	140
Basketball Player	142
Volcano	
Weird Beards	146
Speedboat Frames Caricatures	148
Frames	150
Caricatures	152
Crocodile	154
Crocodile Tornado	156
Monster Mash-up	158
Ferris Wheel	160
Monster Mash-up Ferris Wheel Scaredy-Cat	162
Cyborg Funky Cake	. 164
Funky Cake	. 166

Robot	168
Pictures in Lights	
Cartoon Cute Animals	172
Surfer	174
Cool Shades	176
Frankenstein's Monster	178
Woodland Animals	180
Mountain Bike	182
Straight Patterns	184
Twisty Tree	
Manga Boy	
Submarine	
Troll	
Hockey Player	
Gyrocopter	
Dragon	
Cartoon Expressions	. 200
Spaceship Controls	
Superheroine	
Animal Patterns	. 206
Fishbowl	
Towering Buildings	210
French Café	212
Optical Illusions	214
Streetdancer	216
Creepy Mansion	
Index	. 220
About the Artists	
Acknowledgements	224

AATERIALS

THERE ARE LOTS OF SPECIAL MATERIALS THAT ARE FUN TO TRY OUT. BUT REALLY, ANYTHING THAT MAKES A MARK ON PAPER IS GREAT FOR DRAWING! YOU CAN GET THESE MATERIALS AT CRAFT STORES.

GRAPHITE PENCILS range from hard to soft. H pencil leads are hard and good for light sketching and fine lines. B pencil leads are softer and great for shading and thick lines. HB is in the middle.

PAPER textures can make a big difference to how your drawing looks. Smooth copy paper will give you a sharp, crisp line. Heavy drawing paper is thicker and more textured, so your line will look softer. Watercolor paper absorbs ink or watercolor paints. Colored paper gives an unusual effect and ready-made background.

[RASERS come in handy when you are happy with your final drawing lines and want to get rid of guidelines. Don't rub hard or the surface of the paper will suffer. Instead, gently roll a corner of the eraser on the paper to lift the pencil off. PEN-AND-INK is a popular way to lift a drawing with heavy lines and give the picture character with varied line widths. Use a dip pen or a fine-tipped brush to apply various colors of ink. Practice first because once it's on, it won't come off! You can also use a cartridge pen for a similar effect.

CRAYONS are great for color lines and color texture. Try wax, chalk, or oil crayons in your drawings.

PAINTS-Whether you choose poster, watercolor, or acrylic will depend on what effect you want to achieve. Poster paints tend to be flat but easy to use. Watercolors blend well together to produce an interesting surface and soft look. Acrylics are very vibrant. PENS all have their individual quirks, which can add interest to a drawing. Felt-tip pens are great to add color quickly or vary the color of an outline. Marker pens and highlighters can add a zing to cartoons. The best way of finding out what suits your drawing style is to experiment!

BRUSHES come in a variety of shapes and sizes. Round brushes are used for applying washes and are a good, all around paintbrush. Pointed brushes are good for line and detail. Flat brushes are ideal for painting stripes or applying larger areas of color evenly. Always wash your brushes between colors and when you have finished painting.

7

TECHNIQUES

HERE ARE A FEW SIMPLE TECHNIQUES THAT WILL HELP YOU GET THE MOST OUT OF YOUR DRAWING.

BASIC SHAPES AND GUIDELINES help you plan your drawing before you add any detail. They're a good way of checking proportions, direction of movement, and position on the page. Simple lines and rectangles can make up bodies and limbs, while circles and oval ellipses are useful stand-ins for heads and hands. A center line is useful if you are drawing anything symmetrical, where the drawing on one side of the line mirrors the details on the other side.

LIGHT AND SHADE add dimension and realism to your drawing. Think about your light source—where the light is coming from in your drawing—for where shadows will fall. Leave white highlights in the parts nearest to the viewer, and add shade where the shape is farthest from the viewer for depth.

rubbed edge effect

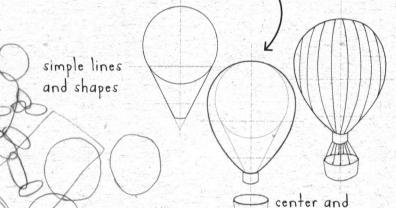

center and symmetrical lines

PENCIL STROKES can add character to a drawing. There are a number of shading techniques you could use. Try holding the pencil side-on to the paper for a rubbed effect. Or, use the point of the pencil to crosshatch lines in opposing directions, almost like a grid, to build up shading. Experiment with changing the pressure on the pencil as you make your marks, using short flicks or longer, sweeping strokes.

crosshatching

changing pressure of pencil to flick and sweep

8

PROPORTION needs to be fixed at the earliest stage of your drawing. Check the sizes of your basic shapes in relation to each other, making adjustments as needed. This is especially useful when breaking down where to position face and body features.

WORKING DIGITALLY is very popular nowadays. You can scan your sketch into a computer and then open it using imageediting software. Use special tools in the software, such as paintbrushes or spray cans, to add color, do touch-ups, or even draw the whole thing on screen!

vanishing point

PERSPECTIVE gives your drawing depth. Planning a horizon line (the place where the ground meets the sky) and vanishing points (where lines in the distance come together) will

provide a clear foreground and background to your picture. Objects in the foreground will appear larger than objects in the background.

body proportions head proportions

scan

brush

spray cans

colors

[OLOR completes your picture and can add mood. Experiment with complementary colors, which go well together, such as red and green, or contrasting colors, such as red and yellow. Complementary colors are opposite each other on a color wheel. Two colors mixed together produce a new color tone. Adding white to a color produces a soft tint that is useful for highlights. Shades produced by mixing black to a color are good for shadows. Try tones of the same color for depth. -

color wheel

horizon line

DRAW AN OVAL SHAPE FOR THE HEAD AND ROUGH GUIDELINES FOR THE POSITIONS OF THE EYES, NOSE, AND MOUTH, POSITIONED AS SHOWN. ADD A VERTICAL GUIDE, TOO.

> **2** USING THE VERTICAL GUIDE TO HELP YOU WITH SYMMETRY, SKETCH SOME ROUGH SHAPES FOR THE EYES, EYEBROWS, AND EARS. USE CURVED LINES FOR THE NOSE, WITH LARGER CURVES FOR THE LIPS. ADD A NECK SHAPE.

> > TO

Add sketchy cheekbone lines for a chiseled cheek look.

SKETCH THE SHAPE OF THE BRIM, AND WORK UP THE FACIAL FEATURES. REFINE THE SHAPES OF THE EYES, ADDING CIRCLES FOR THE IRISES AND PUPILS. ADD NOSTRILS AND DETAILS TO THE EARS. DRAW A SLIGHTLY ANGULAR JAWLINE FOR AN OLDER BOY. **5** USING A HEAVY PENCIL SUCH AS A 4B, FIRM UP THE FEATURES A BIT MORE. IMAGINE THE LIGHT IS COMING IN FROM THE LEFT, AND DRAW A LINE UNDER THE EYES TO MARK THE SHADOW CAST BY THE BRIM. ADD MORE SHADOW LINES TO THE NECK AND THE SIDE OF THE NOSE.

3 SKETCH TWO

CURVED RECTANGLES TO

FORM A CAP SHAPE. MAKE

THE TOP LINE A LITTLE

THE PERSON'S HEAD.

HIGHER THAN THE TOP OF

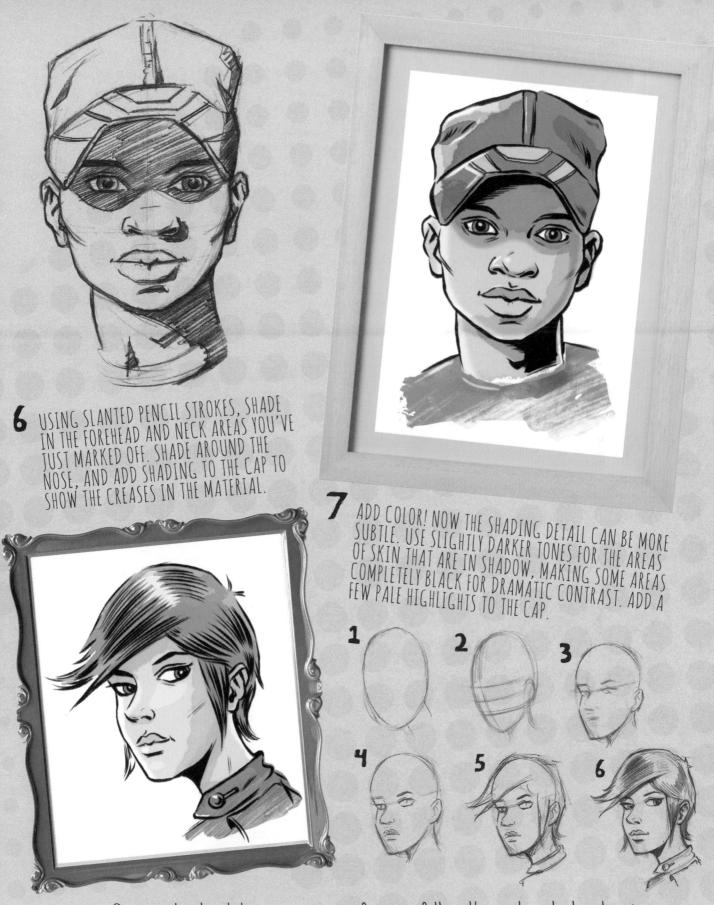

Once you've tried drawing someone face-on, follow these steps to try drawing a face at an angle. This can be more dynamic, visually interesting, and mischievous!

DRAW AN OVAL SHAPE FOR THE HEDGEHOG BODY. ADD AN OVERLAPPING SMALL CIRCLE FOR THE HEAD.

COLOR THE HEDGEHOG WITH THE BASE COLORS, THEN ADD LIGHT AND DARK AREAS FOR A REALISTIC EFFECT. ADD AN EYEBROW AND WHISKERS FOR PERSONALITY.

Build up the scene with little footprints, matching them to the placement of your hedgehog's legs. SHAPE THE HEAD ON A CURVE TO CREATE A SNOUT, AS SHOWN. ADD LEGS, AN EYE, AND A MOUTH. ROUGHLY SKETCH THE REST OF THE HEDGEHOG DETAILS, INCLUDING PRICKLY LINES AND A LITTLE ROUND NOSE.

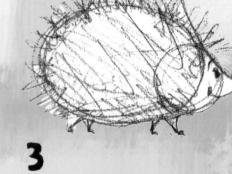

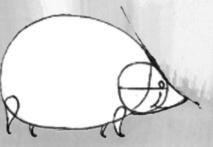

CEN

FOR A HEDGEHOG IN A BALL, DRAW A ROUND SHAPE FOR THE BODY AND A SMALLER ROUND SHAPE INSIDE FOR THE HEAD. ADD EARS, EYES, A SNOUT, A NOSE, AND LEGS FOLLOWING THE GUIDE FOR PLACEMENT BELOW.

ROUGHLY SKETCH THE REST OF THE HEDGEHOG, KEEPING IT LOOSE. Sketch your prickles outward to build the ball effect.

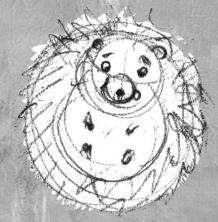

Use your imagination to vary the pose. Simply changing the eyes morphs an alert hedgehog into a sleeping one.

> Tell a story and build character with your drawing, adding little touches such as a stuck-on leaf to this baby.

> > ADD COLOR AS BEFORE. THINK ABOUT WHERE THE LIGHT WOULD BE COMING FROM IN THE PICTURE TO ADD HIGHLIGHTS AND SHADOWS.

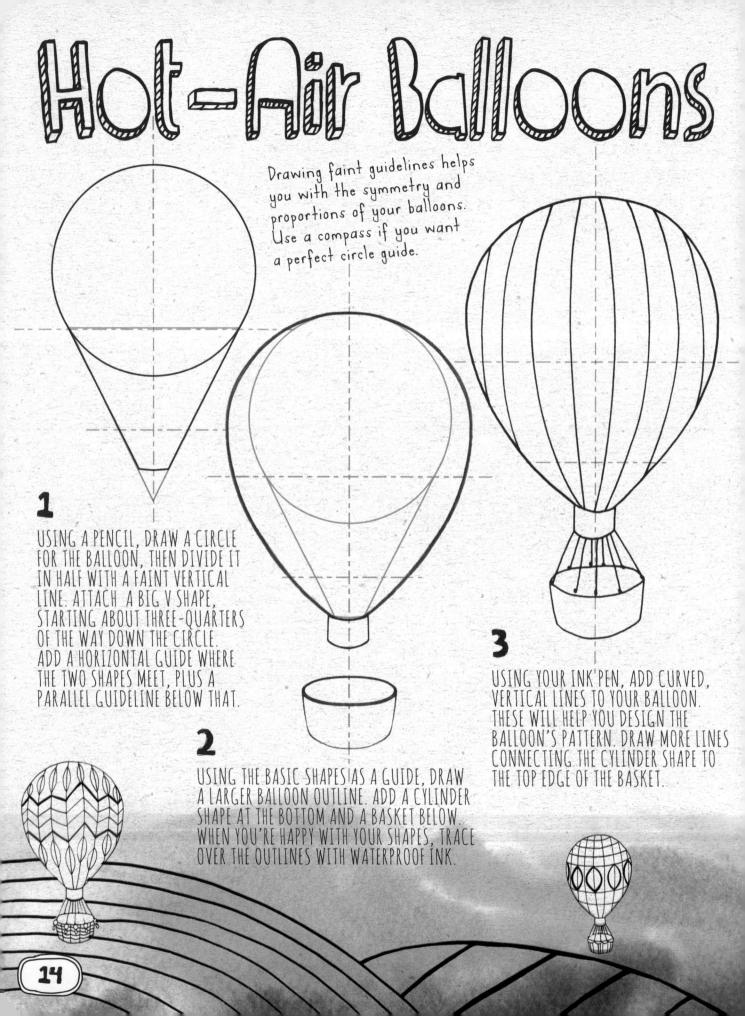

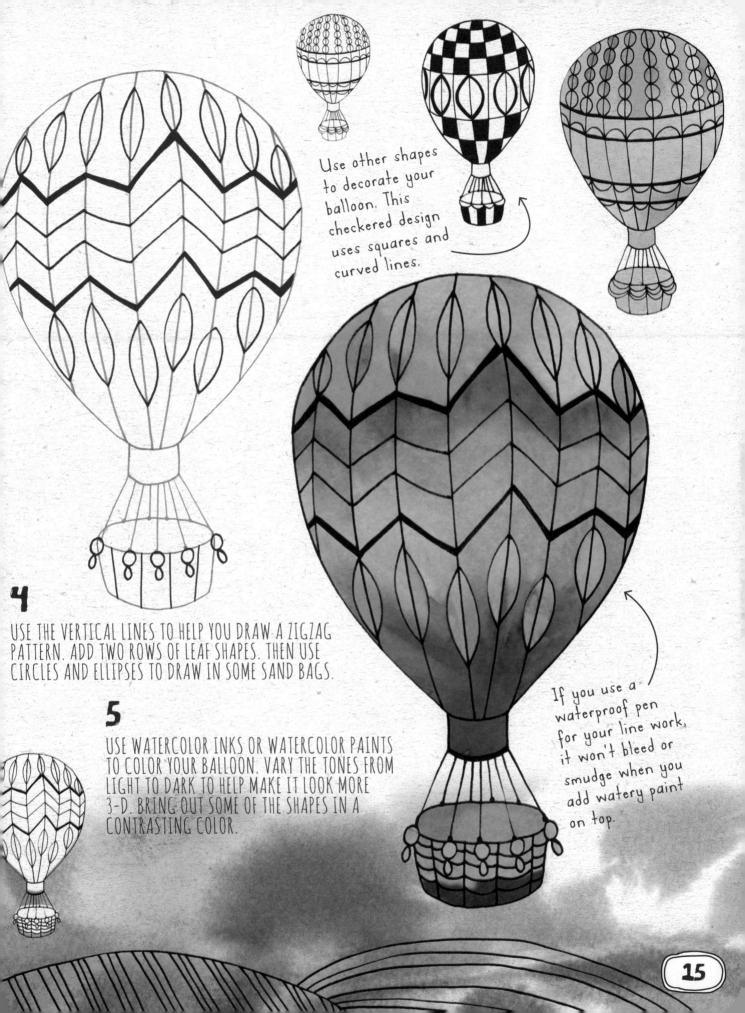

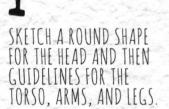

Find inspiration for patterns and colors from magazines. You could even cut out some samples and glue them onto your model to make a collage effect. DRAW ROUGH ARM AND LEG SHAPES AROUND YOUR GUIDELINES.

Fashion Girls

SKETCH A TOP, BELT, PANTS, AND SHOES TO ADD CLOTHES.

TO

FINISH THE HANDS, AND SKETCH LONG HAIR AND A FACE. ERASE ANY ROUGH GUIDELINES. NOW ADD COLOR! USE ONLY ACCENTS TO KEEP THE DRAWING SOPHISTICATED.

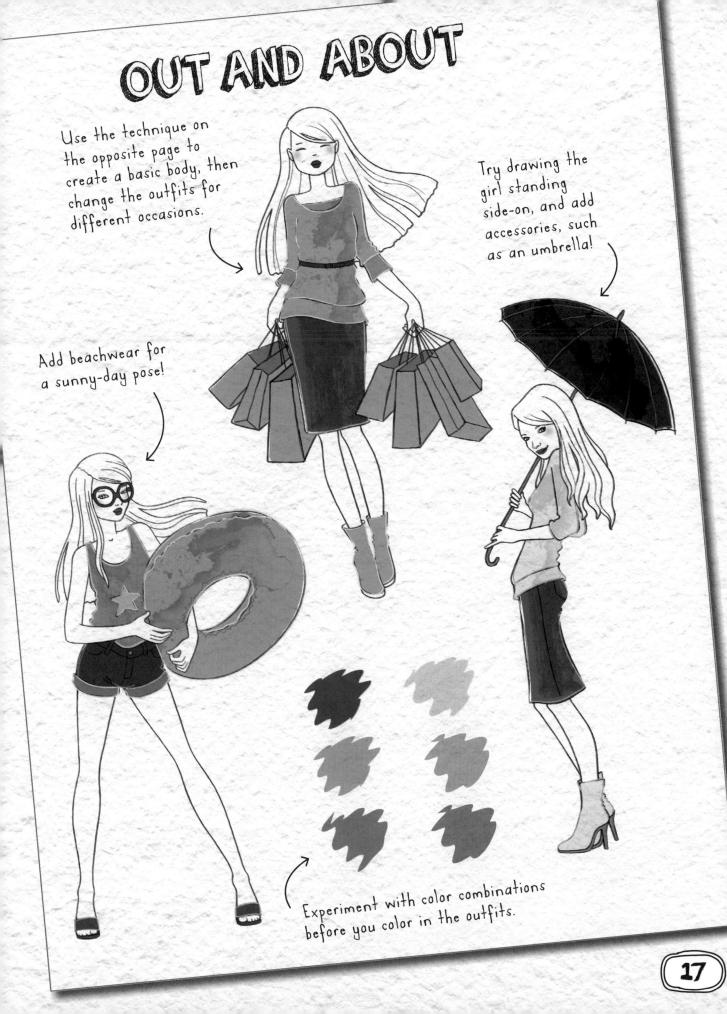

Experiment with pen and ink, colored pencils, and different line weights for various fur textures.

USING A SHARP, HEAVIER GRADE PENCIL, DARKEN THE EYES AND EYEBROWS. FILL IN THE NOSE, USING A HEAVY PRESSURE ON THE LEFT-HAND SIDE AND GRADUALLY TAKING OFF PRESSURE TOWARD THE RIGHT. DARKEN THE INNER EARS.

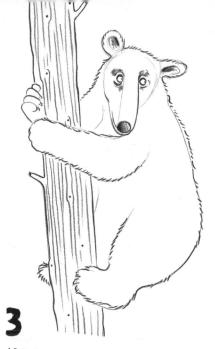

ADD DETAIL TO THE OUTLINE OF THE BEAR, USING EACH PENCIL LINE AS A PIECE OF FUR. DRAW THE KNOTS OF THE TREE THEN ADD ROUGH VERTICAL LINES FOR BARK.

4

FLICK YOUR PENCIL TO CREATE EACH LINE OF FUR, FOLLOWING THE DIRECTION OF THE BEAR'S BODY. WORK FROM THE FACE DOWNWARD SO YOU DON'T SMUDGE THE DRAWING.

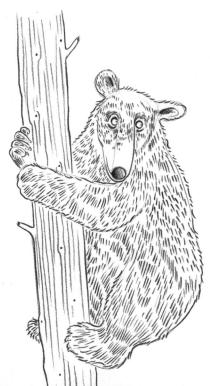

To keep the fur looking soft, use your pencil without sharpening it. The smoother the better! COLOR THE BEAR WITH COLORED PENCILS. ADD TONE BY SHADING CERTAIN AREAS WHERE THE TREE CASTS A SHADOW ON THE BEAR'S STOMACH.

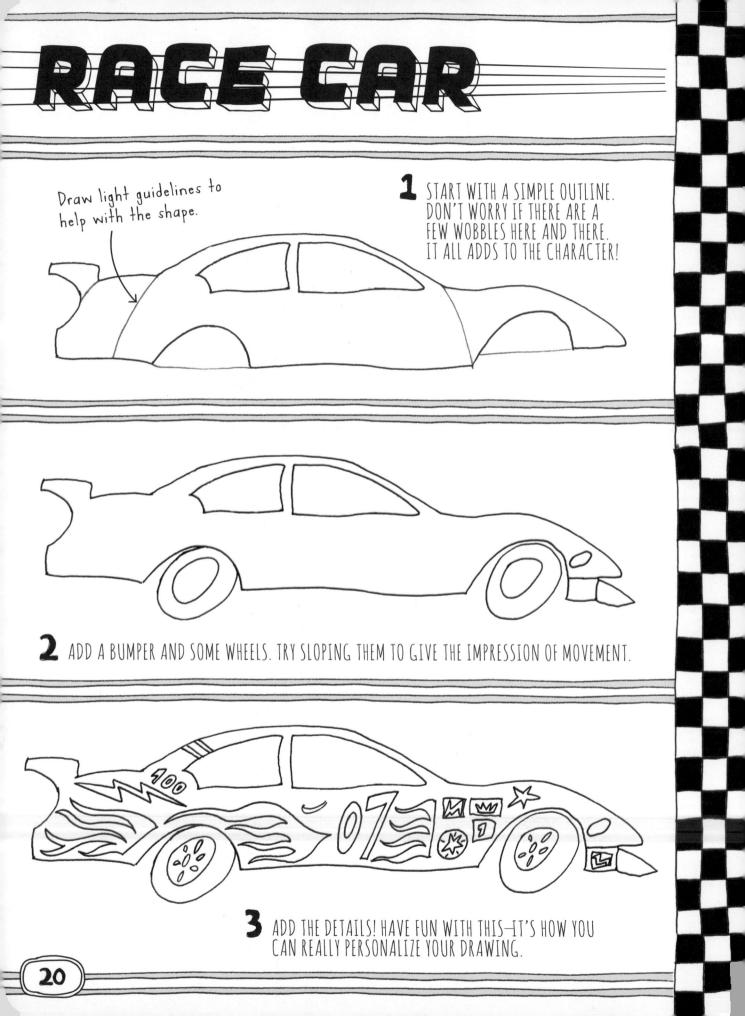

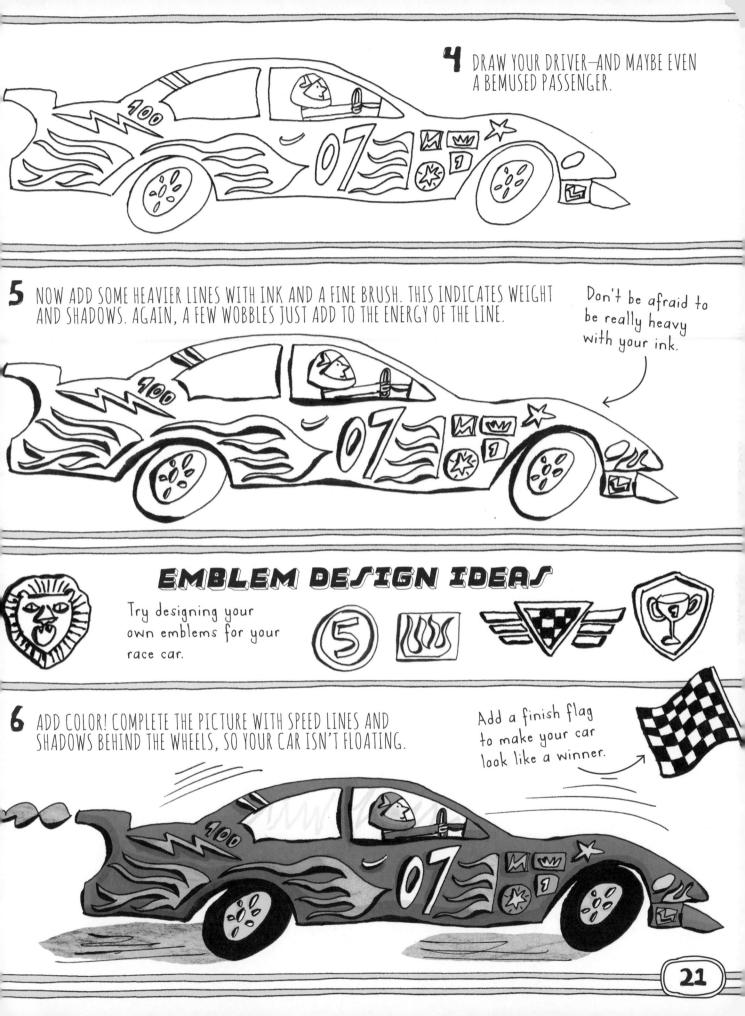

If you think of the shape of a skull, it will help you draw the shape of the head.

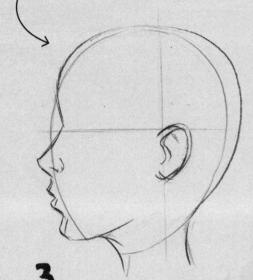

START TO DRAW THE PROFILE IN MORE DETAIL. LOOK CLOSELY AT THE OUTLINE AND DISTANCE BETWEEN THE FEATURES. KEEP USING A LIGHT PENCIL.

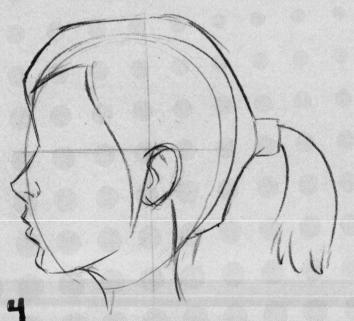

DRAW THE TOP OF THE EAR IN LINE

LINE UP THE BOTTOM OF THE NOSE. Sketch the profile and Jaw.

WITH THE EYE. DRAW A GUIDELINE FROM THE BOTTOM OF THE EAR TO

SKETCH AN OVAL FOR THE HEAD

MARK A HORIZONTAL LINE WHERE THE EYES SHOULD FALL AND A

VERTICAL LINE WHERE THE EAR Would lie. Draw in the Neck.

WHEN YOU'RE HAPPY WITH THE PROFILE, ADD THE SHAPE OF THE HAIR. HAIR NEARLY ALWAYS HAS VOLUME, SO DON'T MAKE IT TIGHT TO THE HEAD (UNLESS IT'S A CREW CUT!).

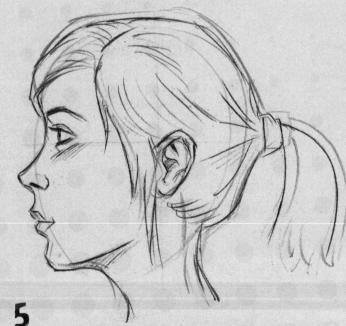

ADD THE EYE-IT SITS INSIDE A SOCKET, AND THE LIDS FOLD OVER TO PROTECT IT. BEGIN TO ADD DETAIL TO THE HAIR, LIPS, AND EARS. THINK ABOUT SHADING BELOW THE EYE, NOSE, AND CHIN. USE A SOFT PENCIL TO WORK UP THE HAIR AND FEATURES.

Remember to keep your wrist relaxed so that the drawing is flowing and alive.

7 WHEN YOU ARE READY TO COLOR YOUR PROFILE, VARY THE TONES TO REFLECT THE LIGHT AND SHADE IN THE DRAWING.

PROFILE FEATURES

Look how various areas of the face stick out in profile. Nudging these in or out changes the character of the face. The length and angle of the nose changes the profile. Look at whether the nose turns up or juts out. Look where the forehead and chin lie in relation to the nose, too.

EYES

The eyeball is exactly that a ball that sits in the socket and is protected by folds of skin, or lids. It's easier to draw them when you understand what's going on under the surface.

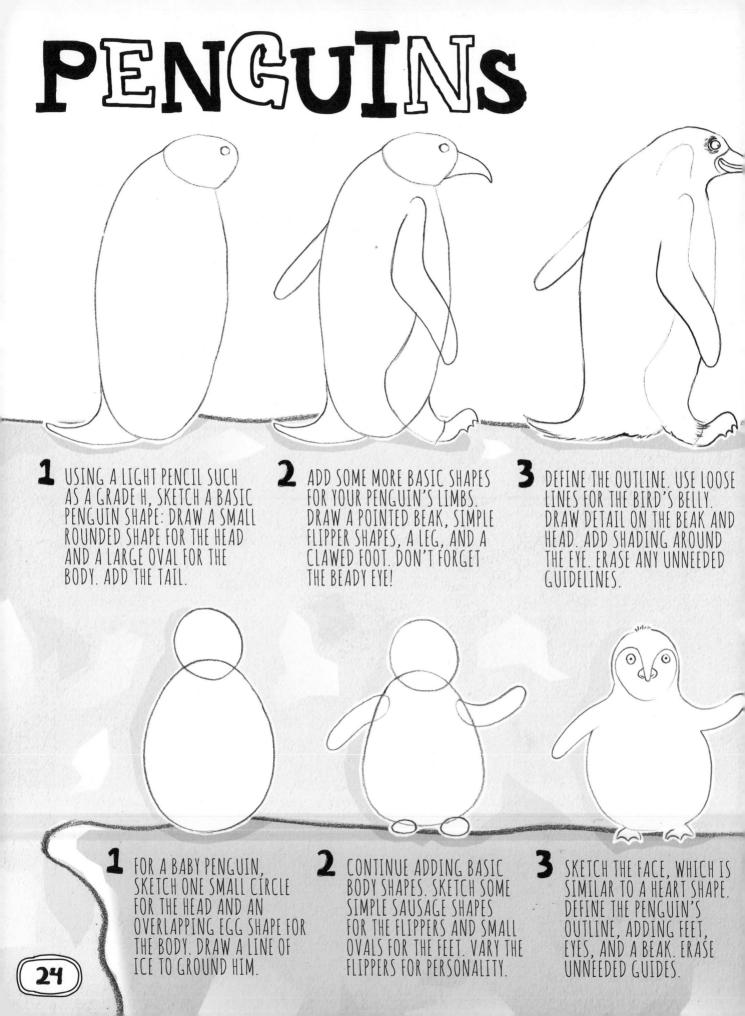

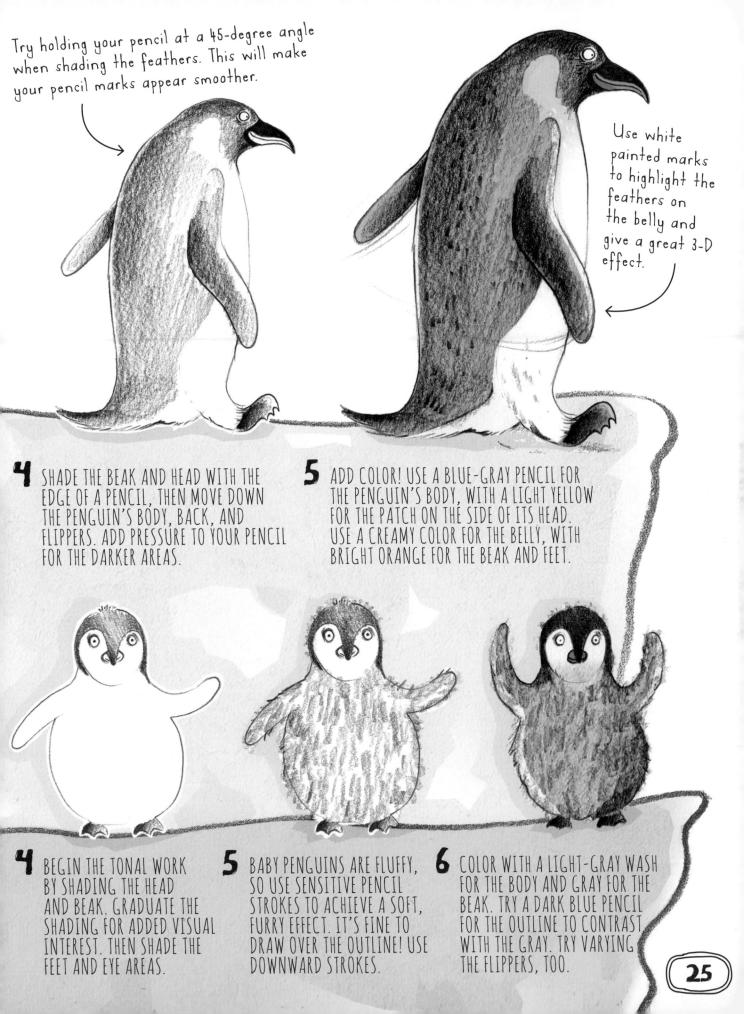

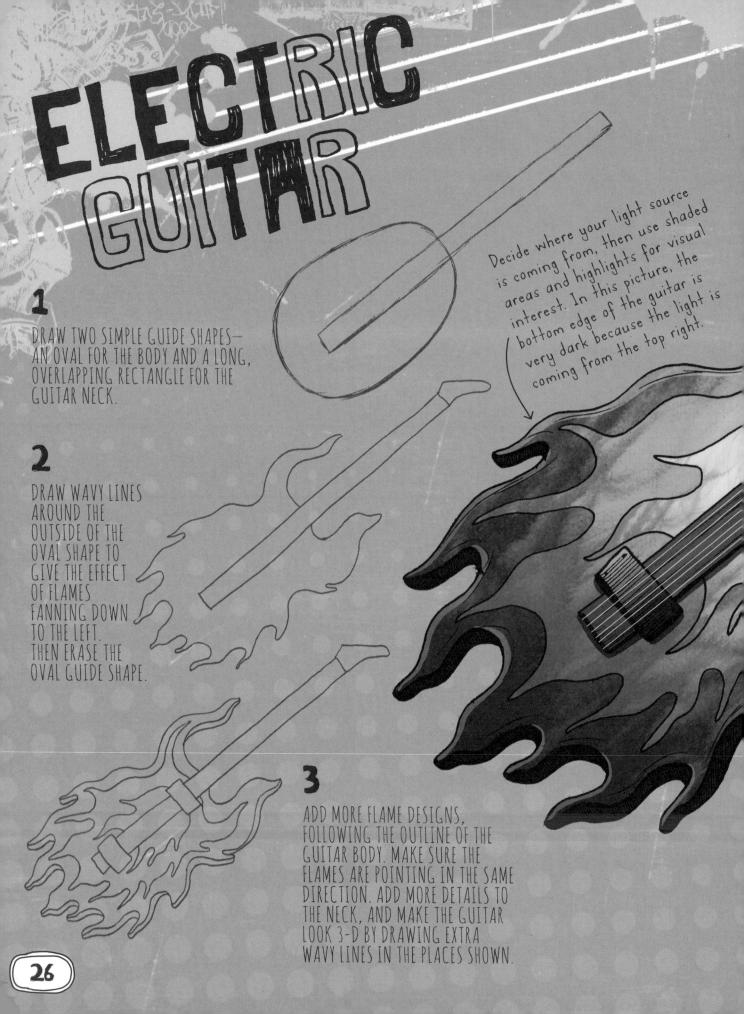

USE BRIGHT COLORS FOR THE BODY OF THE GUITAR AND It's easier to draw the guitar strings last last guitar strings varantee a ruler to guarantees! A DARKER COLOR FOR THE NECK AND HEAD. DRAW FIVE DASHED LINES IN A LIGHT COLOR FOR THE STRINGS, THEN ADD TUNING PEGS AT THE TOP

> You could use animals as inspiration ... This guitar has a scorpion feel to it.

DS OF STRANGE SHARES, EXPERIMENT

D

FCIAN

Streamlined designs look good, such as this triangularshaped guitar.

A rounded edge makes for a more classic-looking electric guitar.

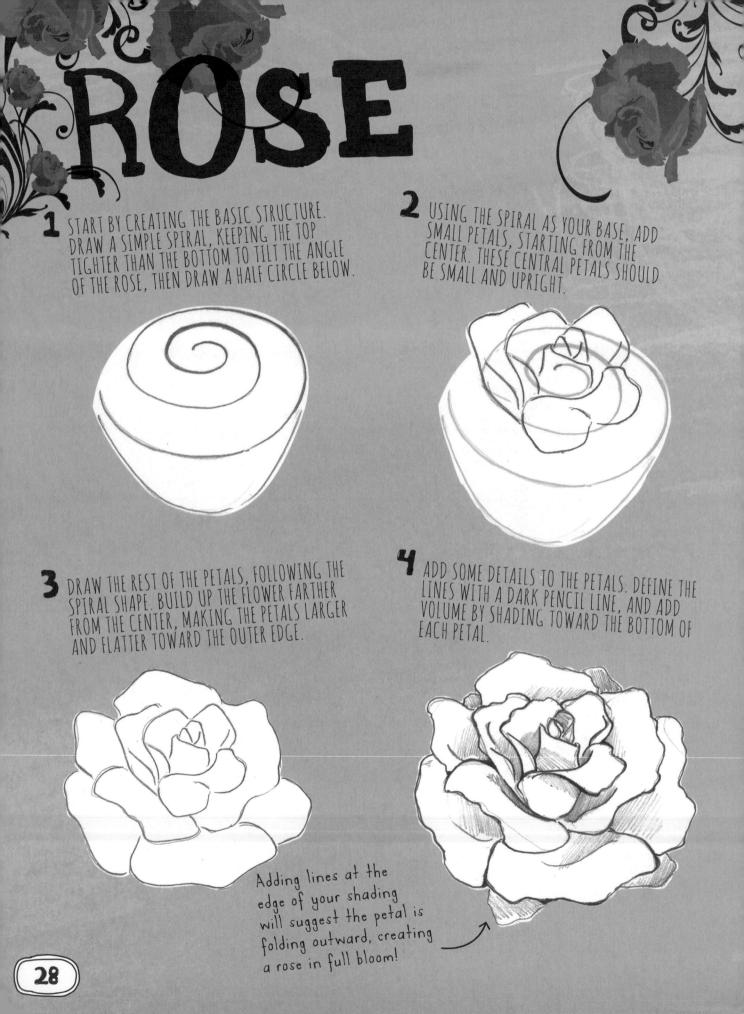

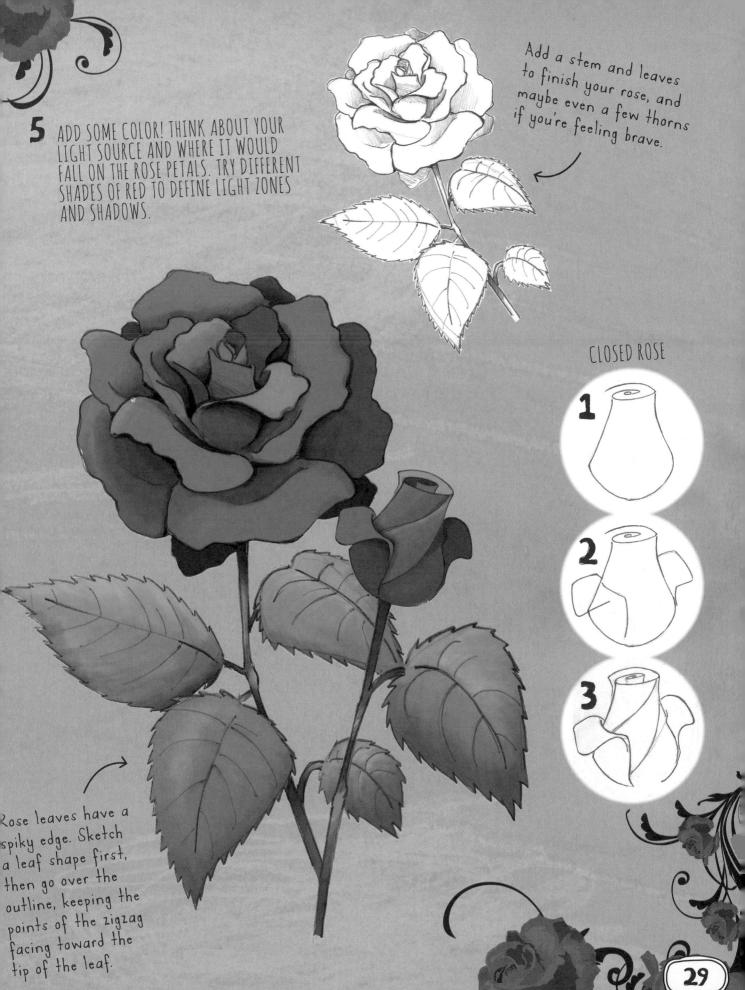

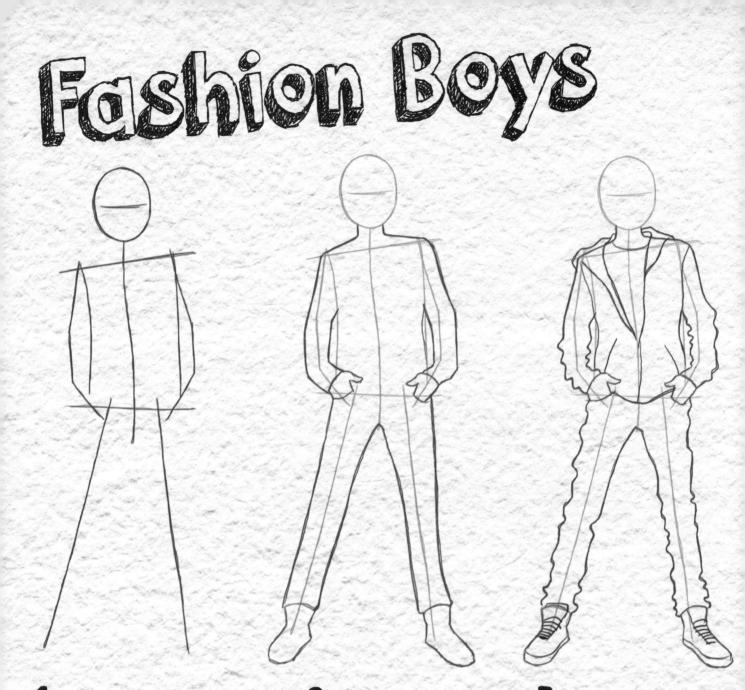

SKETCH AN OVAL SHAPE FOR THE HEAD AND GUIDELINES FOR THE SHOULDERS, BODY, HIPS, ARMS, AND LEGS.

Use light and dark shades of the same color to vary the texture. Try rubbing chalk or wash a damp paintbrush over a color. DRAW ARM AND LEG SHAPES AROUND YOUR GUIDELINES. ADD HANDS AND FEET. ADD A HOODIE AND JEANS TO THE SHAPE. USE WAVY LINES TO SHOW CREASES AT THE ELBOWS AND KNEES.

30

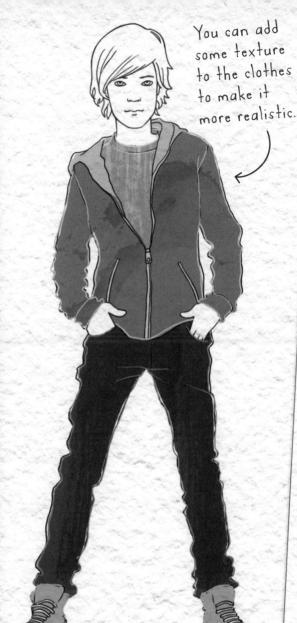

OUT AND ABOUT

Try drawing a figure holding a skateboard. Look at the way this boy's shoulders and hips are tilted and one foot is turned up.

ADD HAIR AND A FACE, AND FINISH THE DETAILS SUCH AS LACES, POCKETS, AND ZIPPERS. ERASE ANY GUIDELINES THAT ARE STILL SHOWING BEFORE COLORING THE FINISHED FIGURE.

Make up swatches of colors you think will look good together. -

Add skater graphics to make your drawing more realistic. Make up your own, or take inspiration from your favorite brands and logos.

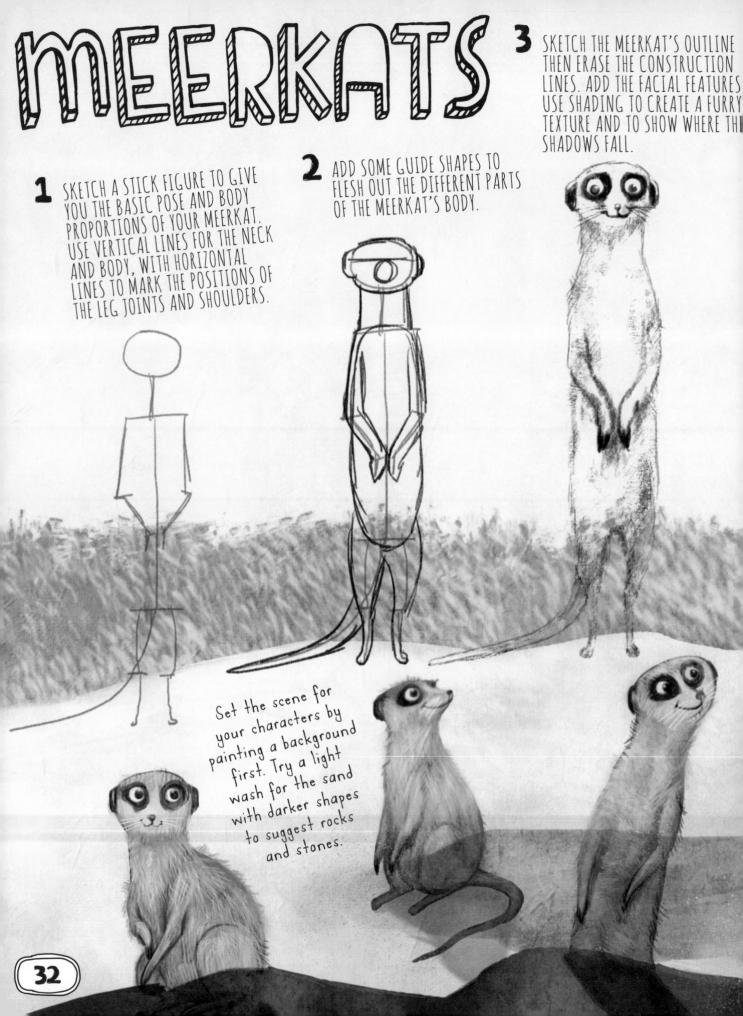

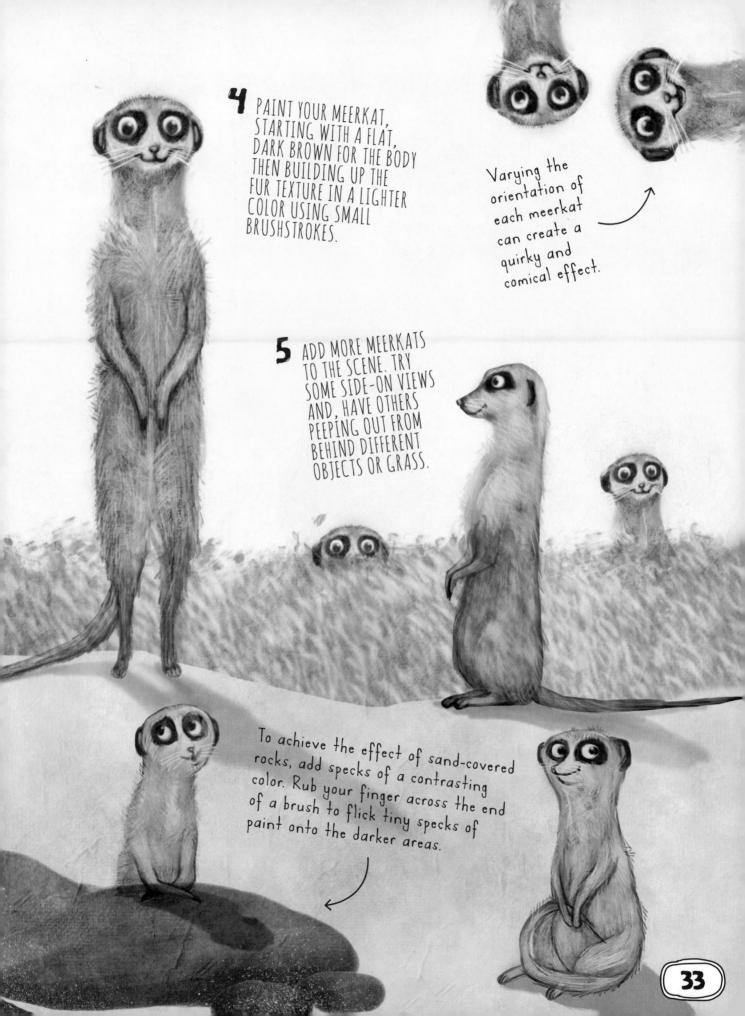

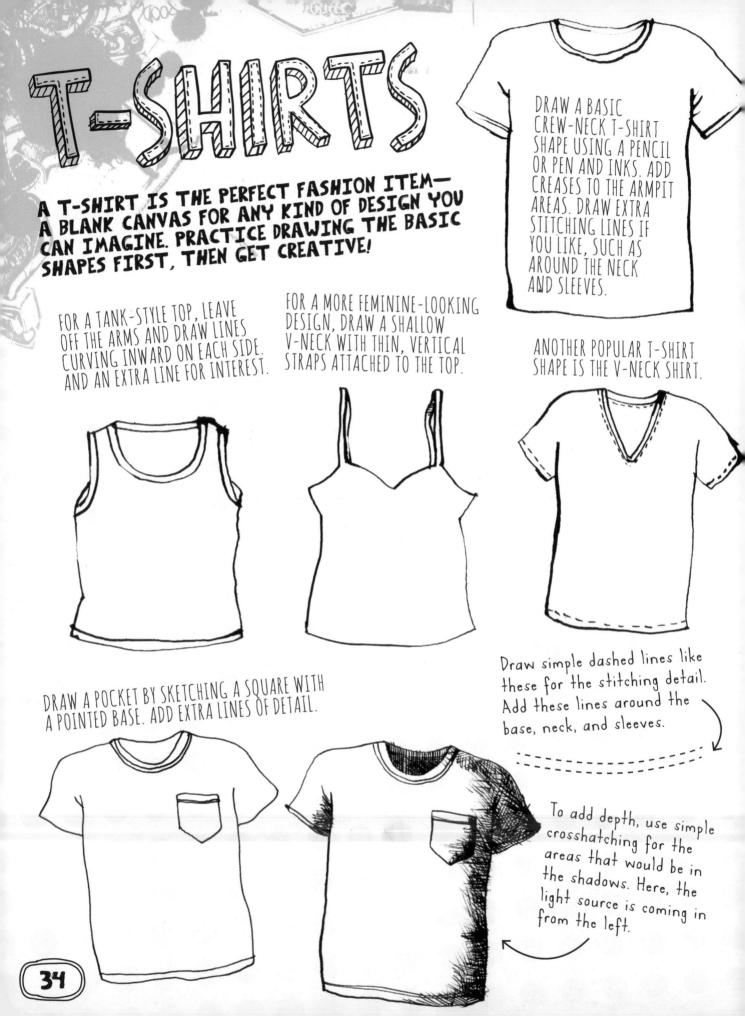

HERE ARE SOME T-SHIRT DESIGNS TO GIVE YOU INSPIRATION.

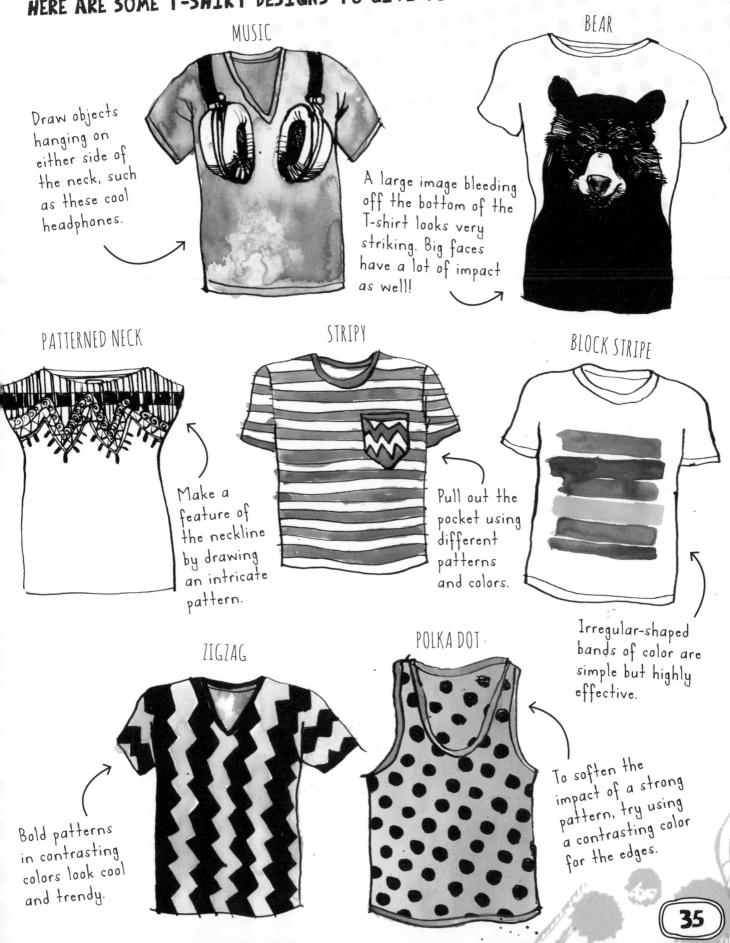

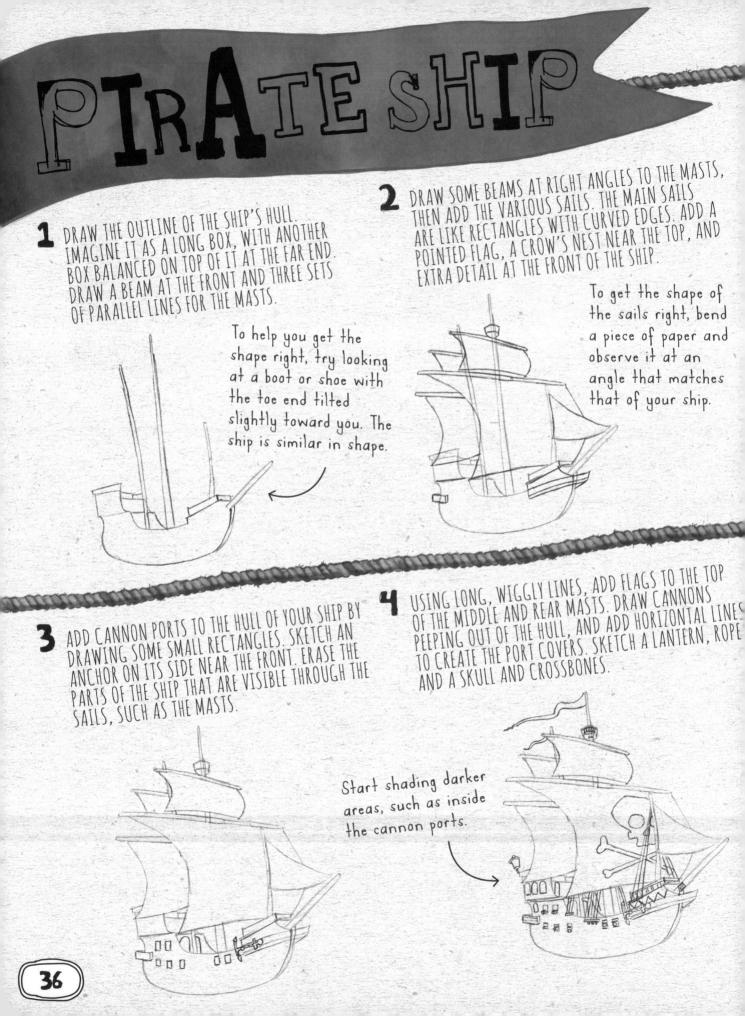

5 WORK ON THE FINE DETAILS. SKETCH A CROSSHATCH DESIGN ON THE REAR WINDOWS, AND ADD HORIZONTAL LINES TO THE RIGGING. DRAW THE SHIP'S WHEEL, AS WELL AS PATCHES AND TEARS ON THE SAILS.

2222

and appression of all the approximation of the second

Fine detail will add extra visual interest. Add extra lines to the hull, beams, and balconies.

> 6 USE DARK AND MUTED COLORS TO GIVE YOUR PIRATE SHIP AN OMINOUS AND MYSTERIOUS FEEL. THINK ABOUT WHERE THE SHADOWS WILL FALL, SUCH AS ON THE DECK AREA AND AT THE REAR OF THE SHIP.

E E E

MITTER

Add slightly lighter areas of gray to the black sails to achieve the effect of creased material billowing in the wind.

MAIN STREET

vanishing point	vanishing point J
horizon line	
USE A RULER TO DRAW A HORIZONTAL LINE. DRAW A DOT AT EACH END OF THE LINE. THESE ARE THE VANISHING POINTS, WHERE ALL LINES WILL COME TOGETHER. NEXT, DRAW A VERTICAL LINE – THIS WILL BE THE HEIGHT OF THE BUILDINGS AT THE FRONT OF THE PICTURE.	
2 DRAW LIGHT PENCIL LINES FROM THE VANISHING POINTS TO THE TOP AND BOTTOM OF THE VERTICAL LINE. ADD MORE VERTICAL LINES TO DIVIDE THE MAIN STREET INTO INDIVIDUAL STORES.	The horizon line will help you The horizon line will help you The horizon line will help you into the divide the buildings into the divide the buildings into the upstairs and the downstairs.
3 ADD EXTRA GUIDELINES TO HELP YOU POSITION STORE DETA FROM THE VERTICAL LINE, AND END AT THE VANISHING PO	
THE SAME LINES ON BOTH SIDES. USING THE VERTICAL AND LINES AS GUIDES, DRAW THE WINDOWS, DOORS, AND AWN	VINGS. near you to get so

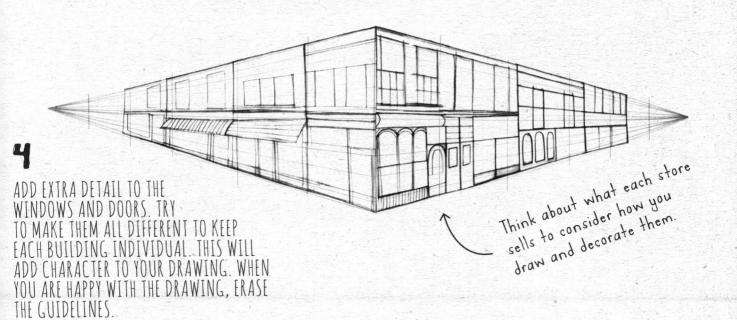

USE AN INK PEN TO OUTLINE YOUR BUILDINGS AND ADD ANY DECORATIVE DETAIL TO THEM. USE WATERCOLOR WASHES TO PAINT THE BUILDINGS AND SHOW REFLECTIONS ON THE WINDOWS. PAINT WITH THE PALEST COLORS FIRST, AND WORK UP TO THE DARKER SHADES.

5

Let the paint ory in between working on each it building so the colors don't building so the colors bleed together.

Let the paint dry in

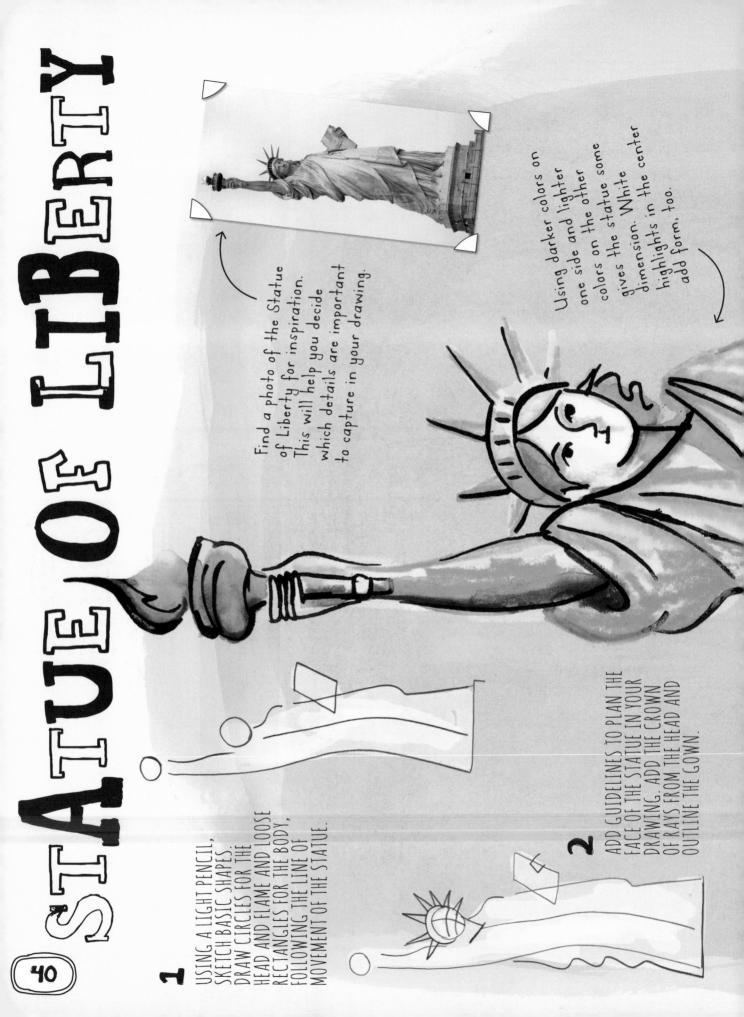

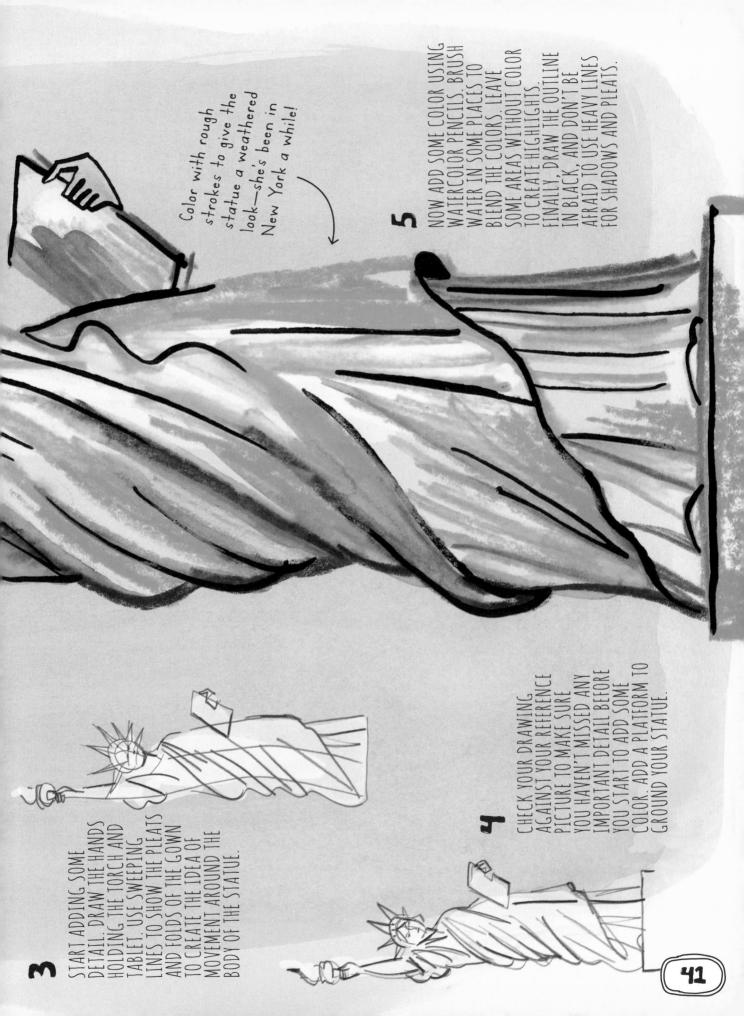

QUAD BIKE

1 DRAW A ROUND SHAPE FOR THE BIKE RIDER'S HEAD, AND THEN USE OVAL SHAPES FOR HIS TORSO, ARMS, HANDS, LEGS, AND FEET, LIKE THIS.

2 SKETCH A LARGE, ANGLED RECTANGLE SHAPE IN FRONT OF THE RIDER FOR THE MAIN BODY OF THE BIKE. THEN DRAW FOUR BIG CIRCLES FOR THE WHEELS.

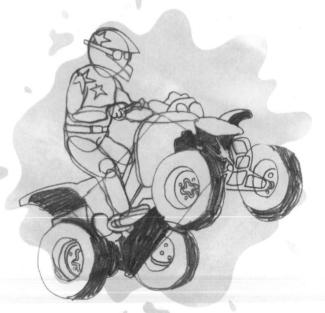

SHADE THE DARKER SECTIONS UNDERNEATH THE BIKE. CONTINUE TO ADD DETAIL TO THE DRAWING. ADD THE STAR DESIGN ONTO THE SUIT AND HELMET.

3 ADD DETAIL TO THE SKETCH BY DRAWING THE TOP OF THE RIDER'S HELMET AND A PAIR OF GOGGLES. THEN ADD MORE DETAIL TO THE QUAD BIKE, AS SHOWN.

5 TRACE OVER THE PENCIL WITH INK. ONCE THE INK IS DRY, CAREFULLY ERASE ANY REMAINING PENCIL. ADD PLENTY OF EXTRA DETAIL IN INK, SUCH AS HANDLEBARS AND SHADOWS. Add shading under the rider's arms and knees to give him more depth. Putting the bike in the air creates an exciting picture full of action. USE PAINT TO ADD COLOR TO THE BIKE AND RIDER. TO MAKE IT LOOK AS IF THE BIKE IS MOVING, SPLATTER FLECKS OF BROWN PAINT ON A MUDDY TRACK. 6

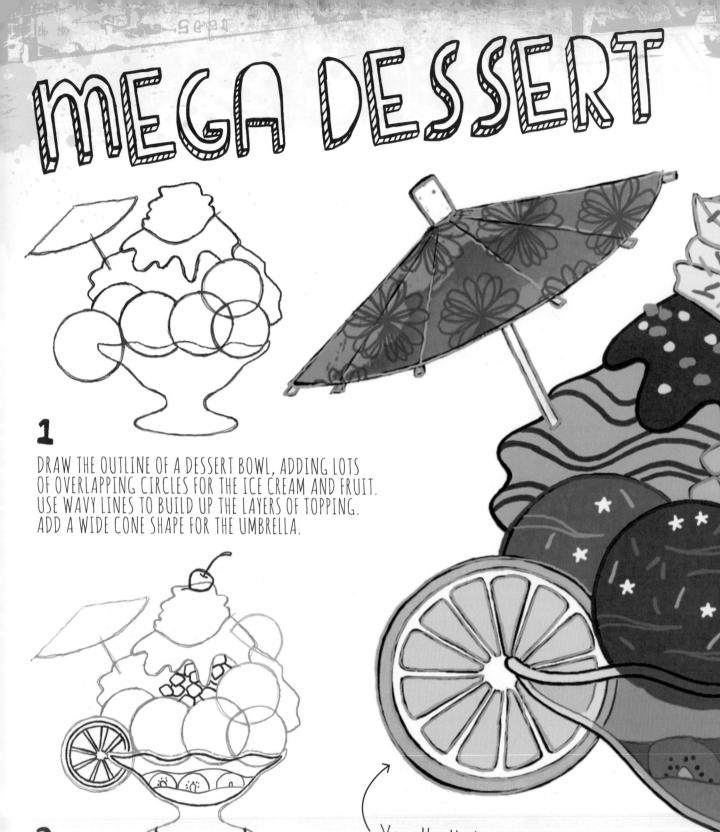

Vary the thickness of the black line work and create extra visual interest by adding thick, colored outlines.

DRAW KIWI SLICES, A CHERRY, BOWL DETAIL, AND SQUARES FOR PINEAPPLE CHUNKS. CREATE

AN ORANGE SLICE BY ADDING MORE CIRCLES AND LINES TO ONE OF THE ROUND SHAPES.

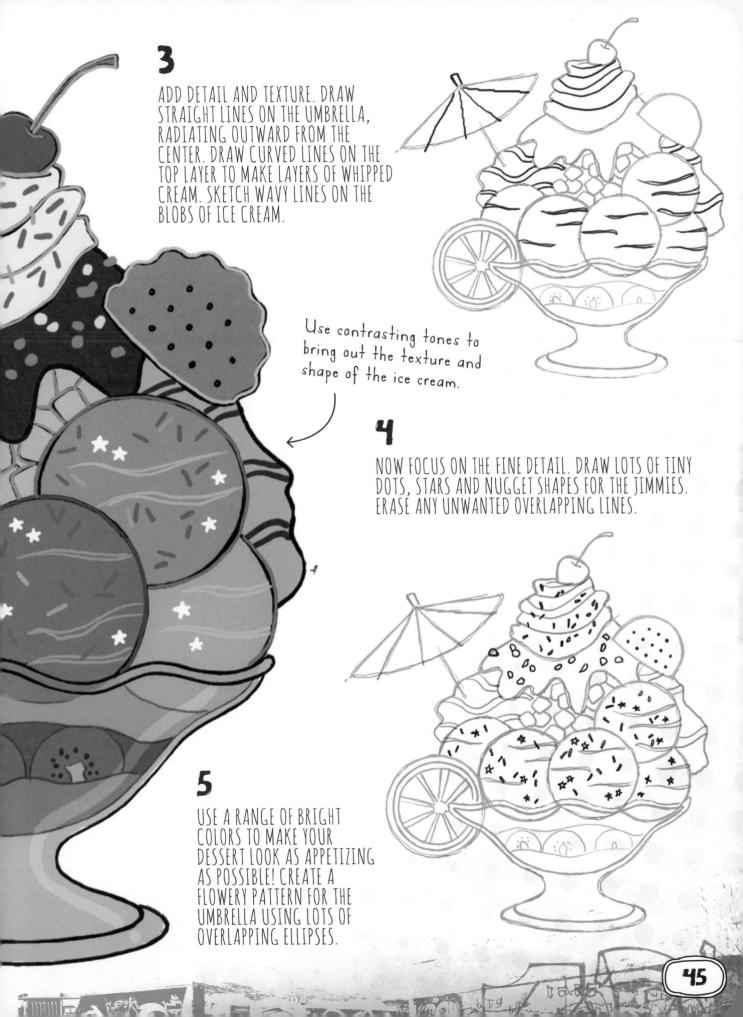

NENJA, 2 DRAW ROUNDED SHAPES FOR THE CHEST, PELVIS, AND

1 DRAW A SIMPLE SKELETON SHAPE, SHOWING YOUR NINJA IN AN ACTION POSE. DRAW STRAIGHT LINES FOR HIS OUTSTRETCHED ARM AND LEG, WITH ANGLED LINES FOR HIS OTHER LIMBS.

Add more ninjas to your scene. Try and think of poses that contrast with the typical high-kicking main action pose. For example, this ninja is crouching down, ready to pounce!

JOINTS. FLESH OUT THE NINJA'S BODY, USING YOUR GUIDES TO GET THE PROPORTIONS RIGHT. MAKE HIS LEFT ARM AND LEG LOOK BULKIER, SINCE THEY ARE IN A BENT POSITION—THE MUSCLES WILL BE BULGING!

DRAW LOOSE CLOTHING ON THE NINJA'S BODY, ADD A SLIT TO HIS MASK, AND REFINE THE SHAPES OF HIS HANDS AND FEET. DRAW

HIS HEADBAND TRAILING

BEHIND HIM, AS IF HE'S

FLYING THROUGH THE AIR.

5 PAINT YOUR NINJA MAINLY BLACK. ADD PATCHES OF LIGHT GRAY ON TOP TO BRING OUT THE HIGHLIGHTED AREAS AND THE CREASES ON HIS CLOTHES.

GO OVER THE OUTLINE OF THE NINJA AND ERASE ANY UNWANTED GUIDELINES. WORK ON THE FINE DETAIL BY DRAWING THE FINGERS AND FACIAL FEATURES. ADD LINES AND SHADING TO SHOW THE CREASES IN THE CLOTHING.

> Paint the background a flat color, adding darker brick shapes and windows. Give it a gritty, urban texture by scratching away the painted surface with a coin or wire brush.

MUSTACHES

LEARN HOW TO DRAW SOME SIMPLE TWIRLY MUSTACHES, THEN TRY CREATING YOUR OWN STYLES—THE MORE OUTLANDISH, THE BETTER!

SHORT STROKES

1 DRAW THE BASIC OUTLINE OF A MUSTACHE. THINK OF IT AS A WIDE, SOFT 'M' SHAPE WITH CURLS ON EACH SIDE. **2** USING A SOFT-GRADE PENCIL, ADD LOTS OF SHORT MARKS FOLLOWING THE CURVED SHAPE OF THE MUSTACHE. START WITH THE OUTLINE, THEN FILL IN THE MIDDLE. THE MARKS WILL LOOK LIKE INDIVIDUAL HAIRS.

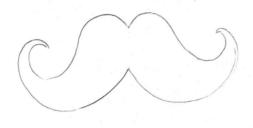

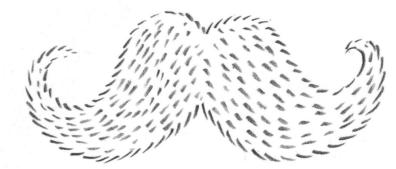

CONTOUR LINES

1 DRAW A CURLIER MOUSTACHE—THE KIND AN OLD-FASHIONED CIRCUS RINGMASTER MIGHT HAVE HAD! USE LONG, CURVED LINES TO DRAW THE LEFT SIDE FIRST, THEN SKETCH THE OTHER HALF TO MATCH. DON'T WORRY IF IT'S NOT EXACTLY SYMMETRICAL. IT WILL LOOK EVEN QUIRKIER IF IT'S NOT COMPLETELY PERFECT.

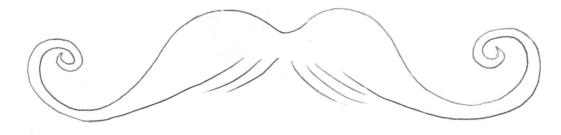

2 ADD SOFTER CURVED LINES, FLOWING FROM THE MIDDLE OF THE MUSTACHE ALMOST TO THE END OF EACH CURL. VARY THE PRESSURE ON YOUR PENCIL TO CREATE THE IMPRESSION OF DEPTH IN YOUR DRAWING.

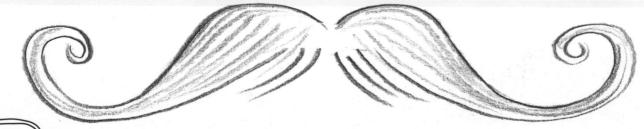

Think about how your mustache designs can be used on faces. This eccentric professor is wearing a suitably mad-looking mustache!

AFTER YOU'VE MASTERED THE BASIC MUSTACHE, TRY VARYING THE SHAPES, AND EXPERIMENT WITH DIFFERENT TECHNIQUES FOR ADDING TEXTURE.

PENCIL STROKES

Mimic the mustache contours with a number of heavier lines. Then add softer shading between them.

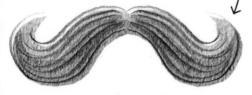

THE HANDLEBAR

USE DIFFERENT PENCIL STROKES FOR THESE MUSTACHES, AND USE PENCIL CRAYONS TO COLOR THEM IN.

Draw each of these short lines with a quick flick of the pencil to make the mustache look bristly.

This simple crescentshaped mustache looks quite neat. Fill the shape with dashed marks to create a uniform pattern.

THE SERGEANT MATOR

FILL YOUR MUSTACHE DESIGNS WITH DOODLES AND PATTERNS.

THESE DESIGNS WERE CREATED USING FINE-LINE MARKER PENS.

THE VILLAIN

PATTERNED

THE POLKA DOT

wacky styles

Draw multiple swirls, then fill them with long, sweeping curves.

THE SWIRLY

MUSTACHE DESIGNS CAN BE AS STRANGE AND OVER-THE-TOP AS

YOU WANT. LET YOUR IMAGINATION GO WILD!

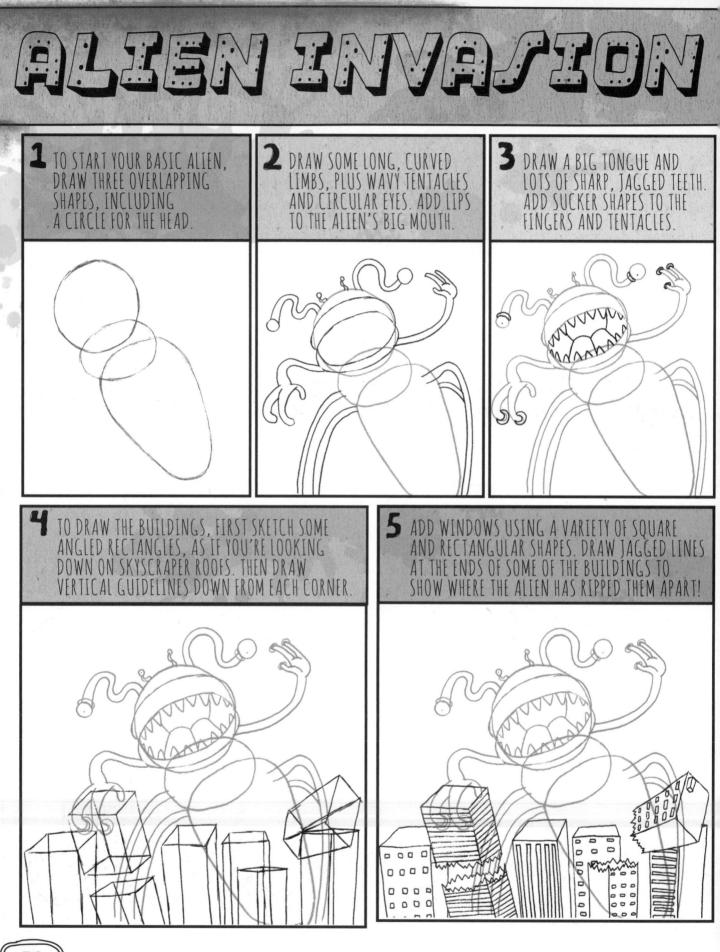

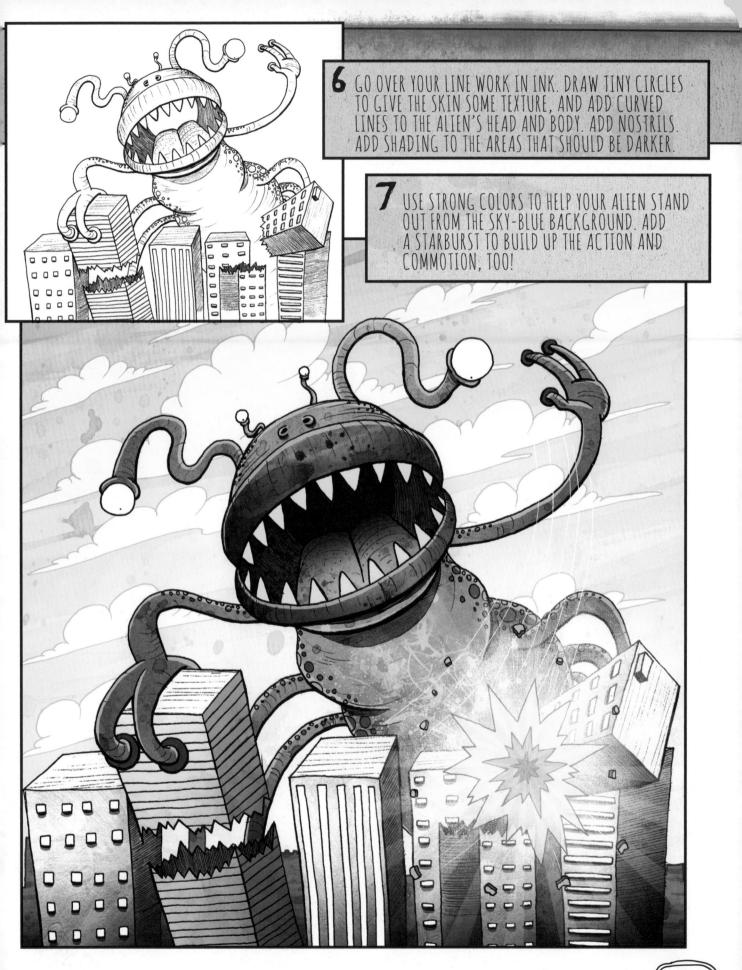

START BY SKETCHING THREE BASIC SHAPES: A SKEWED RECTANGULAR SHAPE FOR THE NECK, A LARGE CIRCLE FOR THE HEAD, AND A SMALLER ONE FOR THE EYE.

4

ADD MORE SIMPLE SHAPES: A ROUGH SEMICIRCLE FOR THE MOUTH AND SAUSAGE SHAPES FOR THE HORNS AND EARS.

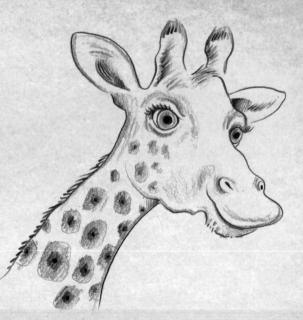

2

USING THE BASIC SHAPES AS A GUIDE, Sketch the outline of the giraffe. Give her some lovely upturned Eyelashes—the eyes on a giraffe are a Big feature! erase your guidelines.

USE SUBTLE SHADING TO BRING OUT THE FACIAL FEATURES. FOR THE PATTERN, DRAW SOME ROUGH CIRCULAR SHAPES, THEN SHADE EACH AREA, ADDING DARKER TONES TO THE CENTER OF EACH ONE.

3

Try drawing on textured heavy drawing paper to give your illustration added visual interest. To create expressive, lifelike eyes, color the pupils dark, then add two spots of white paint on top—one larger than the other for glints.

5 PAINT AN ORANGEY WATERCOLOR WASH ALL OVER YOUR SKETCH. USE A BROWN COLORED PENCIL TO TRACE OVER THE OUTLINE, AND ADD SHADING, INCLUDING IN THE EARS AND ON THE HORNS AND NOSTRILS.

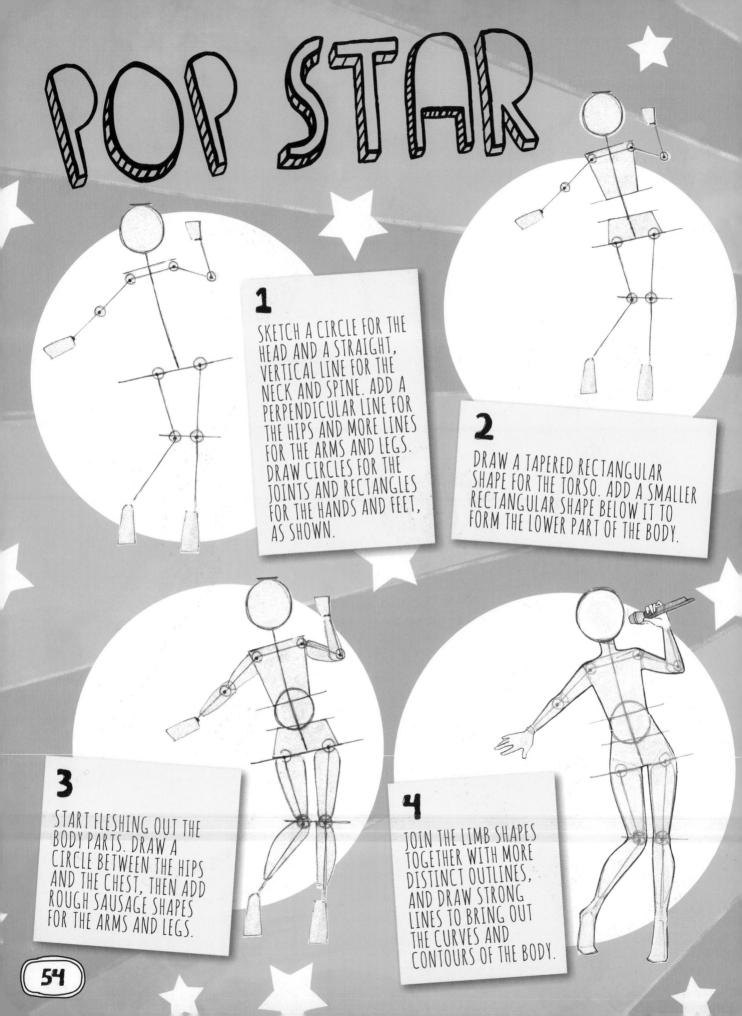

Add facial features and some shading for your pop star's stage makeup.

5

FOCUS ON THE FINER DETAILS OF YOUR

FIGURE, ADDING

HAIR, CLOTHES, AND

DETAILS THAT HELP TO

ADD REAL CHARACTER

ACCESSORIES. IT'S OFTEN THE SMALLER Try adding a two- tone background, choosing colors that contrast with your pop star.

6 ADD SOME COLOR TO YOUR POP STAR. USE SUBTLE SHADING ON THE JEWELRY WITH ADDED HIGHLIGHTS TO BRING OUT THE BLING!

Draw a podium to ground your singer so she doesn't look like she's floating in space.

55

LINE DESIGNS

USE A PENCIL TO DRAW TWO WAVY LINES OF SIMILAR LENGTHS. THE LINES WILL LOOK LESS WOBBLY IF YOU DRAW THEM QUICKLY. A LINE DESIGN SHOULD BE POWERFUL, DRAMATIC, AND MEMORABLE!

ADD SOME SPIRALS AND MORE SWEEPING LINES INTO YOUR DESIGN. MAKE IT LOOK NATURAL. AGAIN, DO THIS QUICKLY AND CONFIDENTLY. GIVE YOUR TWO LINES A BIT MORE DEPTH BY ADDING ANOTHER TWO PENCIL LINES BENEATH THEM, LIKE THIS, MAKING THE LINES LOOK AS IF THEY HAVE BEEN CREATED WITH TWO CLEAN, SWEEPING BRUSHSTROKES.

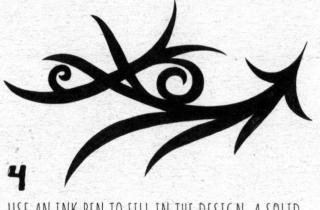

USE AN INK PEN TO FILL IN THE DESIGN. A SOLID BLACK COLOR CREATES A VERY STRIKING IMAGE.

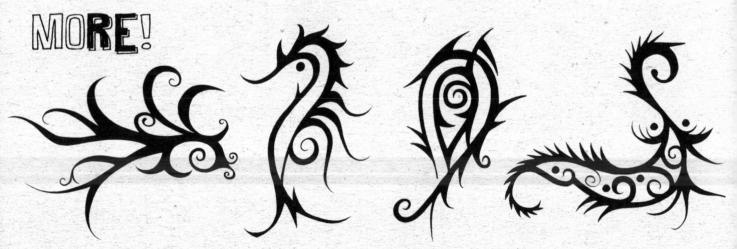

Be as creative and imaginative as you like with line designs, and come up with your own to draw on your things. These ones are spiky, dramatic, and memorable!

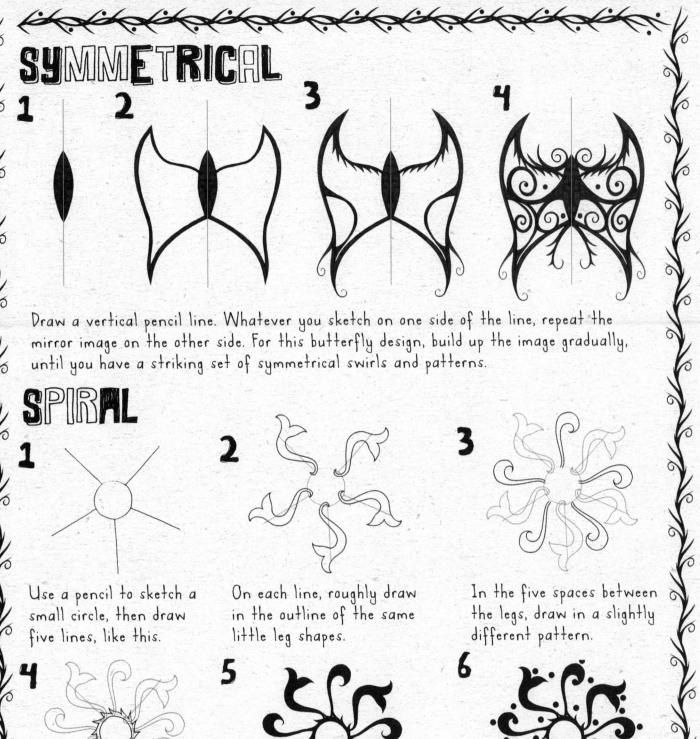

Add a spiky design to the circle in the middle of your pattern.

Using ink, color in your design. Doing this quickly creates a bolder image.

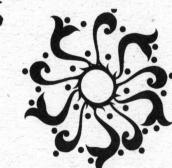

Finally, add some little dots to the image to complete your cool spiral design.

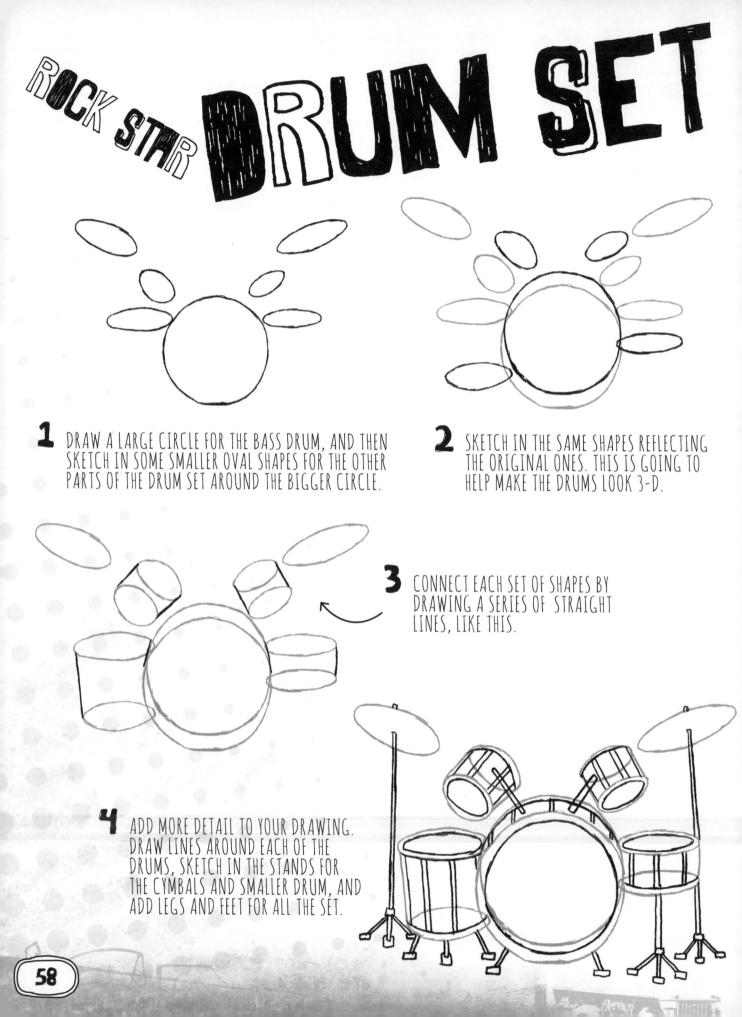

For inspiration for the line design, see pages 56 and 57.

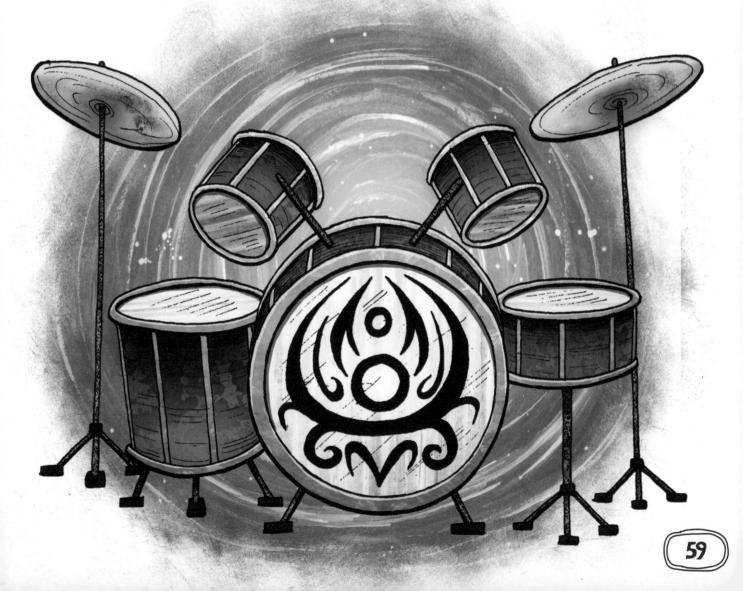

5 TO MAKE THE DRUM SET STAND OUT, DESIGN YOUR OWN BLACK LINE DRAWING ON THE FRONT OF THE BASS DRUM. OR, GIVE YOUR BAND A NAME, AND ADD A SPECIAL LOGO WITH THE NAME IN THE SAME SPACE.

6 COLOR YOUR FINISHED PICTURE WITH GOLDEN COLORS FOR THE CYMBALS AND WOODEN COLORS FOR THE DRUMS. ADD DARK STANDS AND A COOL ROCK STAR BACKGROUND.

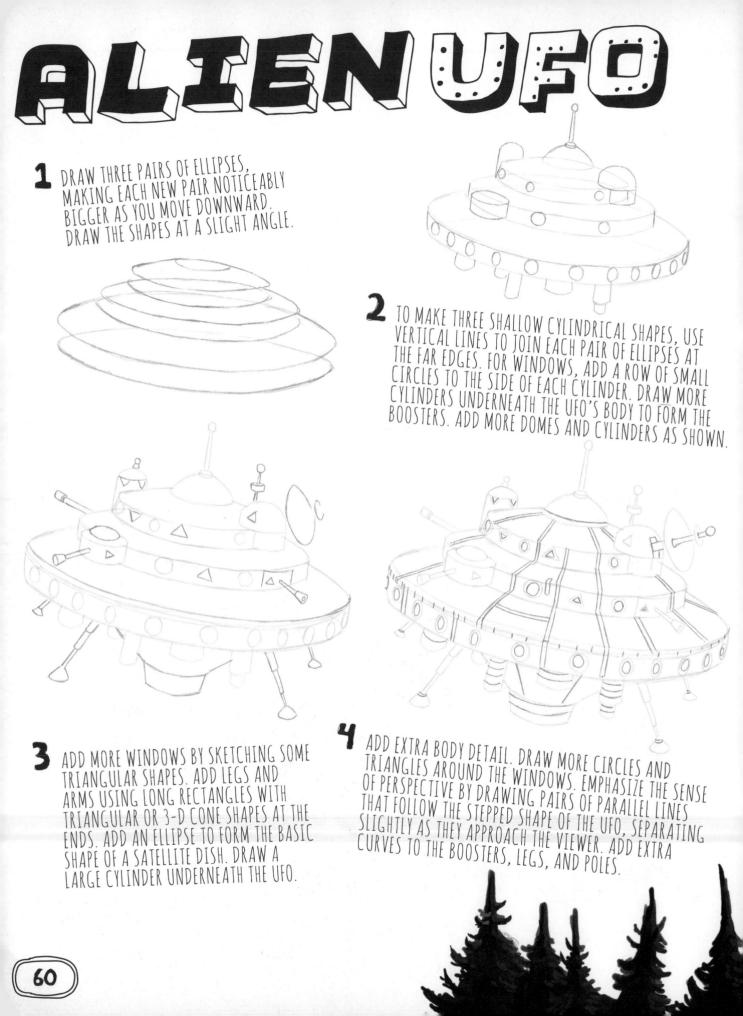

5 PAINT YOUR UFO! THEN USE CHALKS OR PASTELS TO ADD A SOFT GLARE EFFECT AROUND THE OUTER EDGES OF THE WINDOWS. MAKE THE BODYWORK LOOK SMOOTH AND METALLIC BY ADDING PLENTY OF REFLECTIONS AND LARGE HIGHLIGHTED AREAS.

> Use watercolor washes to create a beam of light. Start with a pale blue and fade it out as you approach the center, leaving only the white paper showing. Leave to dry, then repeat with the purple color, starting farther away and fading out where the two colors overlap.

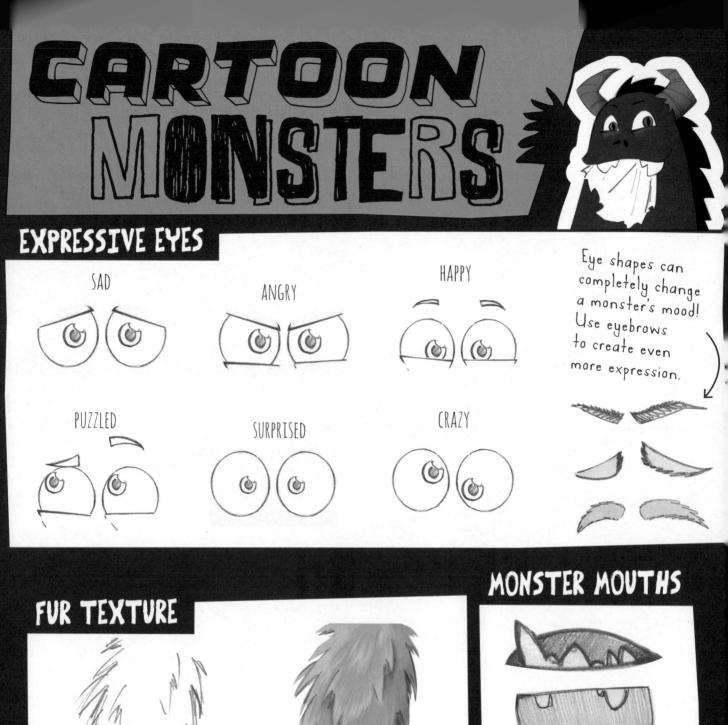

FUR FALLS IN ONE DIRECTION. SKETCH A RAGGED OUTLINE CREATE TEXTURE WITH LIGHT AND SHADOWS BETWEEN THE CLUMPS OF

FUR. USE LINES IN ONE DIRECTION

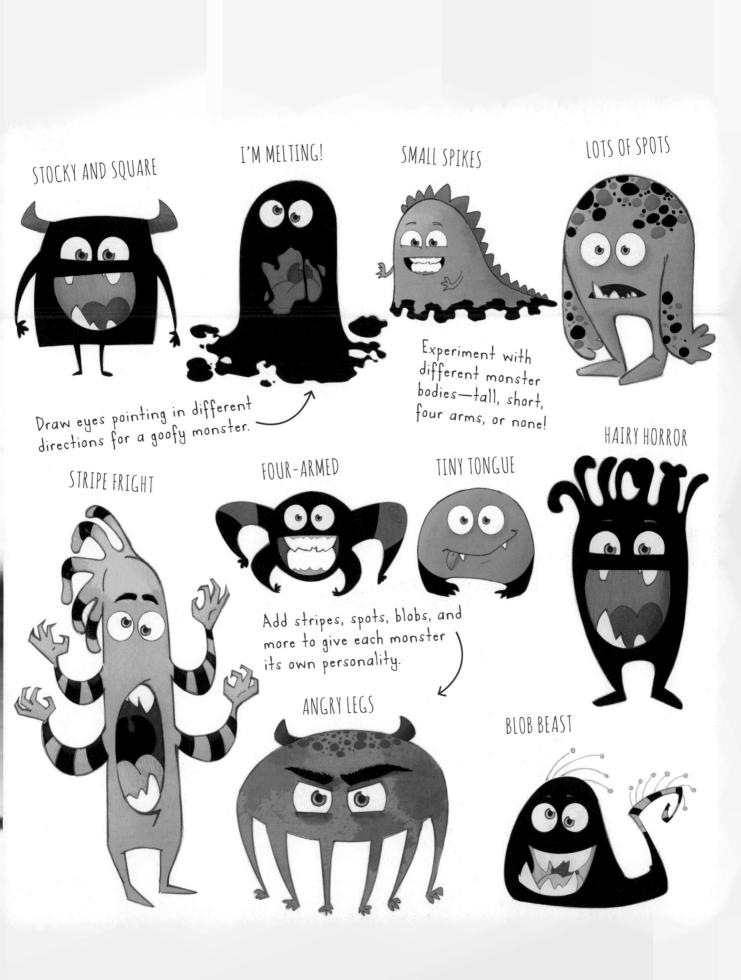

MONKEYS

DRAW A BASIC STICK FIGURE

SHOWING YOUR MONKEY IN AN

ACTION POSE. USE SHORT LINES

DRAW MORE GUIDES TO DEFINE THE MONKELY'S BODY, LIMBS AND TAIL. ADD ROUGH SHAPES FOR HIS FACIAL FEATURES.

TO SHOW THE POSITIONS OF

THE SHOULDER AND

ARM JOINTS

Note how the monkey's body and his right leg follow one continuous line of action. Since the line is curved rather than straight, it makes the overall pose feel dynamic and interesting.

2

SKETCH THE OUTLINE OF

YOUR MONKEY'S BODY

AS A GUIDE

4

USING THE STICK FIGURE

ERASE ALL THE CONSTRUCTION LINES, LEAVING THE OUTLINE OF YOUR MONKEY. REFINE THE FACIAL DETAILS, AND DRAW IN THE FINGERS AND TOES.

5)

PAINT THE FACE, EARS, AND FEET PALE PINK. USE PENCIL CRAYONS FOR THE FUR. MAKE THE BASE TONE FOR THE FUR. MAKE THE BASE TONE DARKER THAN YOU WANT THE FINAL DARKER THAN YOU WANT THE FINAL OLOR TO APPEAR, AND ADD A FUR COLOR TO APPEAR, AND ADD A FUR COLOR TO APPEAR, AND ADD A FUR FOR TONE ON TOP, USING VERY LIGHTER TONE ON TOP, USING VERY FINALLY, ADD AN EVEN LIGHTER TONE FOR HIGHLIGHTS.

> If you want to paint the fur texture instead of using pencils, first paint your monkey in a solid color. Add fine brushstrokes on top in a lighter color. Follow the form of the animal so the fur all lies in the same direction.

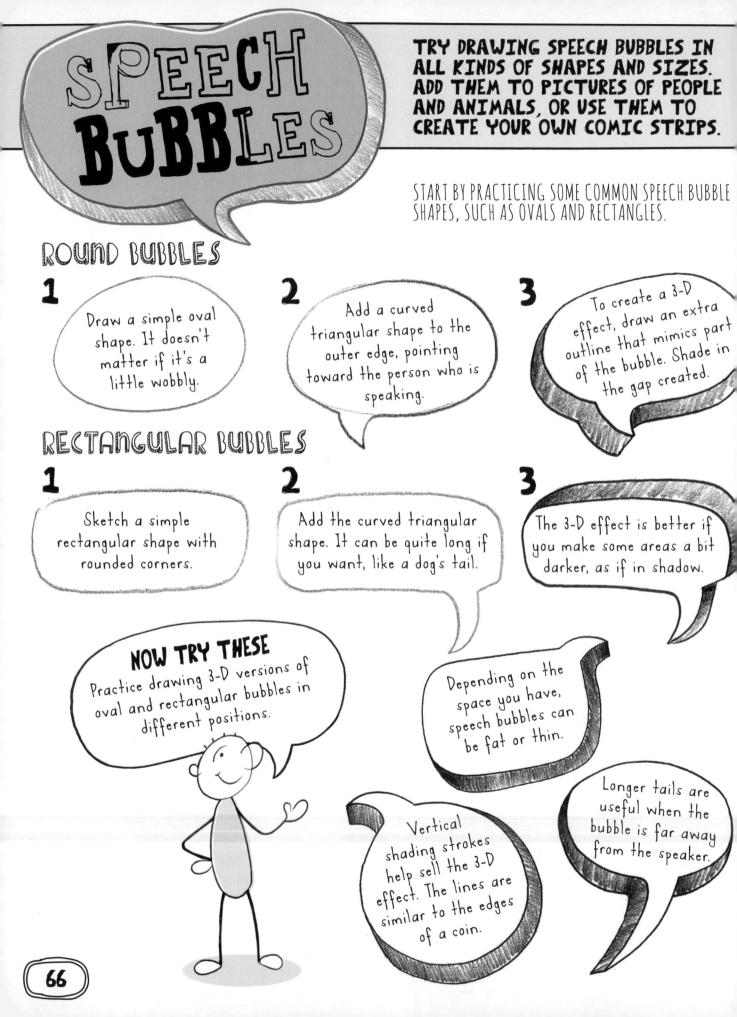

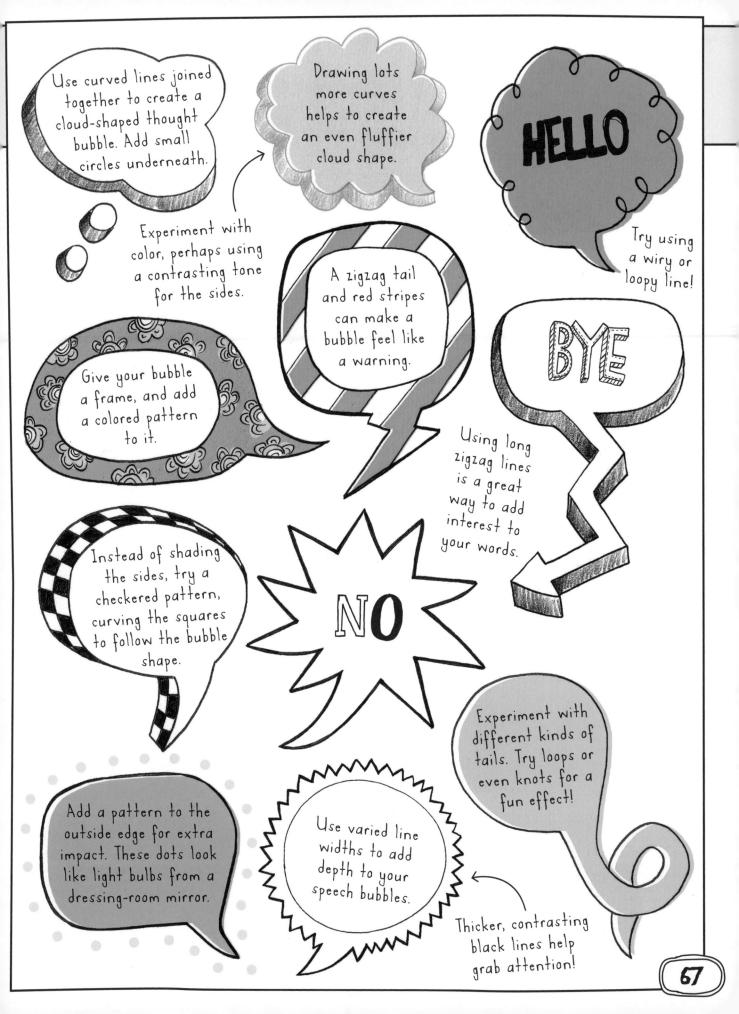

THE BASIC SHAPE OF A SKATEBOARD IS VERY EASY TO DRAW. THE FUN PART IS COMING UP WITH AN EXCITING AND ORIGINAL PATTERN!

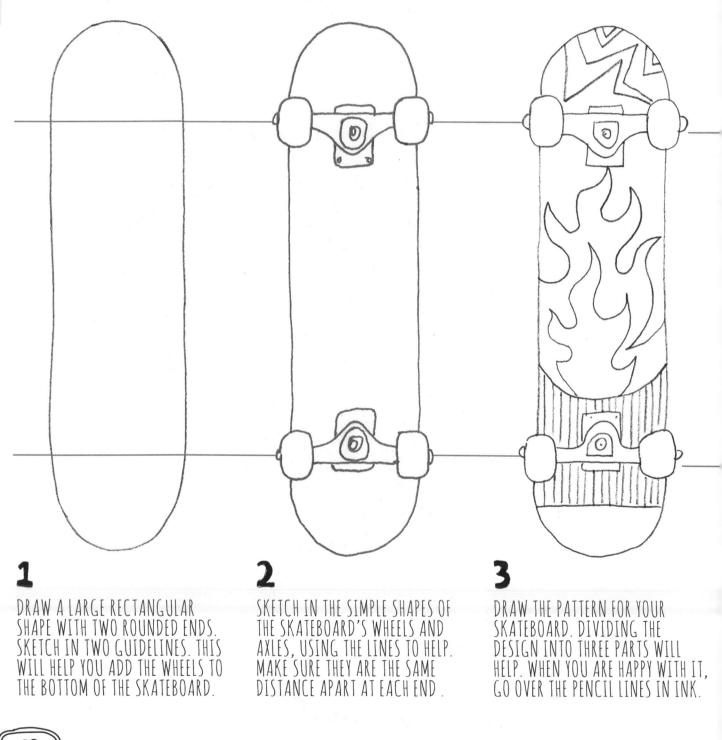

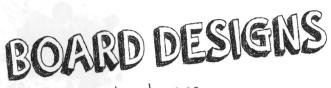

Use your imagination to come up with original designs for the bottom of your board. Color in the skateboards brightly to make the patterns look striking!

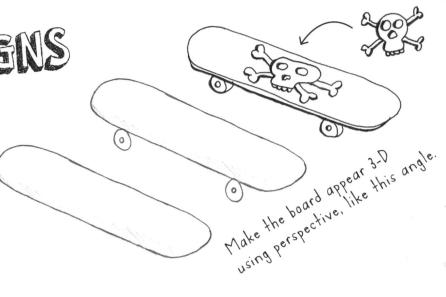

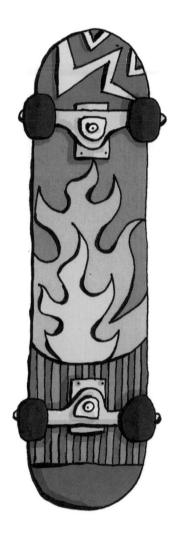

USE PAINTS TO COLOR IN YOUR SKATEBOARD. GIVE DEPTH TO THE DESIGN WITH A SLIGHTLY HEAVIER LINE USING A FINE BRUSH AND INK AROUND PARTS OF THE PATTERN.

PHTM1

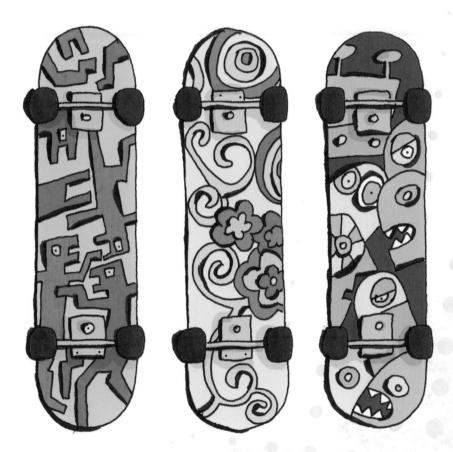

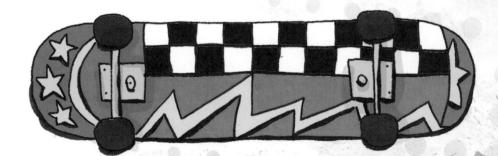

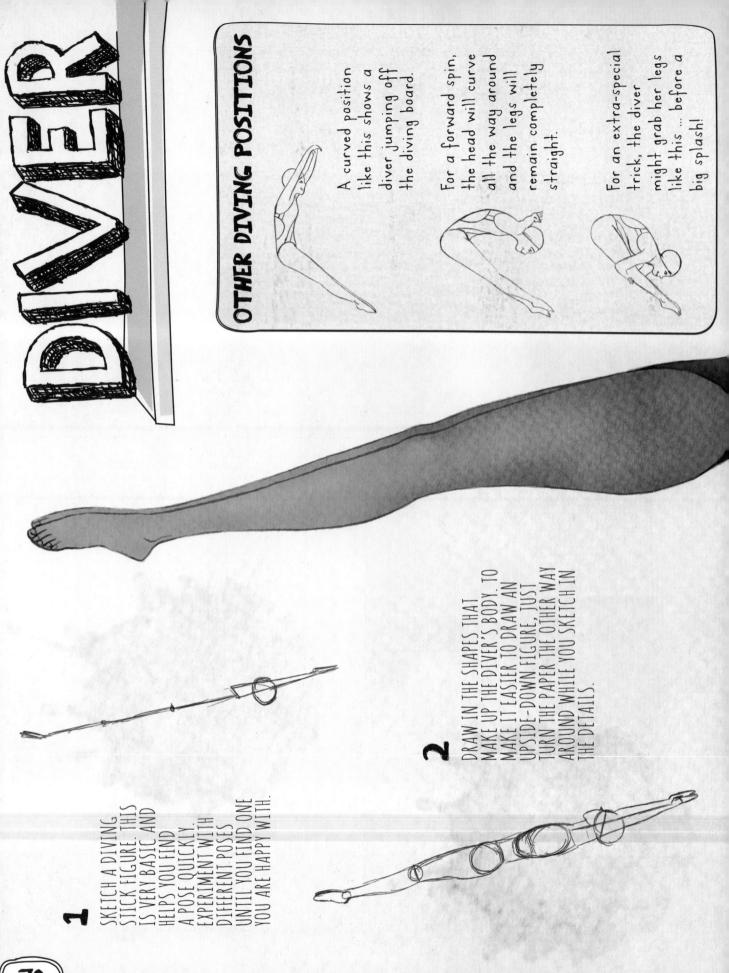

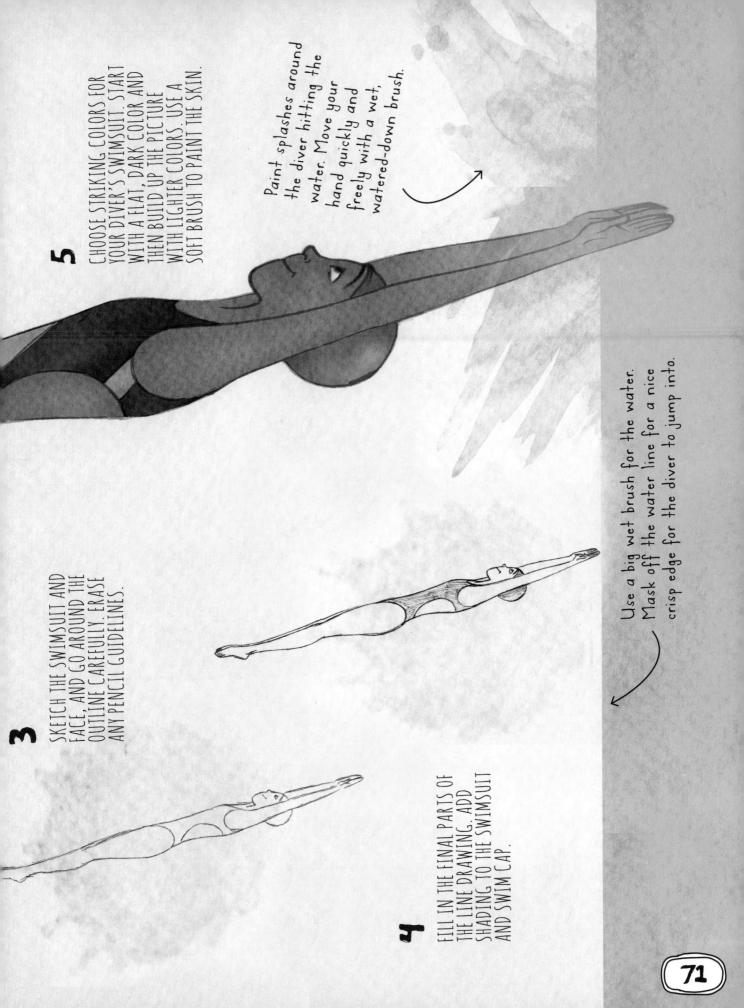

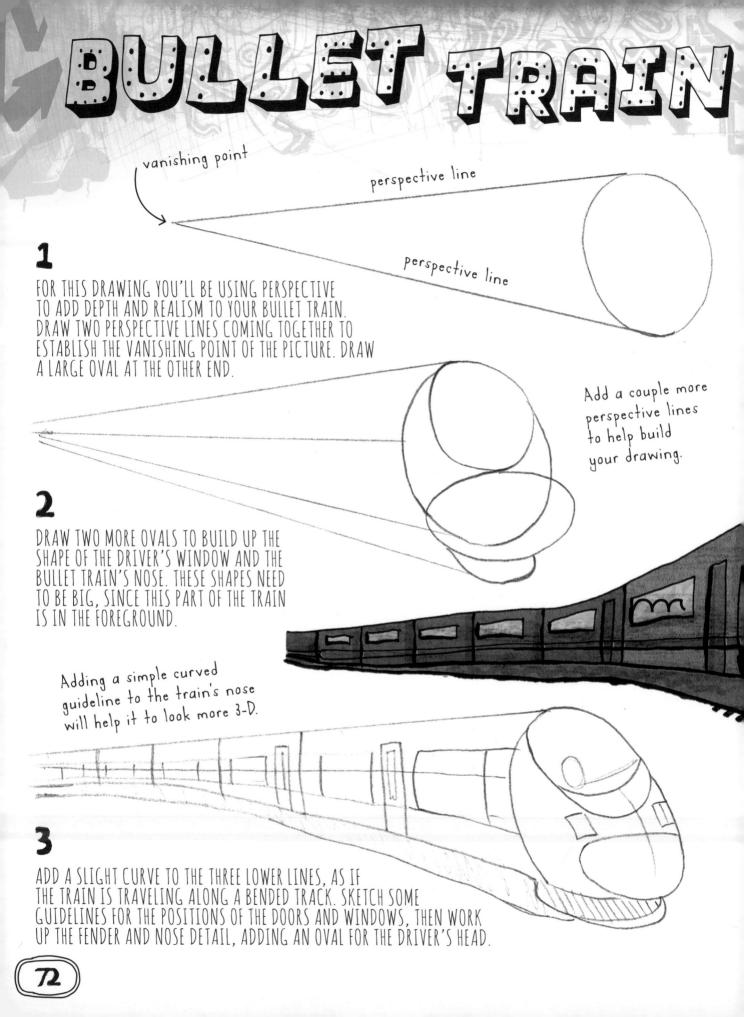

Telola

4

5

000

DRAW MORE OVALS FOR THE PASSENGERS' HEADS. ADD MORE DECORATIVE DETAIL TO THE TRAIN'S EXTERIOR, AND SKETCH MORE LINES ON THE LIGHTS AND FENDER. CONTINUE THE LOWER GUIDELINES TO HELP YOU DRAW IN A SIMPLE TRACK.

COLOR YOUR TRAIN, PAYING SPECIAL ATTENTION TO LIGHT AND SHADE. HERE, A LIGHTER FRONT SECTION REINFORCES THE SENSE OF PERSPECTIVE, MAKING THE TRAIN APPEAR TO COME OUT OF THE PAGE TOWARD US. Imm

Don't worry if your final line work is a little wobbly. It's a feeling of movement you want to get across, maker than an impression of technical perfection!

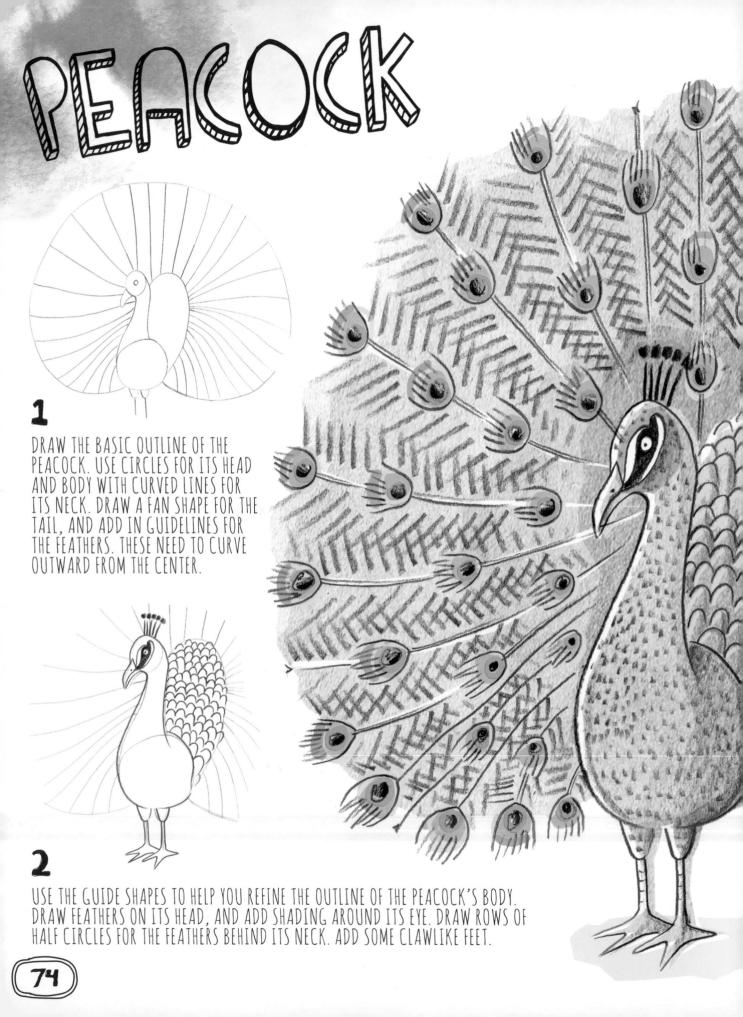

To create a feathered effect, use quick flicks of your pencil, easing off the pressure as you make each stroke.

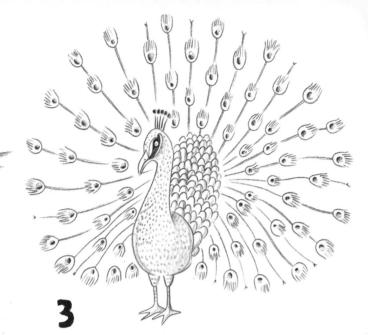

SKETCH EYE SHAPES ALONG EACH OF THE CURVED GUIDELINES. FOR EACH ONE, DRAW A 'U' SHAPE WIH A DOT IN THE CENTER. DRAW VERTICAL STROKES AT THE TOP OF EACH 'U' SHAPE. ADD SHADING AND FEATHER MARKS TO THE PEACOCK'S BODY AND FEET.

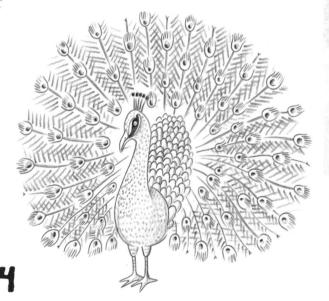

ADD THE FEATHERS IN BETWEEN THE EYE SHAPES BY DRAWING LOTS OF SHORT, SLANTED MARKS ON EACH SIDE OF THE CURVED GUIDELINES.

USE A BLUE WASH FOR THE PEACOCK'S BODY, TRACING THE OUTLINE WITH A DARK BLUE PENCIL. USE A GREEN WASH FOR THE FEATHERED FAN, AND PICK OUT THE FEATHERED DETAIL WITH A DARK GREEN PENCIL. LEAVE SOME AREAS WHITE TO GIVE THE PEACOCK MORE OF A 3-D LOOK.

5

For the "eyes," use bright felt-tip pens. Try blue for the center, with a caramelcolored ring. Add yellow and green curves around the 'U' shapes.

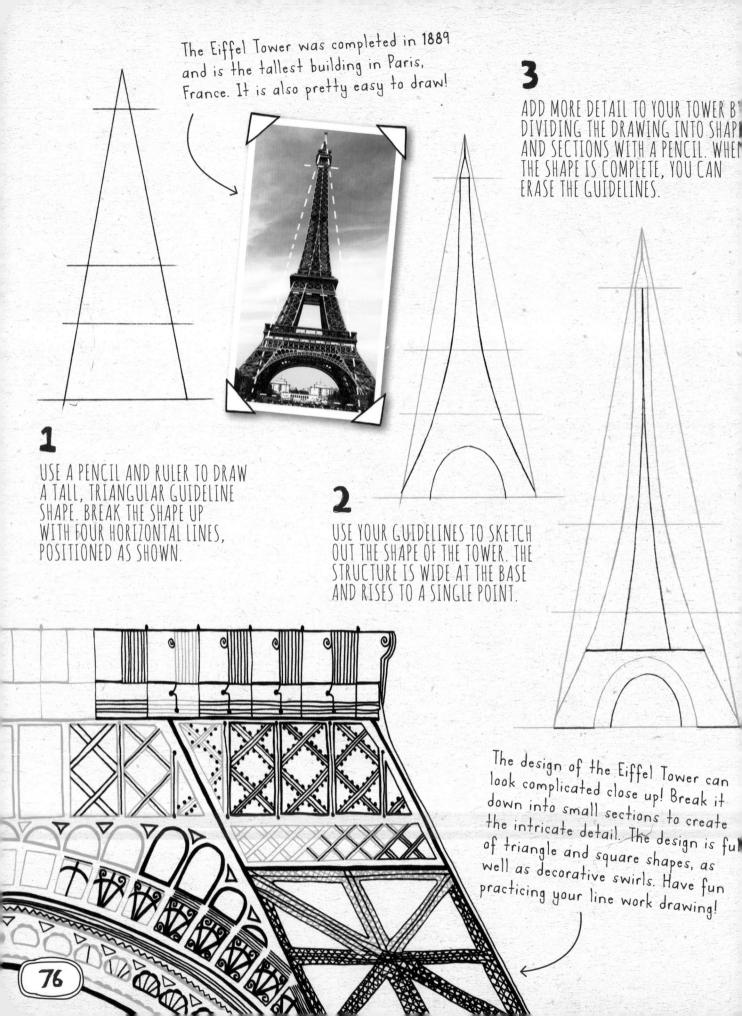

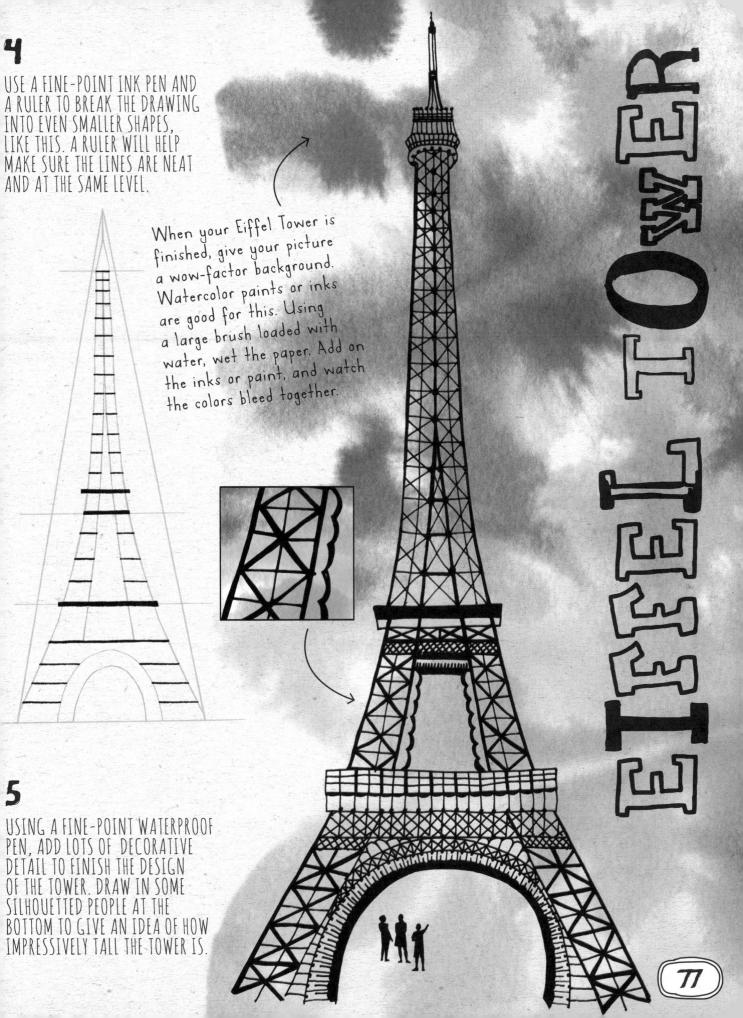

LEARN HOW TO DRAW A VARIETY OF HAIRSTYLES TO USE ON YOUR PORTRAITS. EXPERIMENT WITH COLOR AND TEXTURE!

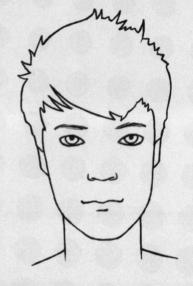

Think about the direction of the hair. Use long, confident strokes for someone who has longer hair, like this.

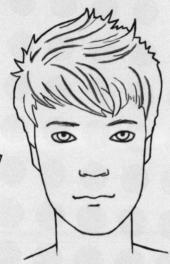

SKETCH IN THE HAIR DETAIL. MAKE SURE LINES ARE CLOSE TOGETHER, AND VARY THE LIGHTNESS AND DARKNESS TO SHOW SHADING, USING DIFFERENT

FOR A BASIC BOY'S HAIRSTYLE, START BY THINKING HOW THE HAIR WILL FALL ON THE FACE. DRAW THE BASIC OUTLINE ON THE TOP OF THE HEAD, LIKE THIS.

The this PENCILS TO ACHIEVE THIS VARIATION. For longer hair, make sure that the strokes of hair are of similar length. Add a little shape to them to show movement.

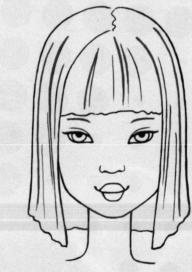

SKETCH IN THE HAIR WITH DOWNWARD PENCIL STROKES. THINK ABOUT THE SHADOWS AND HIGHLIGHTS.

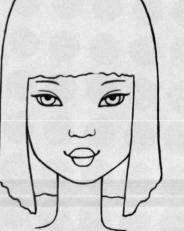

FOR A BASIC GIRL'S HAIRSTYLE, AGAIN START WITH A ROUGH OUTLINE FOR THE SHAPE OF THE GIRL'S HAIR ON A SIMPLE FACE, LIKE THIS.

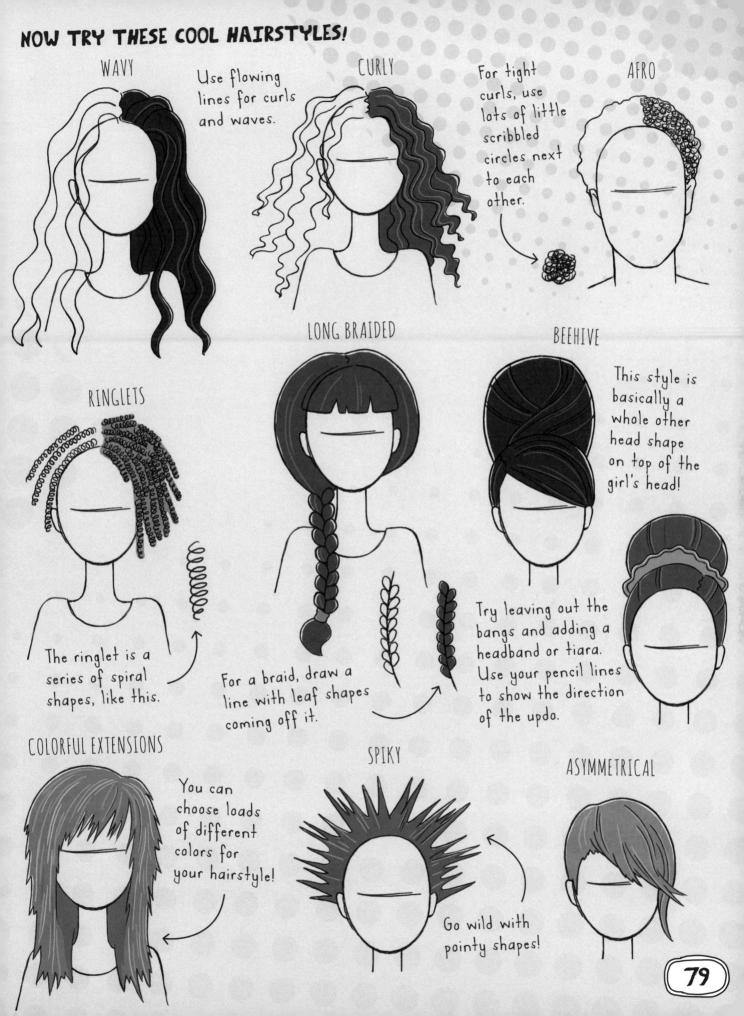

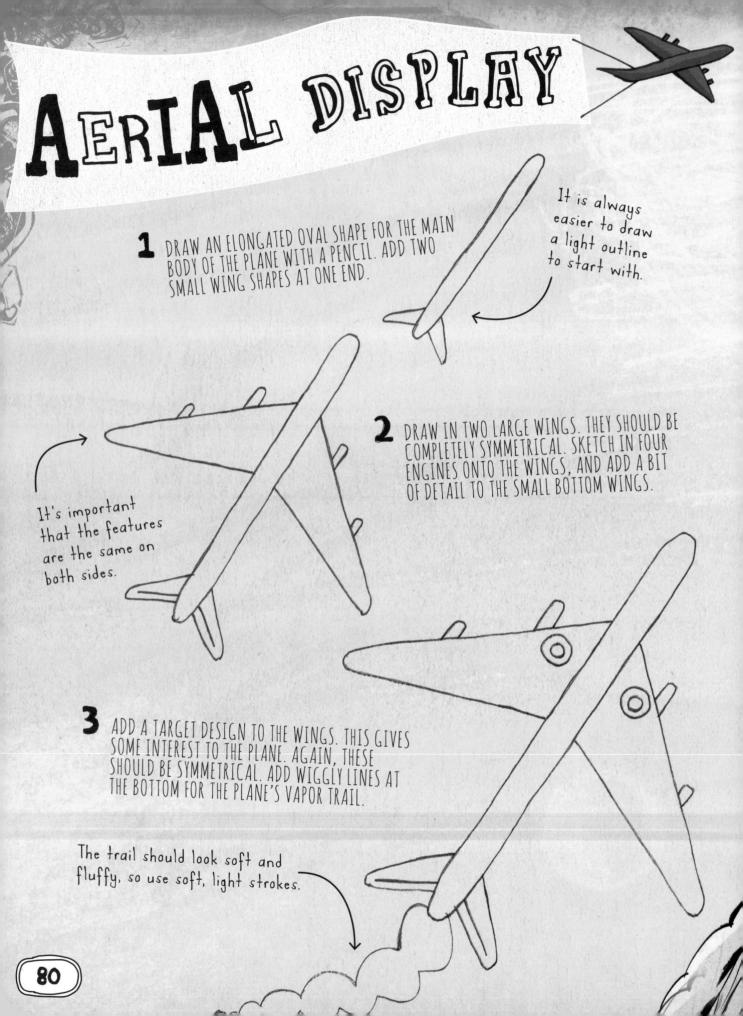

The darker lines on the plane should be in the direction it's flying to help it zoom forward.

4 USE INK AROUND THE PENCIL SKETCH, AND COLOR IT IN. BRIGHT RED LOOKS STRIKING IN THE SKY. ADDING STREAKS OF DARKER COLOR ON THE PLANE MAKES IT LOOK AS IF IT IS GOING REALLY FAST.

> planes could be doing an impressive loop-the-loop, using the trail to give this effect.

One of your

Draw a heart-shaped vapor trail for another plane to zoom through!

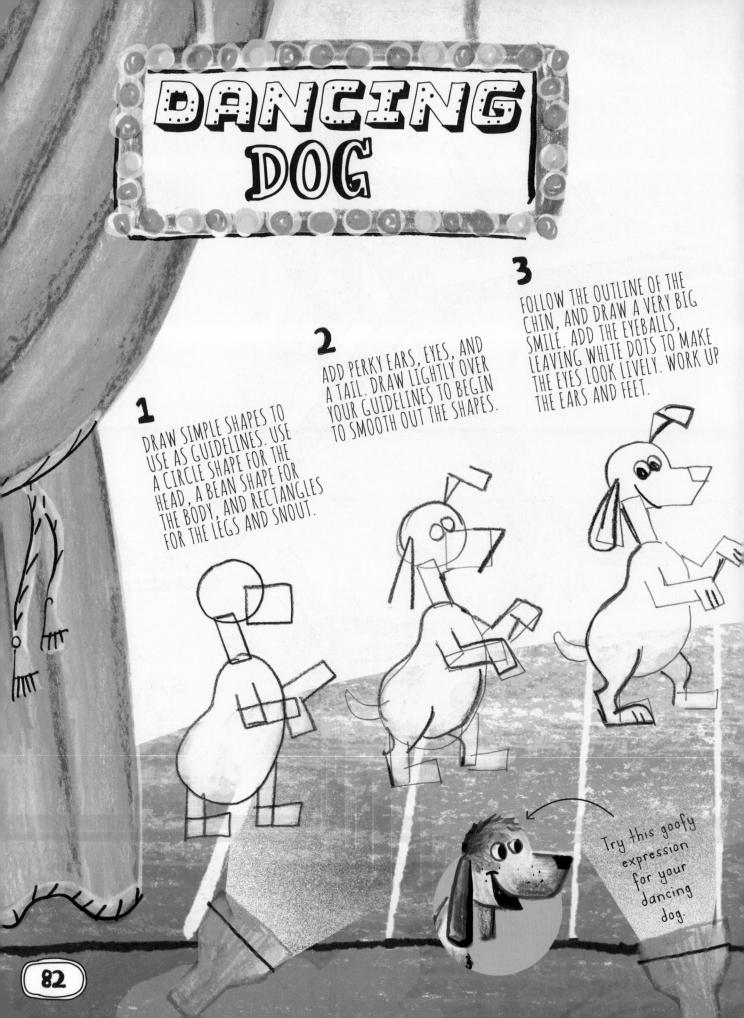

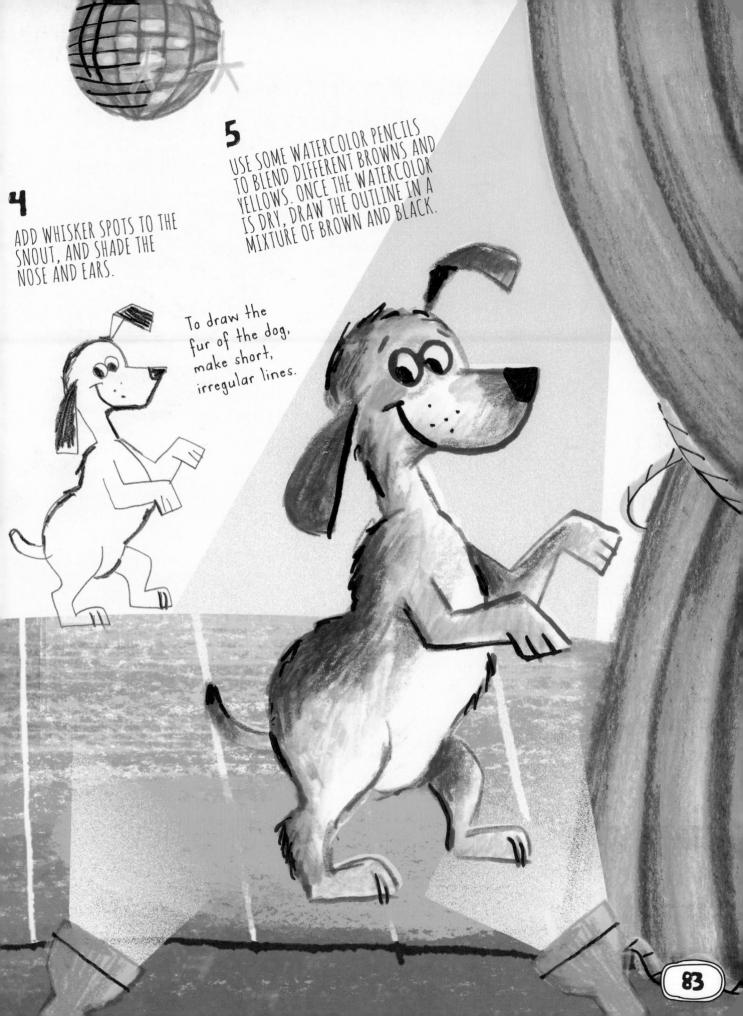

START WITH SIMPLE GUIDELINES. SKETCH A CIRCLE FOR THE HEAD AND LINES FOR THE BODY, ARMS, AND LEGS. USE CIRCLES FOR JOINTS AND RECTANGLES FOR THE HANDS, FEET, AND SNOWBOARD.

> START OUTLINING THE BODY SHAPES. DRAW A VERTICAL RECTANGLE FOR THE TORSO AND CYLINDERS FOR THE ARMS AND LEGS.

2

JOIN THE SHAPES TOGETHER WITH A STRONGER OUTLINE, ADDING SNOW CLOTHING SHAPES AS WELL.

Add steep snowy mountains for a dazzling background. Add gray patches to indicate steep rock faces, giving the impression of the snowboarder being way up high on the mountain!

NOW FOCUS ON THE DETAILS OF THE DRAWING. DRAW THE FACIAL FEATURES, AND WORK UP THE HELMET, MASK, AND CLOTHING.

4

ADD SOME COLOR, USING MARKER PENS OR WATERCOLOR. THINK ABOUT THE LIGHT SOURCE TOP LEFT, AND ADD DARKER SHADOWS ON THE OPPOSITE SIDE.

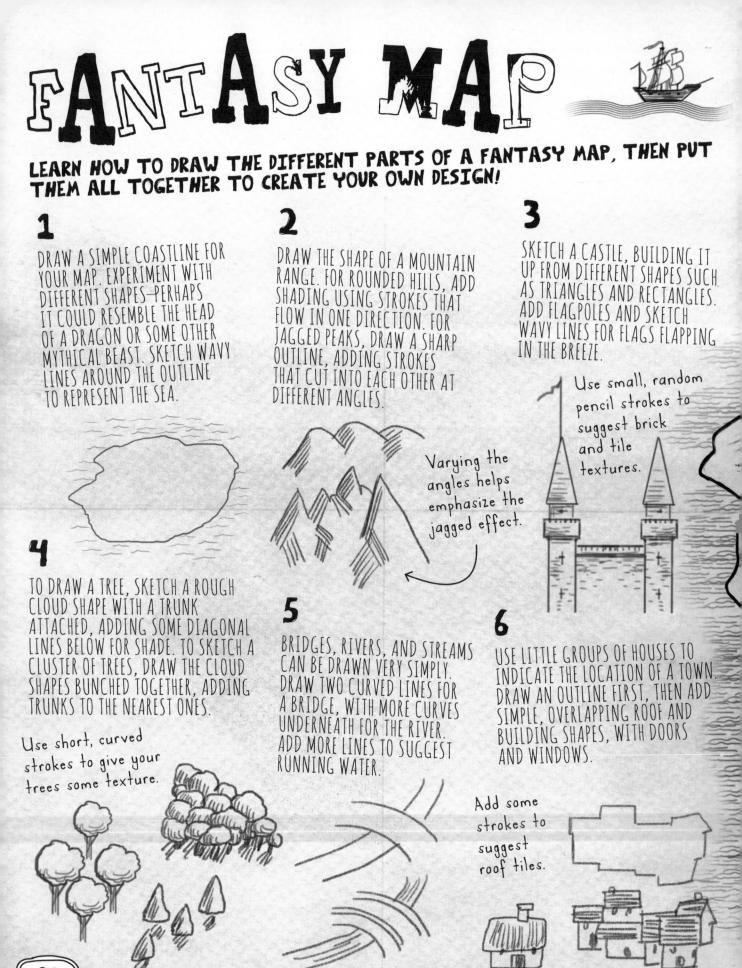

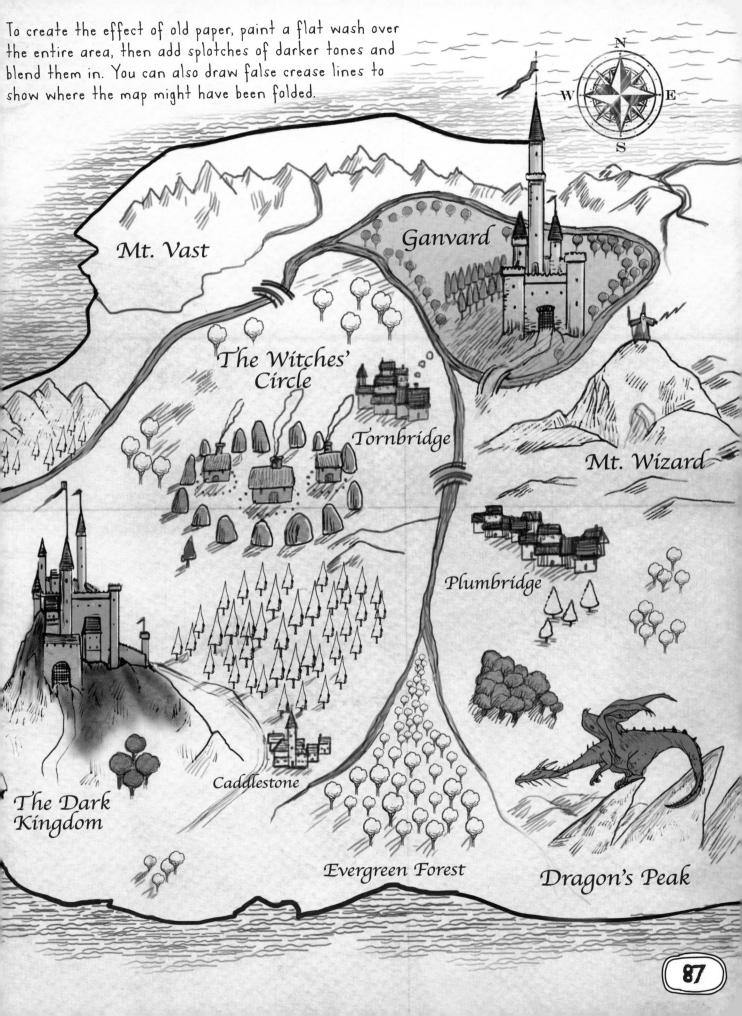

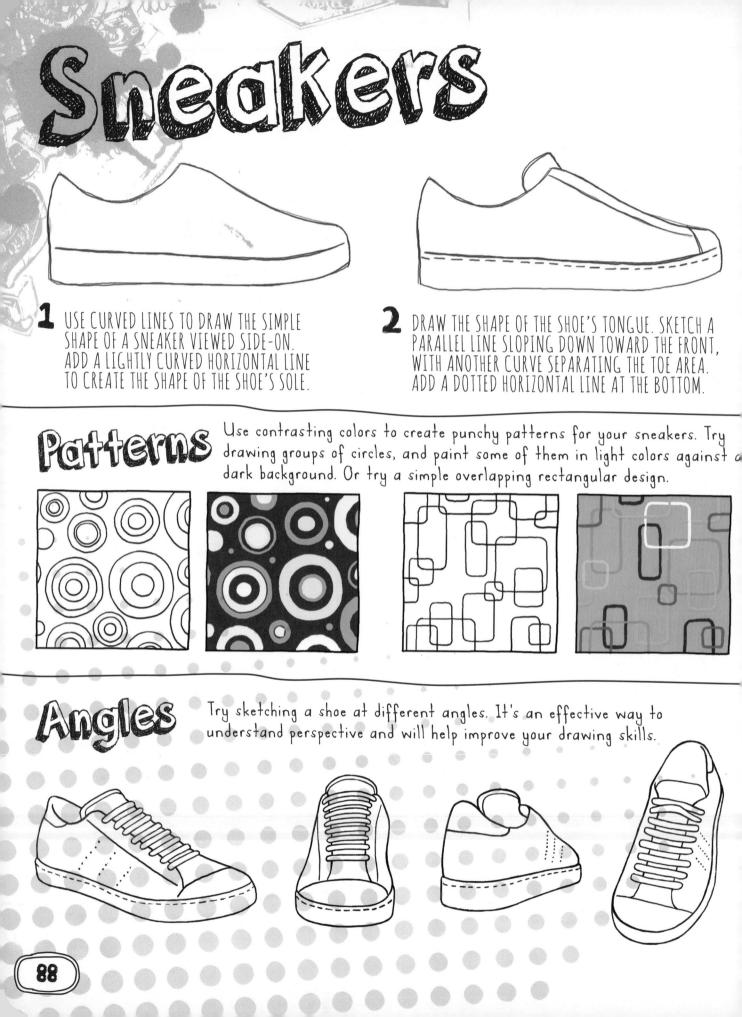

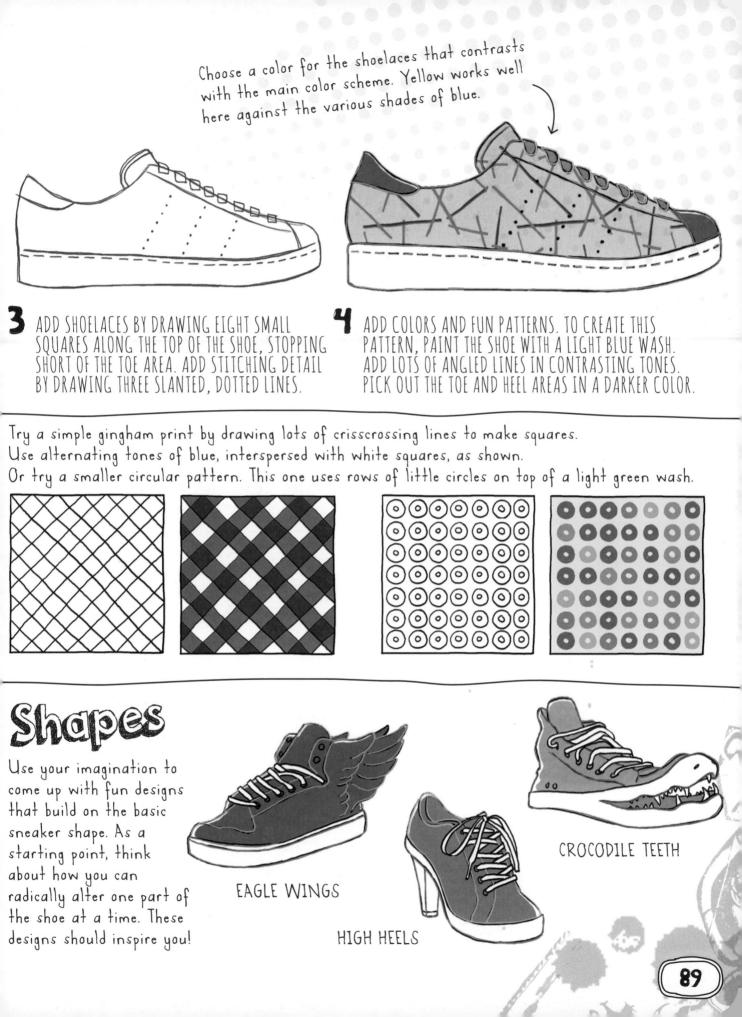

GAR

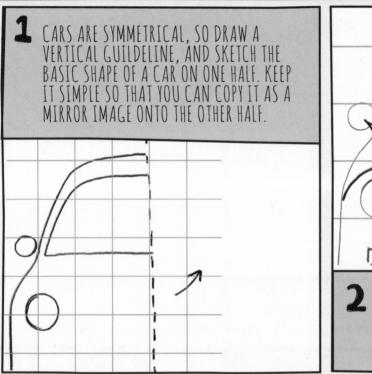

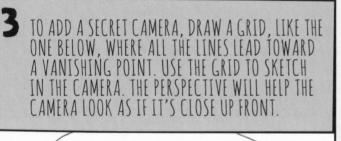

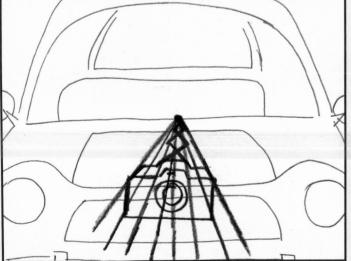

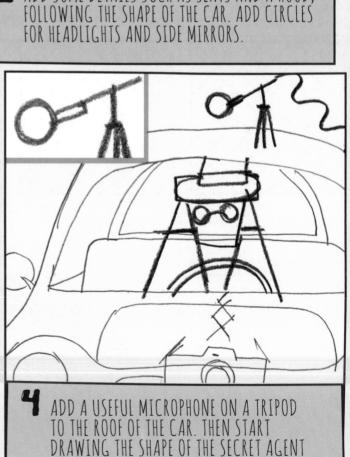

AND STEERING WHEEL USING BASIC SHAPES.

ADD SOME DETAILS SUCH AS SEATS AND A HOOD,

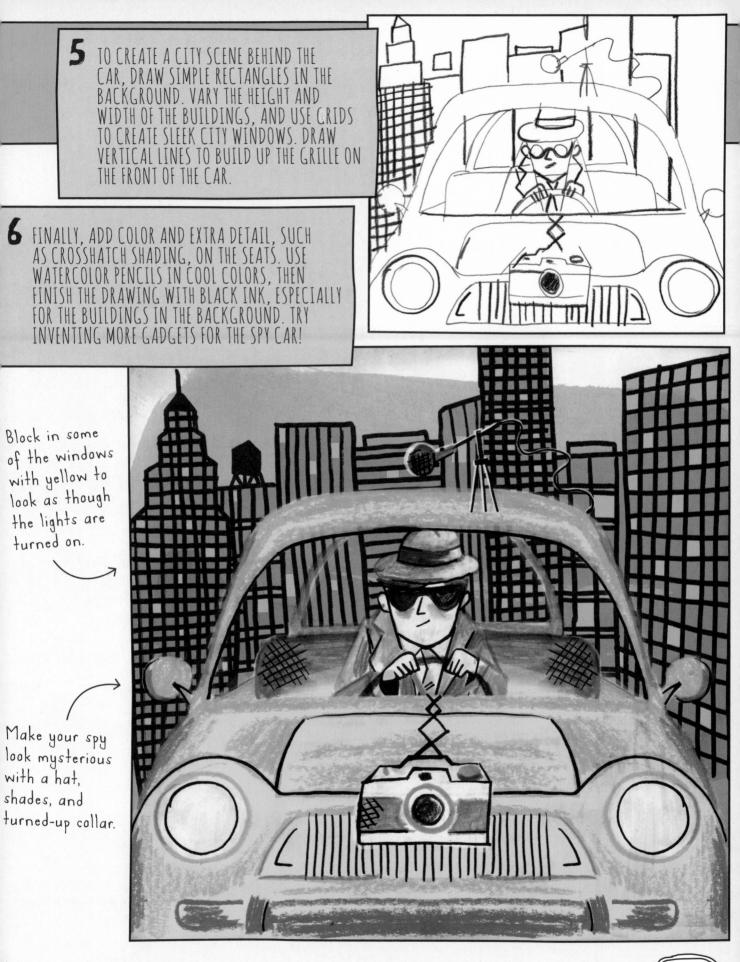

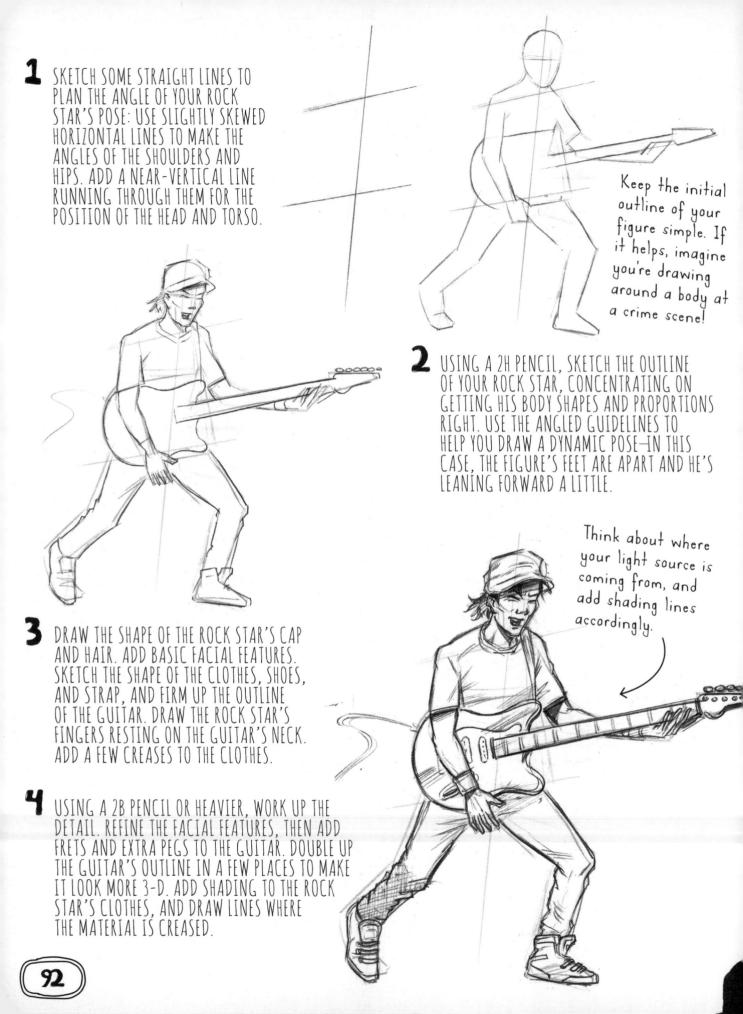

Figure out where the highlights will fall on your figure, and add bands of white just inside the black outline.

RK St

5 GO OVER YOUR LINEWORK USING A BLACK PEN, THEN ADD COLOR. USE A BRIGHTER COLOR FOR THE GUITAR TO CONTRAST WITH YOUR ROCK STAR'S CLOTHES. TRY NOT TO PAINT EACH AREA OR OBJECT A SINGLE FLAT COLOR. INSTEAD, USE PATCHES OF DARKER TONES FOR AREAS THAT ARE IN SHADOW.

Draw the outlines of a few heads and outstretched arms, then paint the entire area a flat, dark color. It's better to keep the audience in silhouette, so that all attention is focused on your rock star!

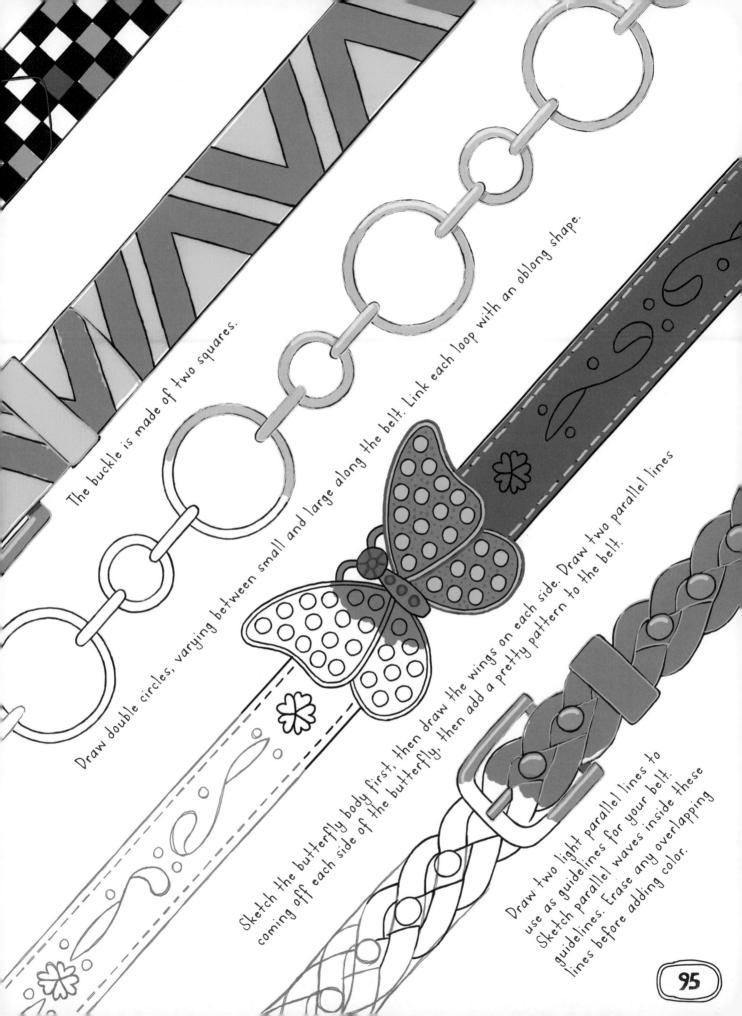

RUPERHERO

USING A HARDER PENCIL SUCH AS A 2H, LIGHTLY SKETCH Some Perspective lines to Create the impression of the Superhero coming toward us. ADD AN OVAL FOR HIS HEAD.

1

LOOSELY BLOCK OUT THE SHAPE AND PROPORTIONS OF THE FIGURE, USING YOUR GUIDES CAREFULLY. THE HANDS ARE THE CLOSEST THINGS TO US, SO THEY NEED TO LOOK QUITE BIG. ROUGHLY SKETCH THE SHAPE OF THE BODY AND CAPE. THE FEET ARE A LONG WAY FROM US SO WILL BE A LOT SMALLER THAN YOU MIGHT THINK. IT'S IMPORTANT TO GET THE PERSPECTIVE RIGHT AT THIS STAGE, SINCE IT'S TRICKY TO ALTER LATER.

WORK ON THE DETAIL OF YOUR FIGURE'S BODY BY ADDING FINGERS, HAIR, AND FACIAL FEATURES. IF YOU LIKE, YOU COULD TRY RAISING UP ONE OF THE KNEES FOR ADDED VISUAL INTEREST. WORK ON THE TOP HALF OF THE FIGURE, ADDING DETAIL TO THE COSTUME. GIVE MORE DEFINITION TO THE MUSCLES AND LEGS. CHOOSE WHERE THE LIGHT SOURCE IS COMING FROM (TOP RIGHT IN THIS SKETCH), AND ROUGHLY SHADE SOME OF THE SHADOWY AREAS, SUCH AS JUST BELOW THE NECK AND HANDS. If you find it difficult getting the hands exactly right, try placing a camera in a high spot and set the self-timer. Then strike a typical superhero pose, and use your pic as reference!

6

USING A DARKER PENCIL SUCH AS A 4B, WORK ON THE FINER DETAIL AND THE SHADOWED AREAS. ADD Some movement lines to give A sense of speed.

Don't be afraid to shade large black areas where necessary. They will add visual impact to your superhero and help to bring out his impressive muscle tone!

COLOR YOUR FIGURE IN BOLD COLORS, USING INKS OR WATERCOLORS. USE LIGHTER TONES FOR THE AREAS WHERE THE LIGHT IS HITTING THE FIGURE AND DARKER HUES FOR THE PARTS THAT ARE IN SHADOW.

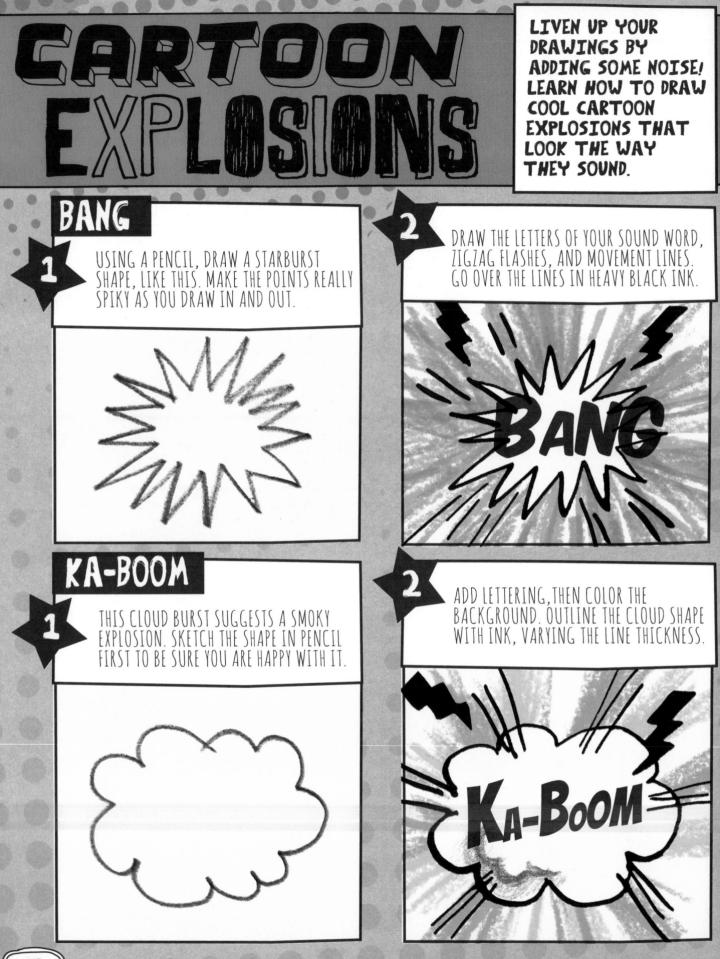

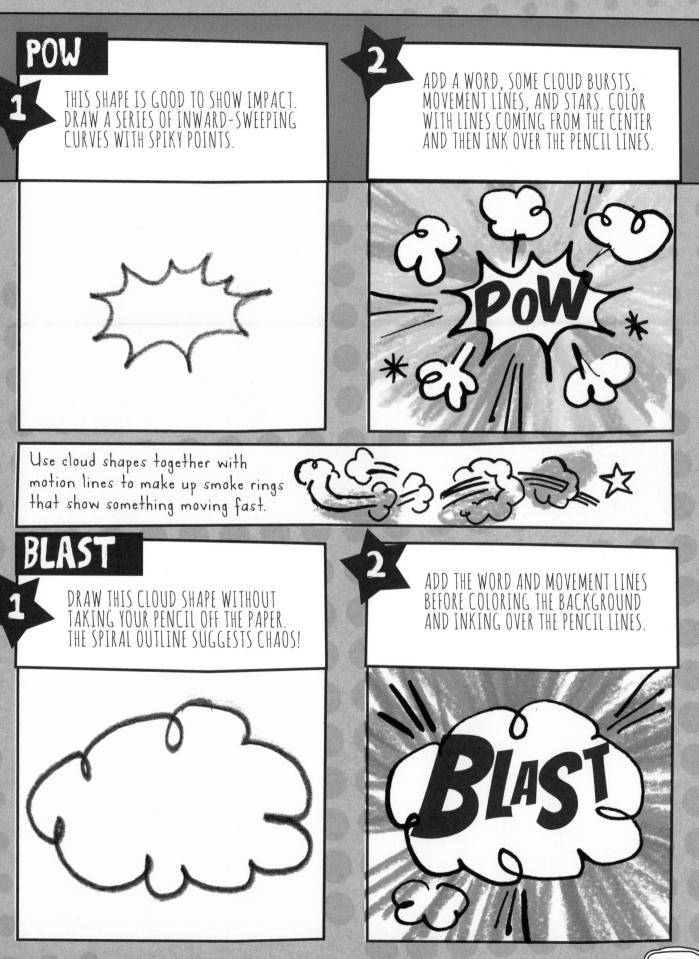

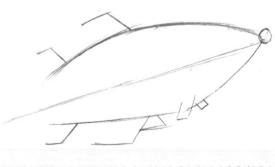

1 START WITH THE BASIC SHAPES OF THE ROCKET BODY AND THE LARGE OUTER FINS. THINK OF THE ROCKET AS A FOOTBALL SHAPE. DRAW A GUIDELINE ALONG THE CENTER TO HELP YOU.

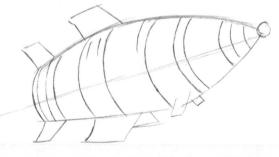

2 NOW DRAW A NUMBER OF LINES THAT FOLLOW THE CURVE OF THE ROCKET'S BODY, AND DIVIDE IT INTO SECTIONS. THESE WILL BE THE PANELS AND HELP WITH POSITIONING OTHER ELEMENTS.

Space doesn't need to be all black! You can use all kinds of colors to brighten up your rocket design!

> **5** COLOR THE ROCKET WITH METALLIC - COLORED PAINTS. ADD SOME STRONG FLAMES OUT OF THE BOOSTER TO GIVE THE ROCKET EXTRA MOVEMENT.

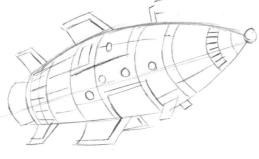

 \bigcirc

3 ADD SOME LINES ALONG THE LENGTH OF THE ROCKET. REMEMBER THE SURFACE ISN'T FLAT AND CURVES INWARD TOWARD THE TIP. ADD PANELS, RIVETS, AND A BOOSTER AT THE BACK.

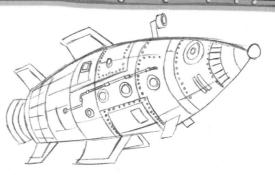

CONTINUE TO ADD DETAIL. DIVIDE THE BOOSTER UP INTO SECTIONS, PUT IN MORE RIVETS WHERE PANELS MEET, AND ADD CIRCULAR FRAMES FOR THE PORTHOLES. ERASE GUIDELINES.

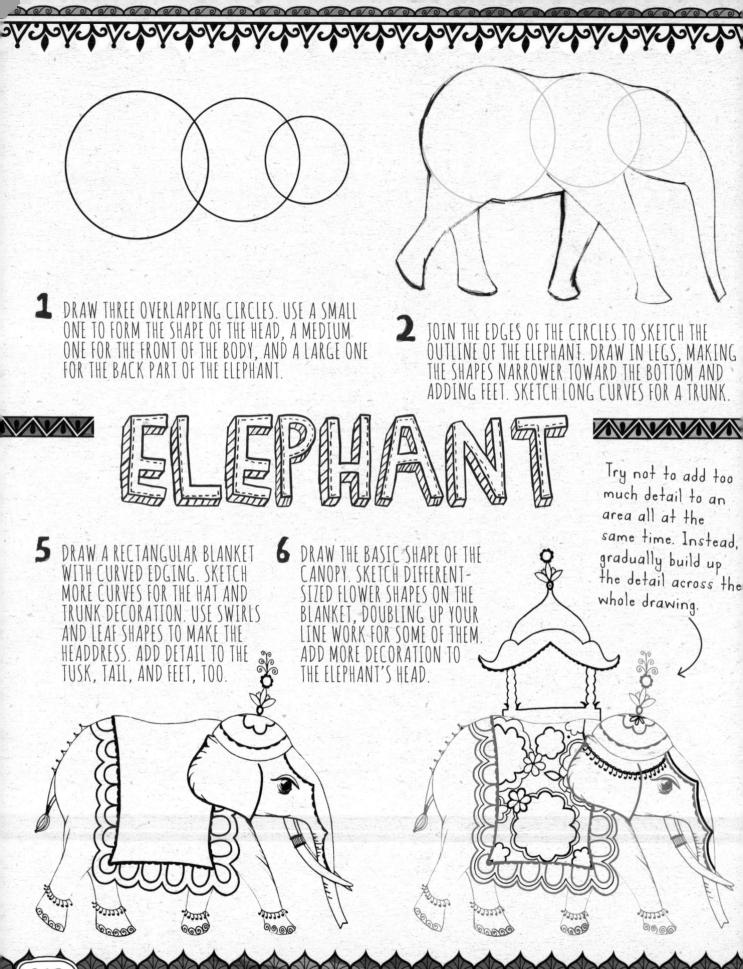

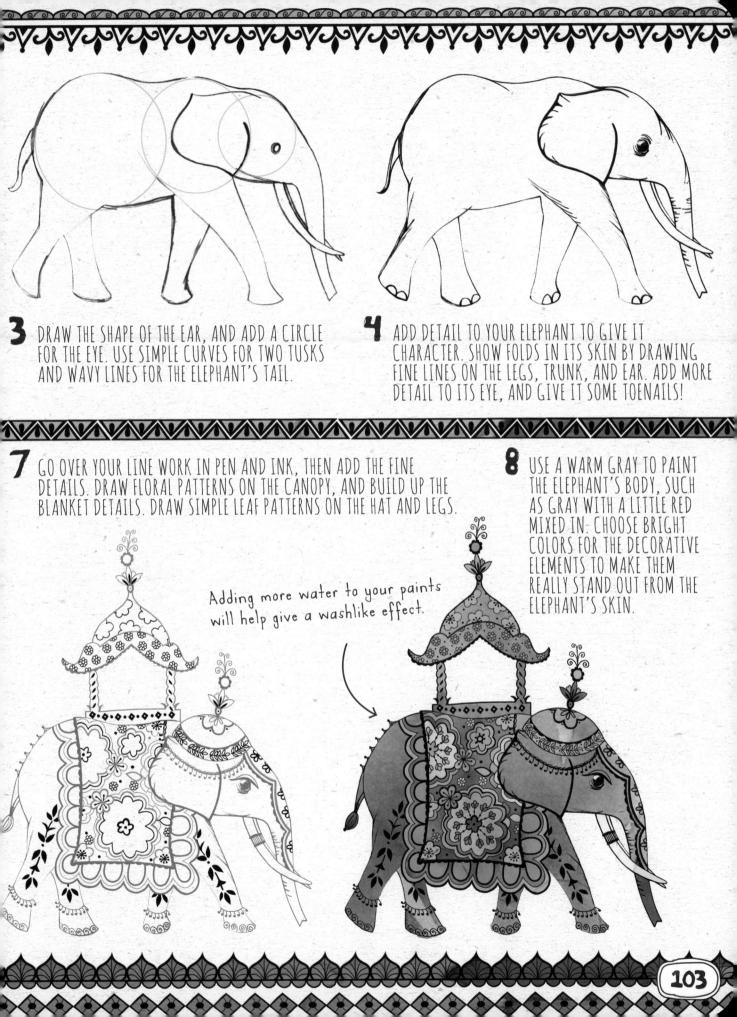

TRY DRAWING SOME GRAFFITI ART-WHERE IT'S ALLOWED, OF COURSE! BEFORE YOU ATTEMPT A MORE DETAILED COMPOSITION, PRACTICE DRAWING THESE SIMPLE 3-D SHAPES WITH A BLACK PEN OR INK.

Draw a star shape, and add some lines coming away from three of the points, as shown. Create a 3-D effect by making the star a lighter color than its tail.

SIRE

Draw a simple arrow, and make it look 3-D by adding lines underneath that follow the same basic shape.

A doughnut is basically an oval shape. Draw a hole in the middle, and add some messy frosting and perhaps a few sprinkles.

The popsicle is simply a rectangular shape curved at the top. Draw a line below to achieve the 3-D effect, and add a stick and a little shading.

This waffle cone is a semicircle attached to a triangle. Use some simple crosshatching to create the cone texture, then add an ice-cream peak on top.

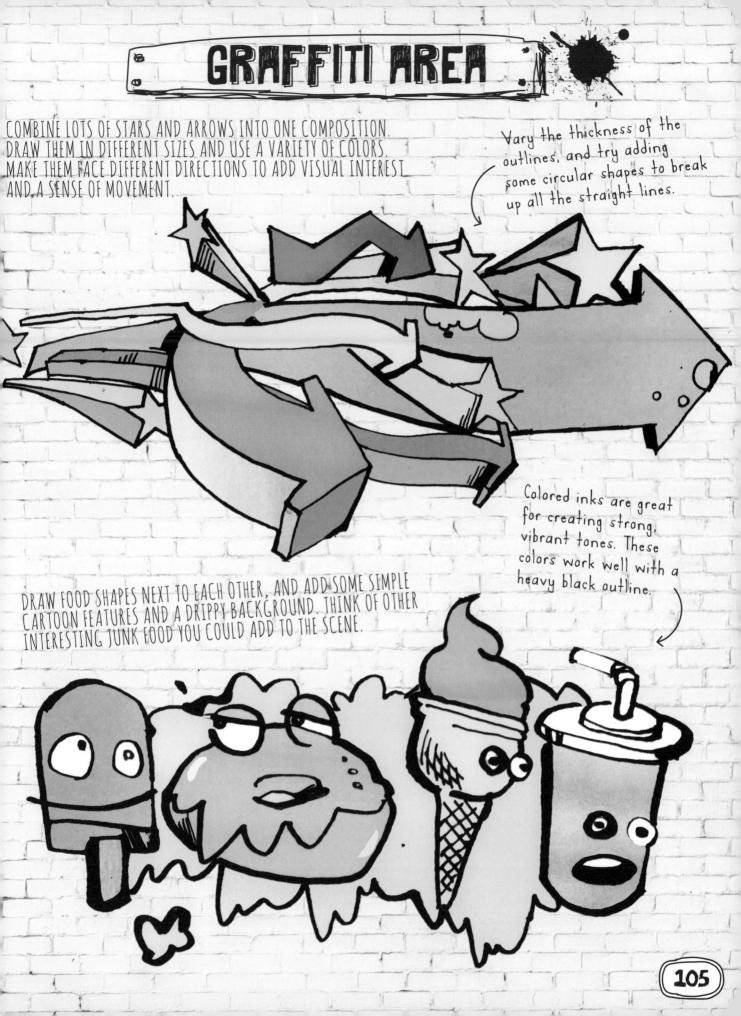

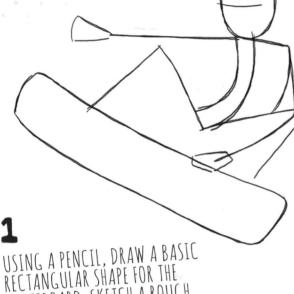

RECTANGULAR SHAPE FOR THE SKATEBOARD. SKETCH A ROUGH CIRCLE FOR THE BOY'S HEAD AND GUIDELINES FOR HIS BODY, ARMS, HANDS, AND LEGS.

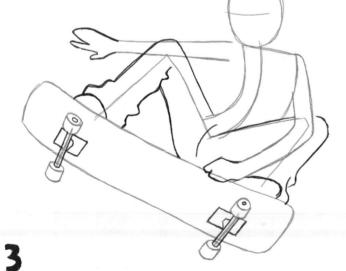

ADD MORE DETAIL TO THE BOARD'S WHEELS, AND GIVE YOUR FIGURE SOME ROUGH HANDS AND JEANS. DRAW TWO CURVED LINES FOR HIS SHOES.

2 SKETCH IN THE SKATEBOARDER'S ARMS, AND DRAW THE WHEELS ON THE BOTTOM OF THE BOARD.

> The helmet should sit slightly above the top of the skateboarder's head.

4

DRAW A HALF CIRCLE ABOVE THE HEAD FOR THE SKATEBOARDER'S HELMET. SKETCH IN GUIDELINES FOR HIS T-SHIRT, BELT, AND SHOES.

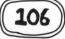

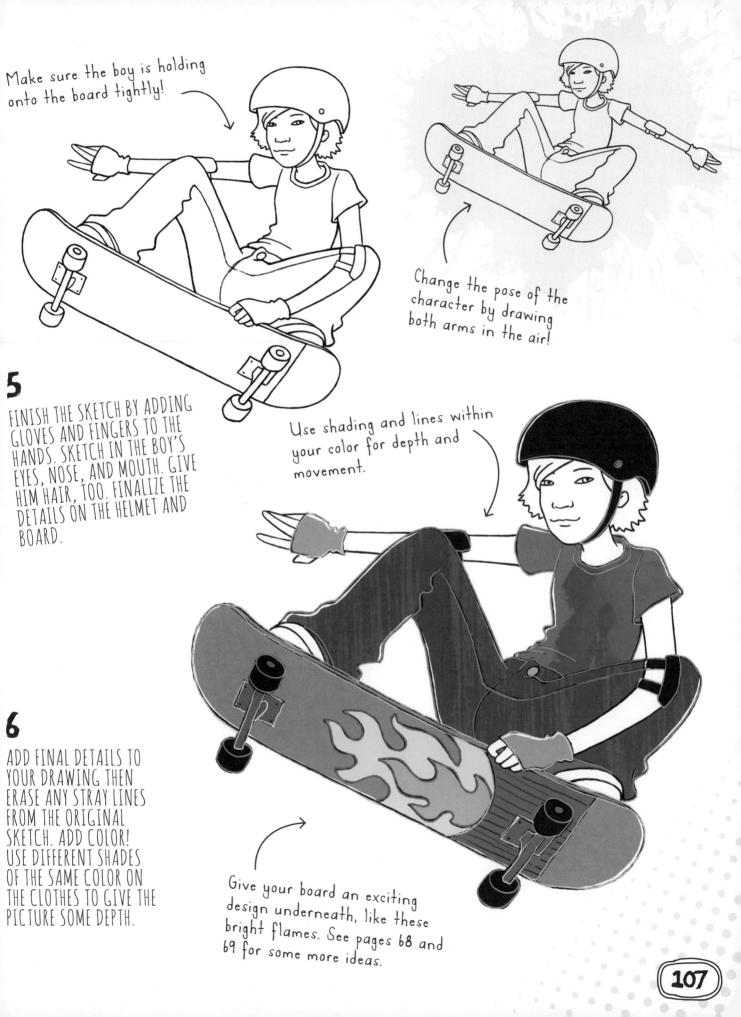

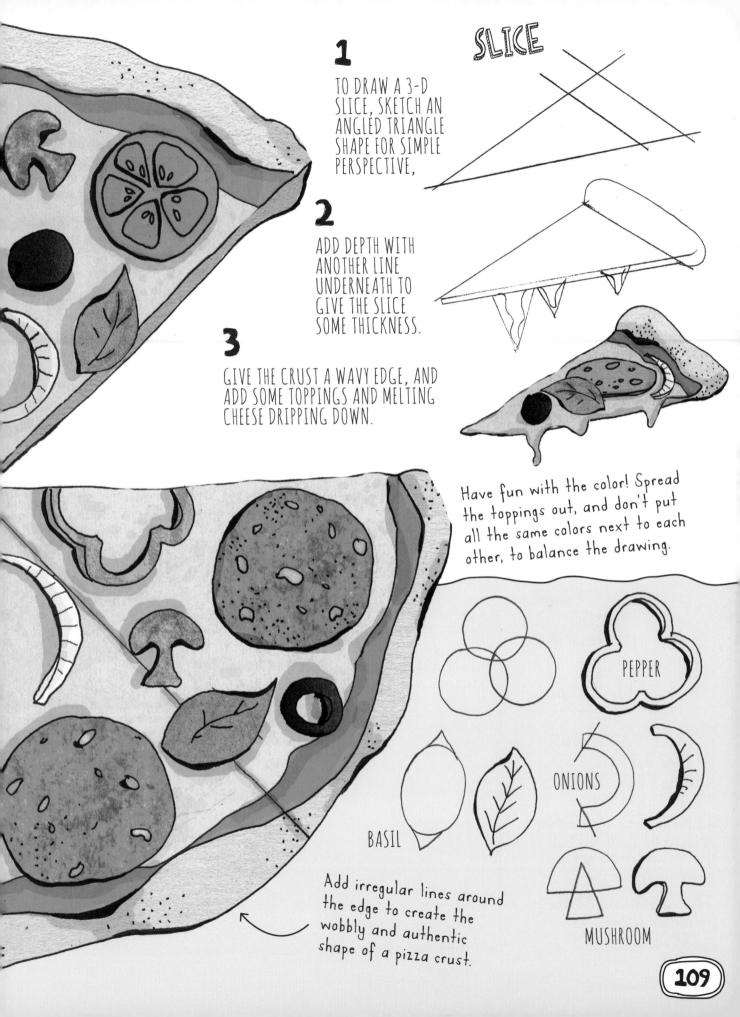

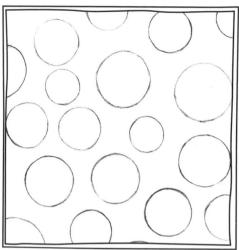

Circles

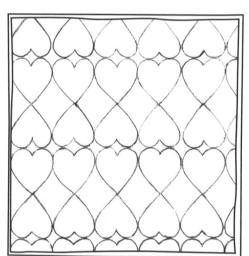

licerts

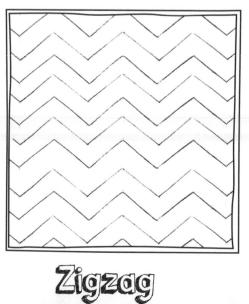

ADD REPEATED CIRCLES AROUND LOTS OF DIFFERENT-SIZED CIRCLES. COLOR EACH RING, OVERLAPPING FOR EFFECT.

MIRROR-IMAGE HEARTS MAKE UP A COC Pattern. Color the gaps in between To emphasize the diamond shape.

DIVIDE ZIGZAGS BY COLORING ONE SIDE LIGHT AND ONE DARK.

CREATE PATTERNS USING BASIC GEOMETRIC SHAPES. START WITH SIMPLE REPEATING SHAPES, AND BUILD UP TO SOMETHING MORE COMPLEX. TRY OVERLAPPING SHAPES OR USING MIRROR IMAGES.

Ovals

Diamonds

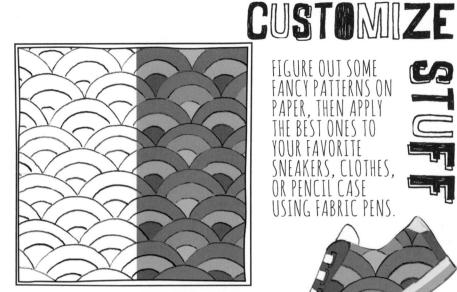

BUILD UP THE PATTERN BY ADDING OVALS INSIDE OVALS. START AT THE BOTTOM AND WORK YOUR WAY TO THE TOP.

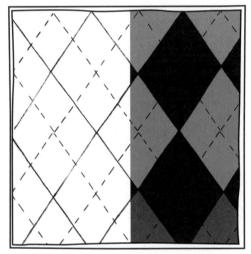

BUILD UP A DIAMOND PATTERN WITH CRISSCROSS DOTTED LINES INSIDE SOLID ONES TO ADD TEXTURE.

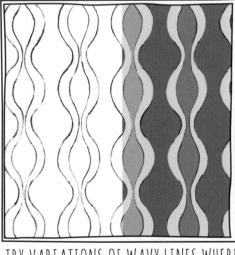

TRY VARIATIONS OF WAVY LINES WHERE GAPS ARE WIDER OR THINNER.

FIGURE OUT SOME FANCY PATTERNS ON PAPER, THEN APPLY THE BEST ONES TO YOUR FAVORITE SNEAKERS, CLOTHES, OR PENCIL CASE USING FABRIC PENS.

ADD BASIC SHAPES FOR THE NECK, EYE, ARMS, LEGS, AND THE TIP OF THE TAIL. USE THE SHAPES FROM STEP ONE TO HELP YOU PLOT WHERE EACH PART NEEDS TO BE DRAWN.

DRAW THE BASIC SHAPE OF THE T. REX WITH A PENCIL. THE DINOSAUR IS MADE UP OF CIRCULAR AND OBLONG SHAPES, AS SHOWN.

Gently rub a pencil over the areas you want to shade to create different skin tones and shadow.

ADD SHADING TO YOUR DINO. LEAVE CERTAIN AREAS WHITE TO HELP TO SHOW THE DIFFERENT SKIN TONES.

1º

SKETCH IN THE OUTLINE OF THE DINO'S BODY. IT HAS SMALL RIDGES ON THE NOSE, NECK, LEGS, AND TOES. SKETCH THE OUTLINE WITH A FAINT LINE TO BEGIN WITH, THEN GO OVER WITH A HEAVIER, MORE CONFIDENT LINE. DRAW IN THE OTHER FEATURES OF THE DANGEROUS BEAST. GIVE IT A BIG EYE AND SOME NOSTRILS.TO MAKE IT LOOK EXTRA SCARY, MAKE SURE IT HAS REALLY RAZOR-SHARP TEETH AND CLAWS!

> Don't forget a beady yellow eye and shadows on those sharp claws!

Drawing in small movement lines will make the dinosaur look as if it is running fast!

FINISH WITH SOME COLOR. ADD LOADS OF DIFFERENT MARKS USING TRIANGLE SHAPES AND DOTS TO CREATE A PATTERN FOR THE SKIN. LEAVE THE TEETH WHITE, AND GIVE YOUR T. REX A BIG RED TONGUE.

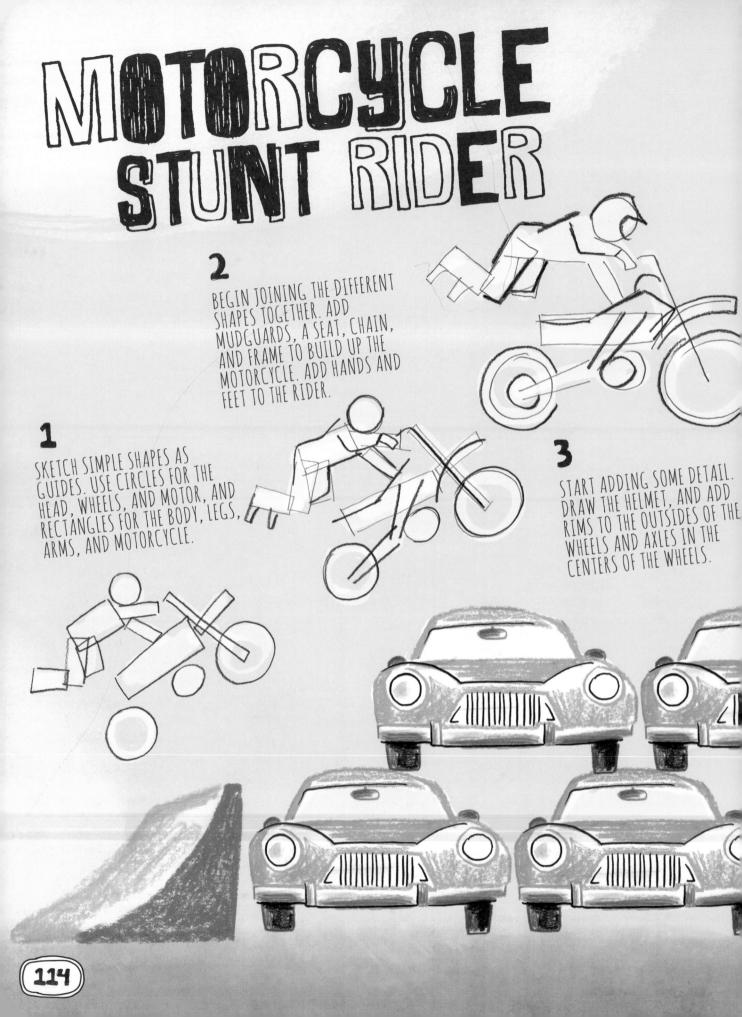

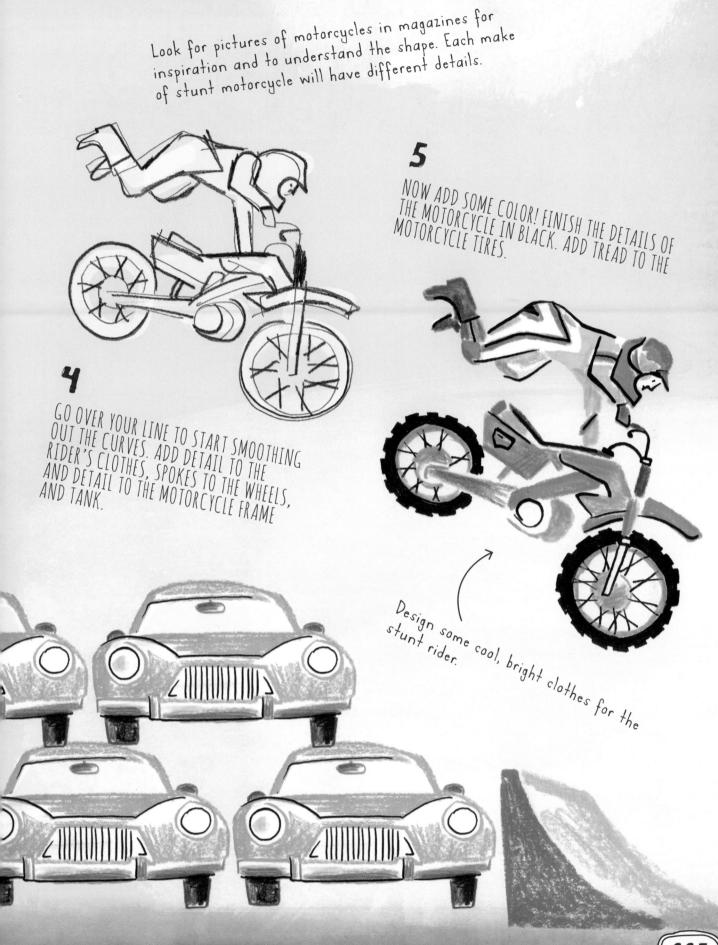

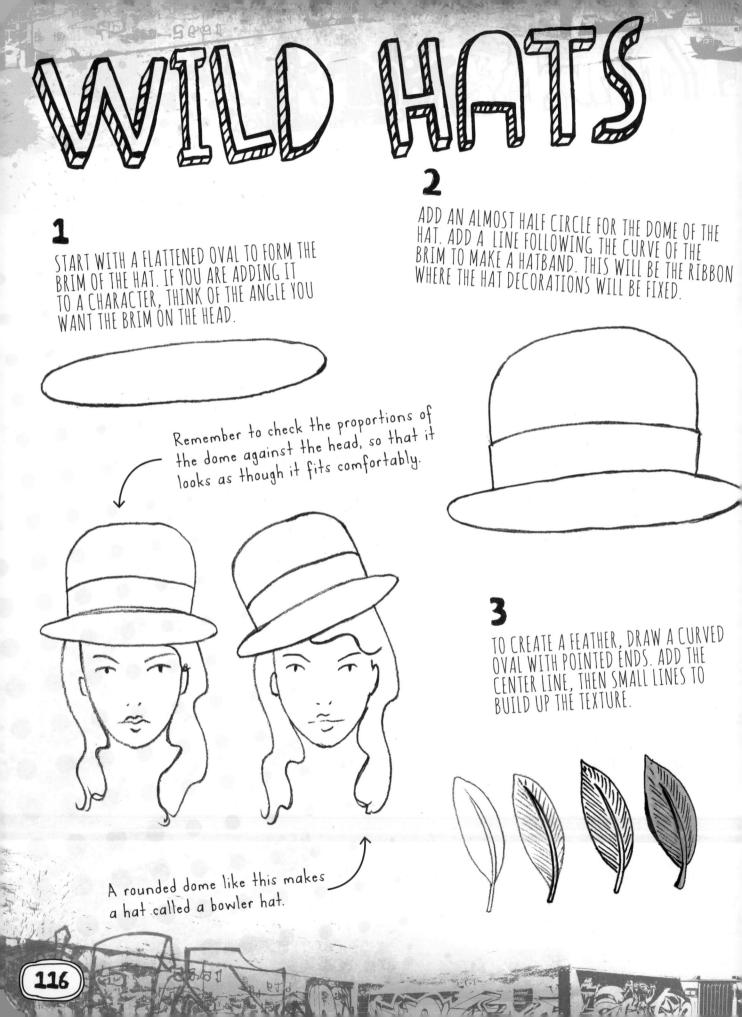

ADD COLOR USING A VARIETY OF MATERIALS TO BUILD UP TEXTURE AND INTEREST. FOR EXAMPLE, FIRST APPLY A WATERCOLOR WASH, THEN ADD SOME LOOSER PENCIL LINES, WITH SOFT PASTEL OR CHARCOAL OVER THE TOP.

5 FINALLY, APPLY AN INK OUTLINE WITH A BRUSH. EXPERIMENT WITH THICK AND THIN LINES FOR SOME OF THE FEATHERY TRIMMINGS. ADD A SOFT SHADOW BELOW THE BRIM WITH PENCILS OR PAINT.

Add the feather to the hatband like this.

CUPCAKE HAT

Draw a shaped grid like this to create a net veil that adds mystery to your character.

EXPERIMENT WITH THE SHAPES OF THE DOME AND THE SIZE OF THE BRIM. TRY OUT FEATHERS, FLOWERS, INSECTS, EVEN FOOD—GO WILD!

FANCY TOP HAT

PIANO BOWLER HAT

Build on the basic bowler hat shape with a cool twist of piano keys.

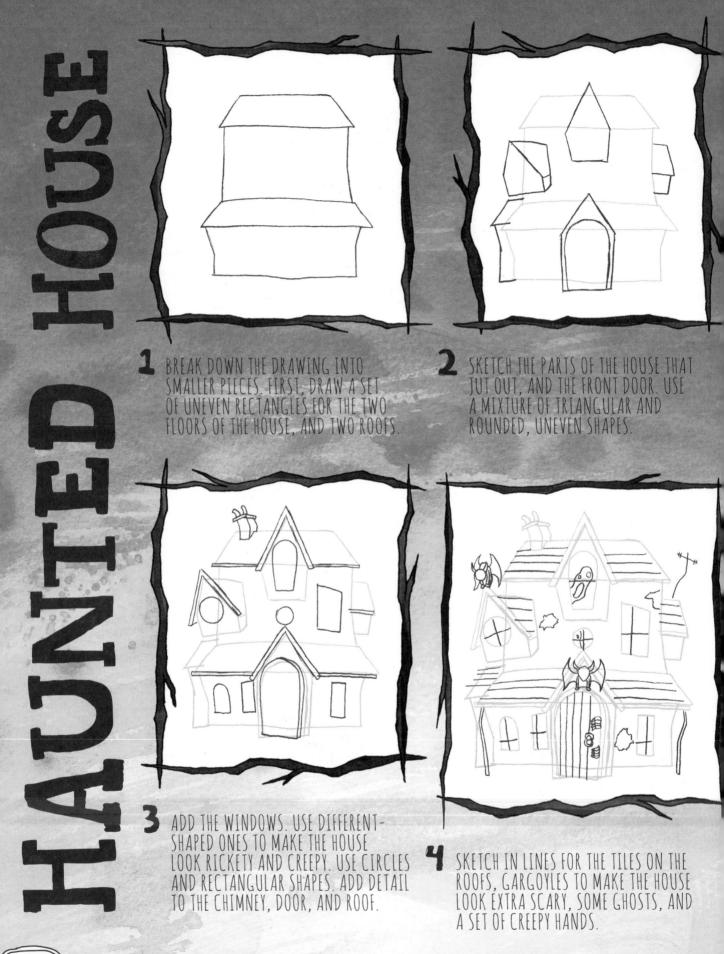

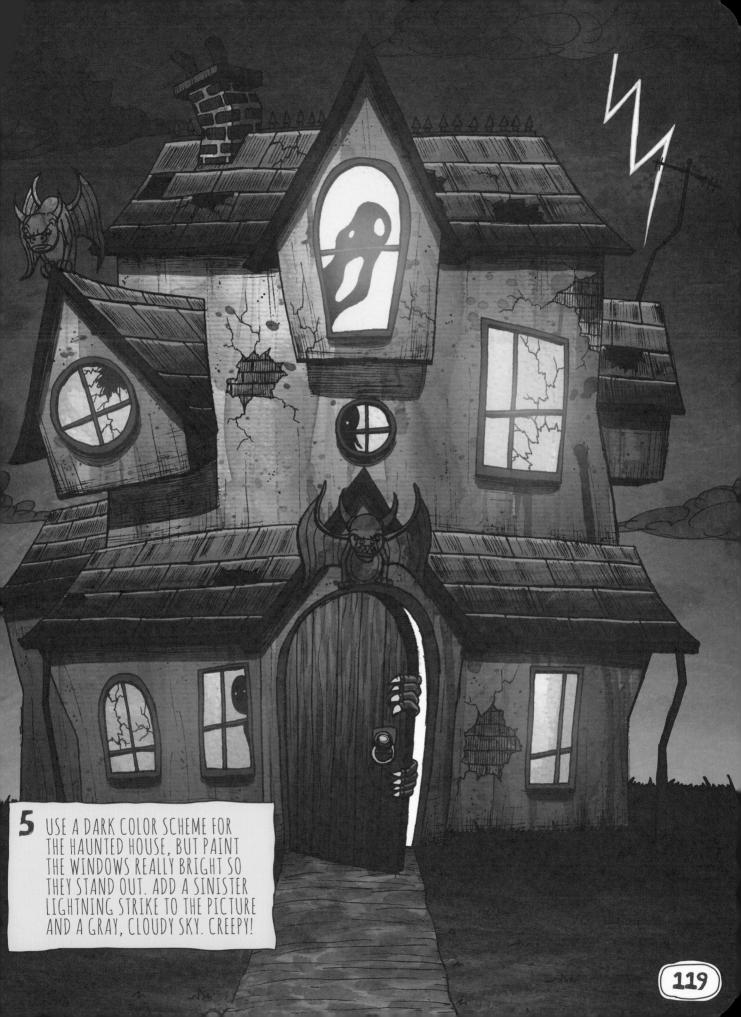

FIND A PHOTO OF A CUTE, COOL GIRL FOR INSPIRATION. USE A HARD PENCIL TO DRAW SOME GUIDELINES TO GET THE FEEL OF THE POSE.

SKETCH THE SHAPE OF THE FIGURE. MAKE HER HEAD BIG AND EMPHASIZE THE HAIR. THE LEGS AND FEET CAN BE QUITE DELICATE TO MAKE HER MORE DOLL-LIKE.

START DRAWING THE HANDS AND FACE. THE EYES SHOULD BE BIG AND STAND OUT. SKETCH THE OUTLINE FOR THE CLOTHES. ADD JEWELRY FOR EXTRA INTEREST.

Manga eyes are lots of fun to draw, so go crazy! Work in light spots to make the pupils shine. Try adding big eyelashes, too!

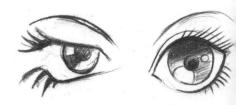

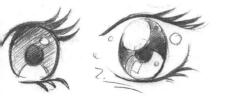

ACID GREENS AND ELECTRIC PINKS ARE GREAT VIBRANT COLORS TO BRING YOUR MANGA CHARACTER TO LIFE. USE A DARKER TONE TO CREATE THE SHADOWS THAT WILL GIVE THE FIGURE DIMENSION.

HAIRSTYLES

Manga hairstyles are wild, so don't hold back! Try the hairstyles below, or experiment with some creations of your own.

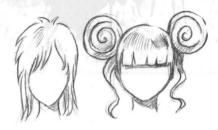

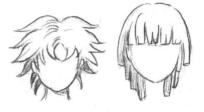

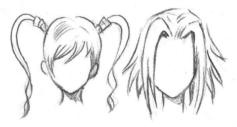

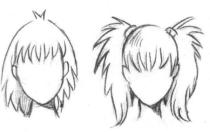

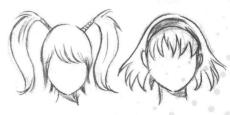

URBAN BRIDGE

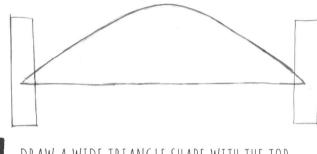

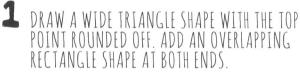

Use dark lines and shadows to make some elements of your drawing fade into the background. Here, the blackened bars help the red ones in the foreground to stand out.

ADDIDA

2 DRAW MORE CURVES ABOVE AND BELOW YOUR GUIDE ARCH. LEVEL OFF THE TOP CURVE ENDS. ADD MORE HORIZONTAL LINES ALONG THE BOTTOM OF THE TRIANGLE FOR THE ROAD, AND ADD SETS OF DIAGONAL LINES FOR THE FRAMEWORK BELOW. ERASE ANY UNWANTED GUIDELINES.

TURN THE RECTANGLES INTO BUILDINGS BY ADDING WINDOWS AND STONEWORK DETAIL SKETCH ROUGH OUTLINES OF A COUPLE OF TREES BEHIND. ADD SOME APARTMENT BUILDINGS BELOW BY DRAWING A FEW VERTICAL RECTANGLES. THEN ADD ROUGH SQUARE SHAPES FOR WINDOWS. Draw a few leaves here and there, then paint a yellowy-green wash. Draw some jaggedy, inky lines for leafless branches. 3 0 aa 000 mistairi atur uns 00090 **5** GO OVER YOUR OUTLINES IN PEN AND INK, KEEPING ADDF THE LINE WORK LOOSE AND SCRATCHY TO CREATE AN URBAN FEEL. DRAW MORE BUILDINGS IN THE DISTANCE. PAINT THE BRIDGE A BRIGHT COLOR TO MAKE IT STAND OUT. D

DRAW A SEQUENCE OF CRISSCROSSING BARS TO FILL THE GAP BETWEEN THE TWO CURVED Shapes. Add a little shading here and There to create a 3-d effect.

GARTOON MILD MNIMHLS

CARTOON ANIMALS ARE EASIER TO DRAW THAN YOU THINK! CHECK OUT THESE SUGGESTIONS, THEN GO WILD WITH YOUR PENCIL AND PAINTS.

IOSES

DIFFERENT ANIMALS HAVE DIFFERENT NOSE SHAPES-TRIANGLES, TRUNKS, OR EVEN JUST TWO DOTS FOR NOSTRILS, LIKE ON A HIPPO.

FEET

WHAT KIND OF FEET DOES YOUR CARTOON ANIMAL NEED? TRY THESE SIMPLE SHAPES. DON'T FORGET TO ADD MARKS FOR TOES!

EARS

WHETHER THEY'RE ROUND AND FUZZY OR WIDE AND FLAPPY, ALWAYS LOOK AT HOW HIGH ON THE HEAD THE EARS SHOULD BE.

EYES

START WITH CIRCLES, THEN ADD STRAIGHT EYELID LINES TO GIVE YOUR CARTOONS DIFFERENT EXPRESSIONS. USE LITTLE SEMICIRCLES TO ADD GLINTS TO THE EYES, TOO.

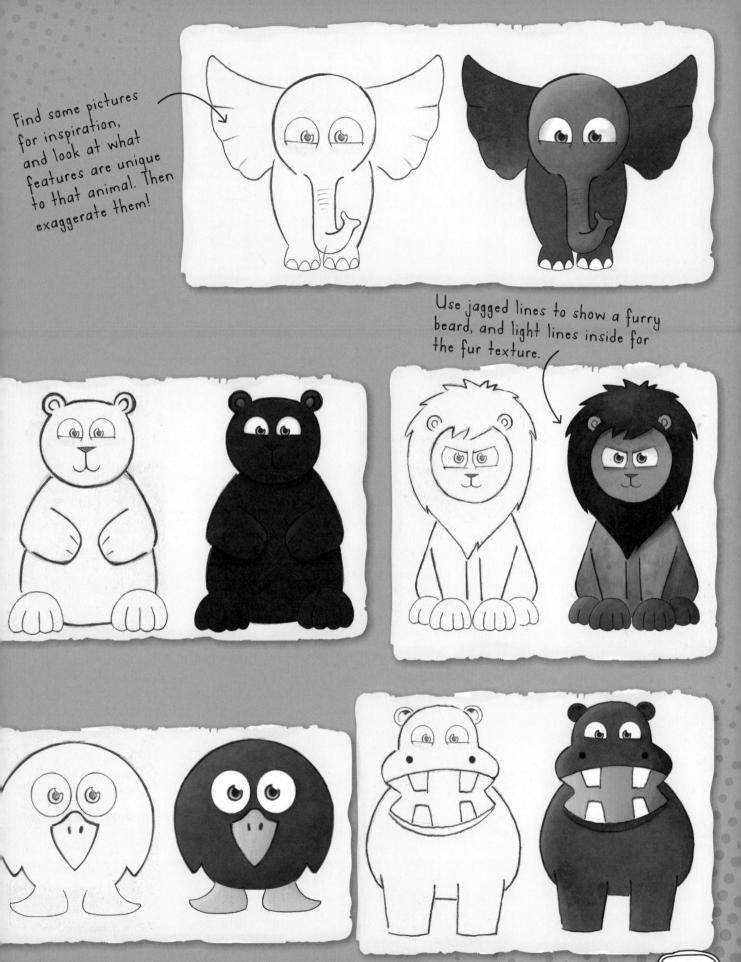

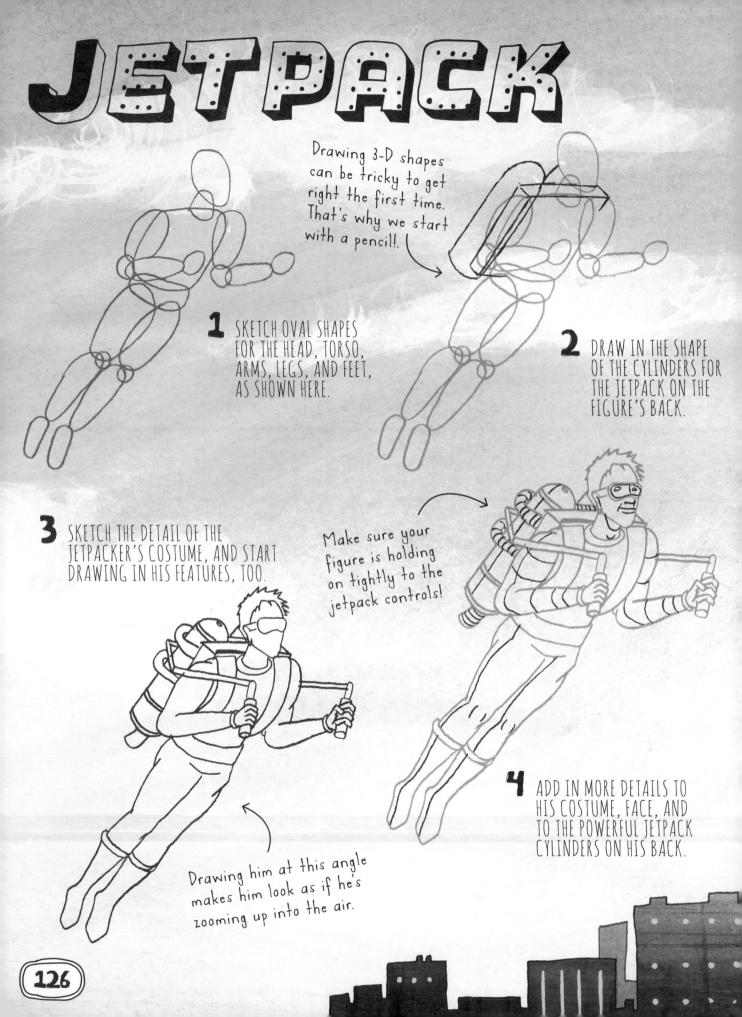

Create smoke texture with a light crayon or by smudging in pencil. 5

ADD SHADING TO THE EDGES OF THE LIMBS AND BODY TO GIVE THE

PICTURE A MORE DRAMATIC FEEL.

6 ADD BRIGHT COLORS TO THE JETPACKER'S COSTUME TO MAKE HIM STAND OUT FROM THE BLUE SKY BEHIND HIM.

> Draw in tall buildings in the background to make the jet packer look high in the sky!

MONSTER PLANT

DRAW A SQUARE POT WITH AN OVAL AT THE TOP. FOLLOW THE CURVE OF THE OVAL TO GIVE YOUR POT DEPTH.

2 LIGHTLY DRAW THREE CURVING GUIDELINES COMING FROM THE POT. DRAW PARALLEL LINES ON EITHER SIDE OF THE GUIDELINES TO MAKE THE PLANT STALKS. USE OVALS OR CIRCLES AT THE END OF EACH STALK TO MAKE MONSTER-HEAD SHAPES.

Add a caterpillar crawling up the stalk, using a line of circles stuck together.

DRAW ROOTS BURSTING OUT OF CRACKS IN THE POT. THE ROOTS SHOULD BECOME THINNER, ENDING IN A SHARP POINT.

Use a leaf shape to draw stalks winding around like tentacles.

G DRAW FANGS AND GROSS LIQUID DRIBBLING OUT OF THE MOUTH. ADD SOME BULGING EYEBALLS OR EYES.

Add a random eyeball to the stem, like a plant bud.

Add some leaves with rough circles to make it look like the leaves have been eaten.

5 FINISH THE PLANT WITH WATERCOLOR PENCILS. BLEND YELLOWS AND GREENS TOGETHER. MAKE THE STALKS DARKER AT THE EDGES TO CREATE THE EFFECT OF A CYLINDER. THEN USE BLACK TO GIVE THE MONSTER PLANT A HEAVY OUTLINE.

Add sharp triangular thorns.

Draw a juicy black fly for the monster plant's slurping tongue to catch.

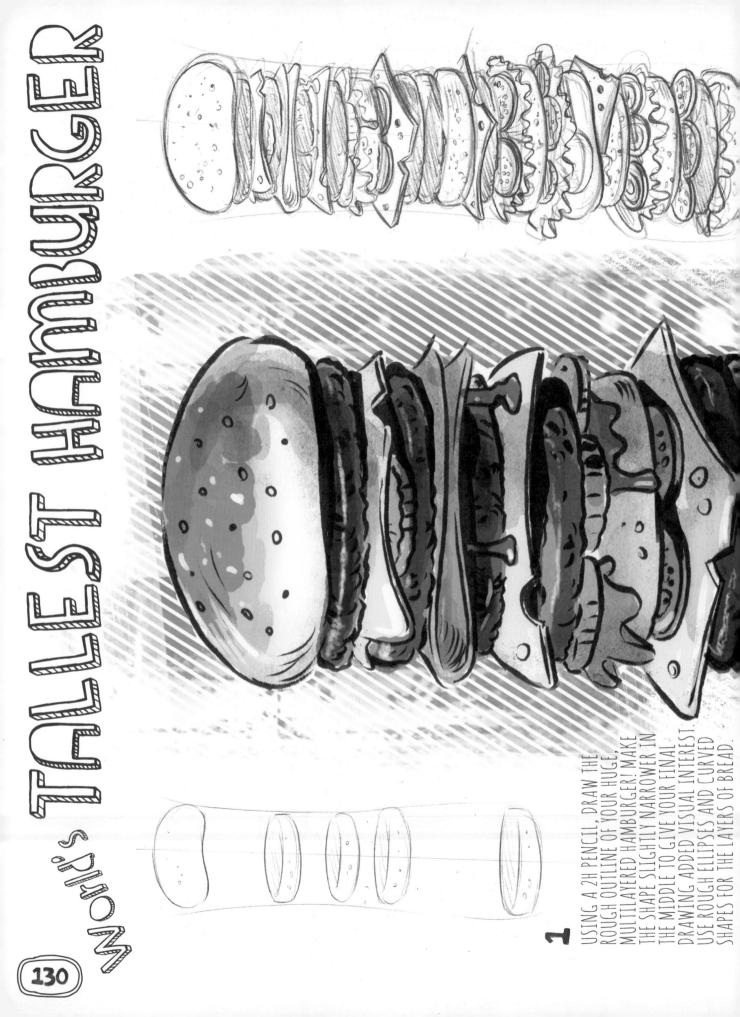

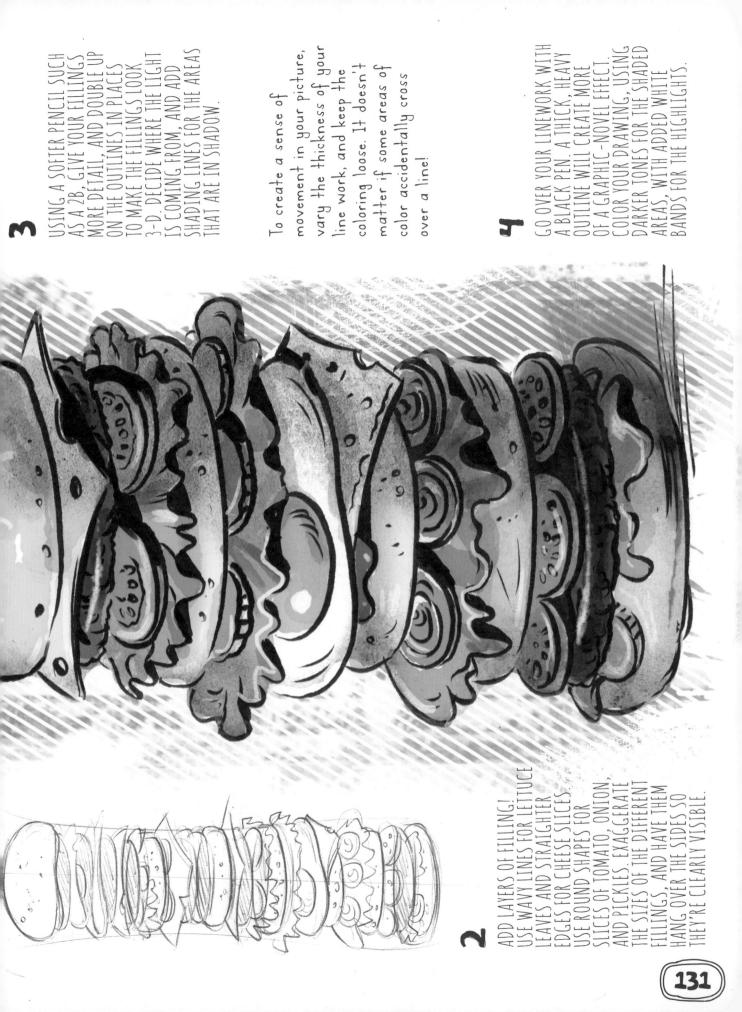

MAKE USE OF THE EASY-TO-DRAW CIRCLE SHAPE TO COME UP WITH PATTERNS THAT LOOK MORE COMPLICATED THAN THEY ARE! USE THEM TO DECORATE YOUR THINGS OR DRAWINGS.

One simple circular pattern option is to draw lots of circles inside each other. Use thick and thin lines for the rings.

For a color option, choose different tints for each ring of the pattern. Try colors that work well together until you find combinations that you like.

Or try drawing tiny circles around your center circle. Experiment with outlines and solids, or circles of different sizes. Add color or not!

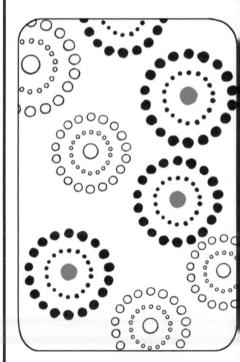

MAKE A PATTERN BY MIXING UP THE OUTLINE SHAPES AND SOLID COLOR SHAPES. THEY DON'T ALL HAVE TO BE THE SAME SIZE.

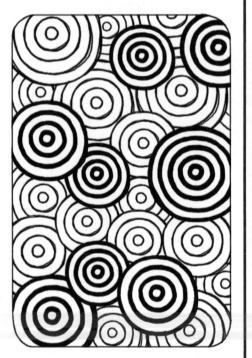

MAKE A COMBINATION PATTERN BY DRAWING YOUR PATTERNS ONE ON TOP OF THE OTHER, VARYING THE THIN AND THICK LINES.

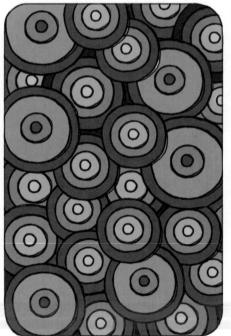

MIX THE TWO DIFFERENT-COLORED CIRCLES PATTERNS THAT YOU HAVE CREATED TO MAKE A LARGER, DYNAMIC COLORED PATTERN.

WITH A PENCIL, DRAW TWO BASIC CIRCLES INSIDE EACH OTHER. ADD LEAF SHAPES OR TEAR DROPS AROUND THE OUTSIDE, THEN ADD COLOR!

DRAW AN INNER CIRCLE, THEN AN OUTER CIRCLE. DIVIDE THE CIRCLE IN HALF, THEN QUARTERS, THEN AGAIN TO END UP WITH 12 SECTIONS LIKE A CLOCK. DRAW A ZIGZAG LINE IN EACH CIRCLE. EXPERIMENT WITH COLORS

GEOMETRIC

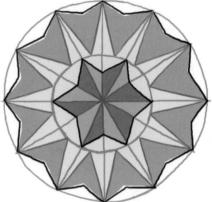

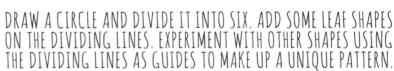

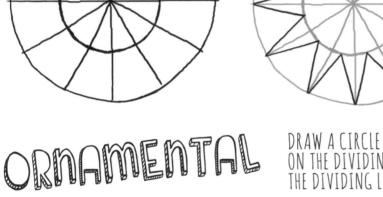

USE A PENCIL TO DRAW A SIMPLE STIEK FIGURE. SKETCH THE BASIC SHAPE OF ONE HAND REACHING OUT.

Z SKETCH IN THE SHAPE OF THE ZOMBIE BODY, BIT BY BIT.

ADD DETAIL TO THE ZOMBIE'S FACE, BODY, AND CLOTHING. GIVE HIM AN UNNATURAL POSE.

3

As your sketch takes shape, use darker lines to create the outline you'll go with for your monstrous figure. DRAW IN MORE ZOMBIE DETAIL. GIVE HIM BIG, Dark Shadows around his eyes, horrible Skin, and rips in his shabby clothing.

> **5** USE COLOR TO BRING YOUR TOMBIE BACK TO LIFE. THREE DIFFERENT TONES OF THE SAME COLOR (DARK FOR THE SHADOWS, MEDIUM FOR THE NEUTRAL AREAS, AND LIGHT FOR HIGHLIGHTS) WILL MAKE THE FIGURE LOOK 3-D-TIKE HE'S COMING STRAIGHT AT YOU!

Create the texture on the zombie's dirty jeans by starting with a dark, flat blue color and then adding lighter strokes of blue, leaving plenty of creepy shadows.

CANDY MACHINE

DRAW A COMPLICATED-LOOKING, GADGETY, MAGICAL CANDY MACHINE BY BREAKING IT DOWN INTO DIFFERENT PARTS.

1 USE A PENCIL TO CREATE A SIMPLE CYLINDER SHAPE. DRAW A SMALL CIRCLE FOR A PRESSURE GAUGE. LINES FOLLOWING THE FORM OF THE CYLINDER BASE WILL GIVE THE EFFECT OF METAL PANELING ON YOUR MACHINE

Add containers and levers to make the machine look more complex!

For the control panel,

and rectangles, and draw

button shapes onto them.

lots of even smaller

split the front face of the box into smaller squares

2 DRAW LIQUID SPILLING OUT OF A FAUCET USING LOOSE WOBBLY LINES. ADD CIRCLES AROUND THE LIQUID TO GIVE THE IMPRESSION THAT IT'S BUBBLING AND SPLASHING. SHADE THE FUNNEL FOR A 3-D LOOK

3 SKETCH ANOTHER CYLINDER SHAPE UNDER THE MACHINE'S EUNNEL

To draw a valve, start with a cylinder then draw another, thinner cylinder sticking out from it. Draw a big circle on top of it.

Draw a cross at the center of the circle to help you position the arms of the value that join the outer ring.

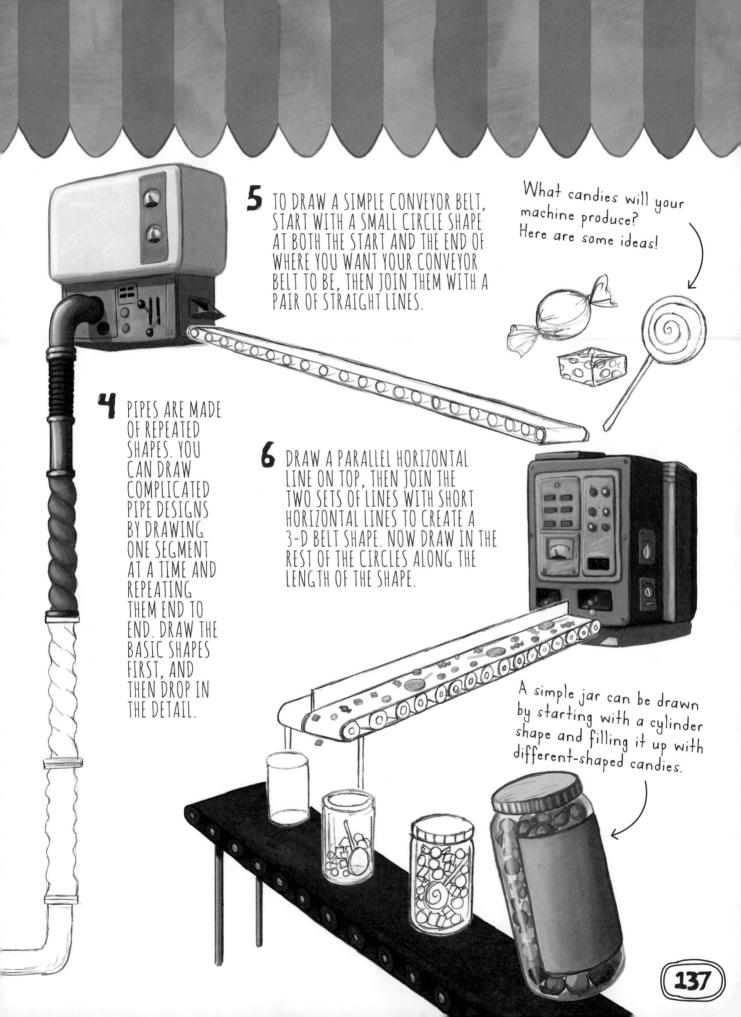

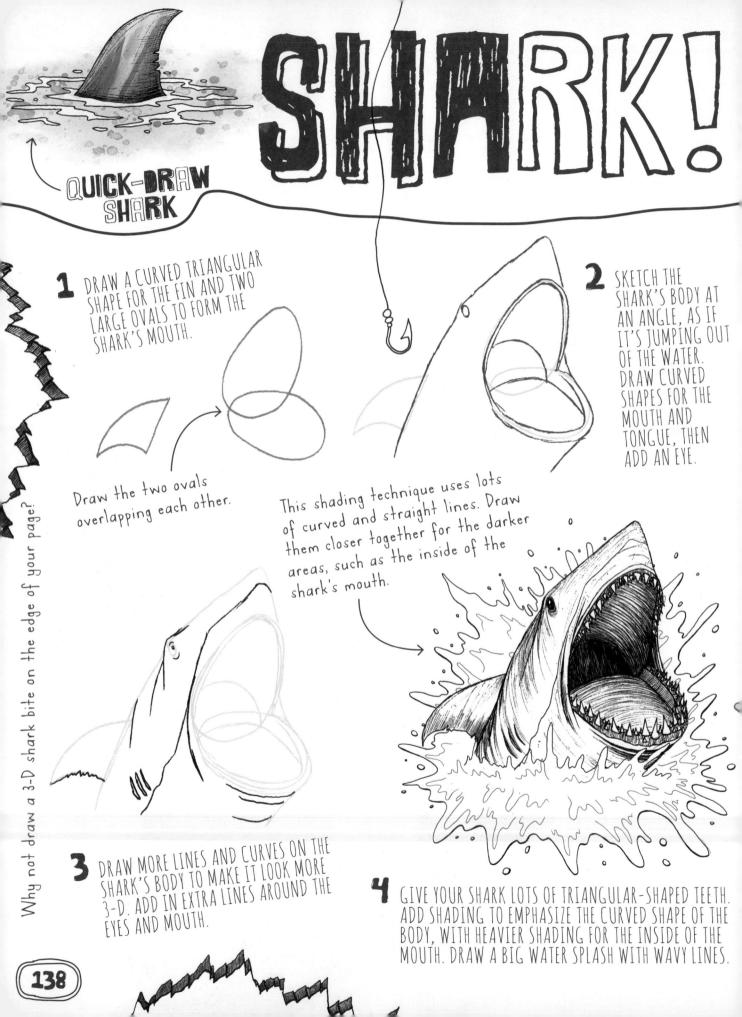

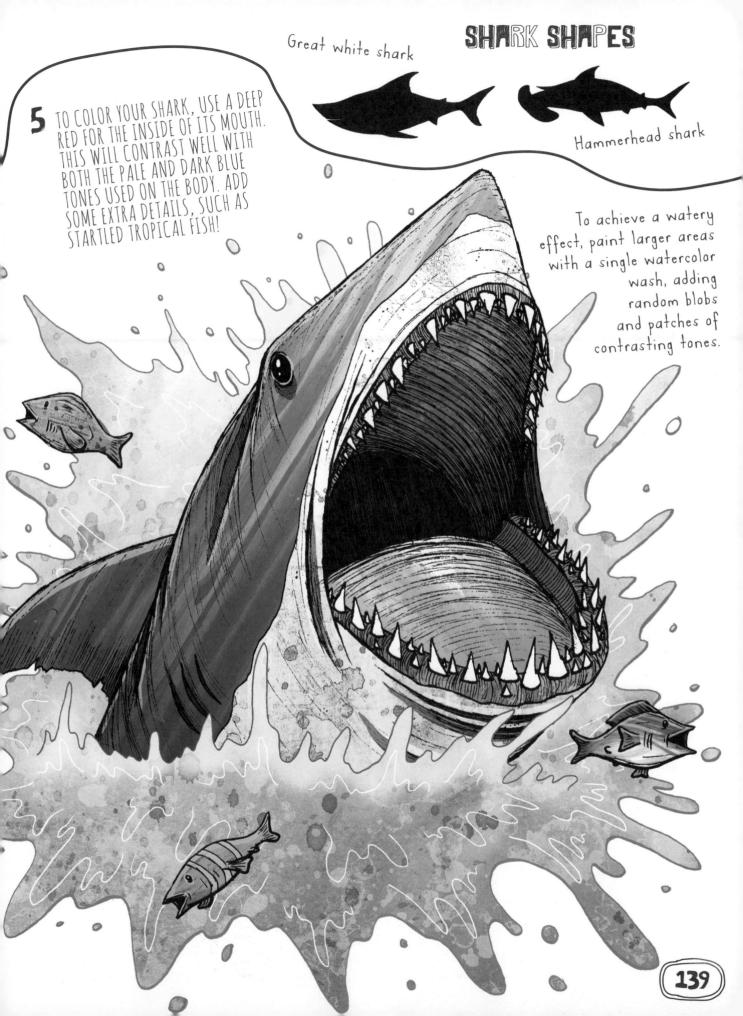

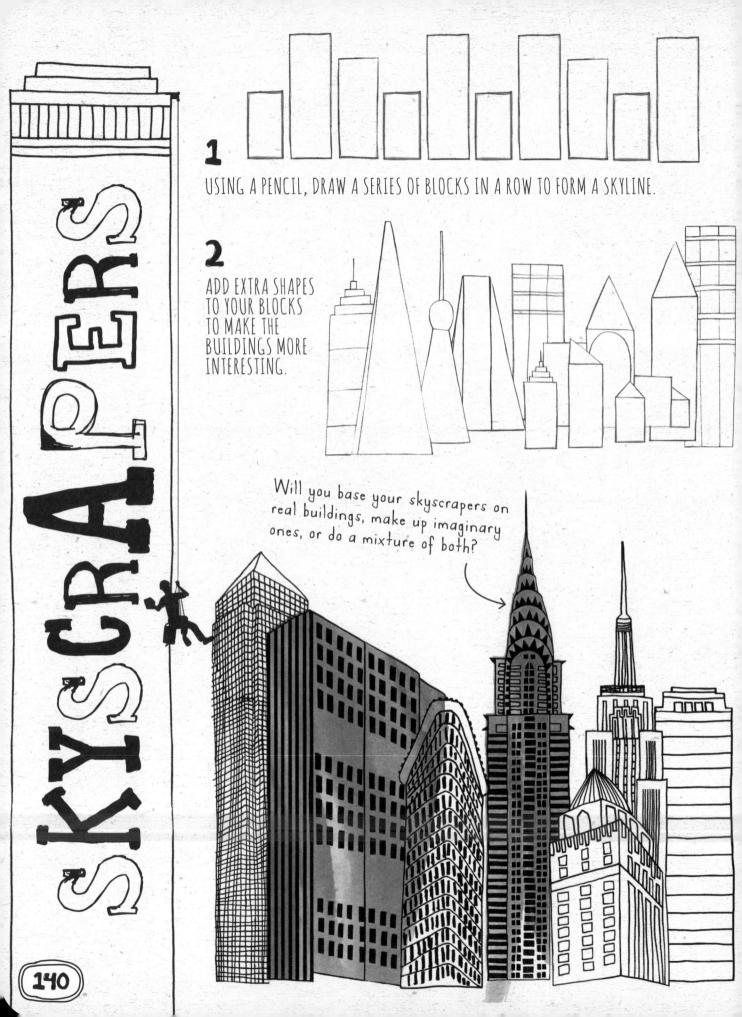

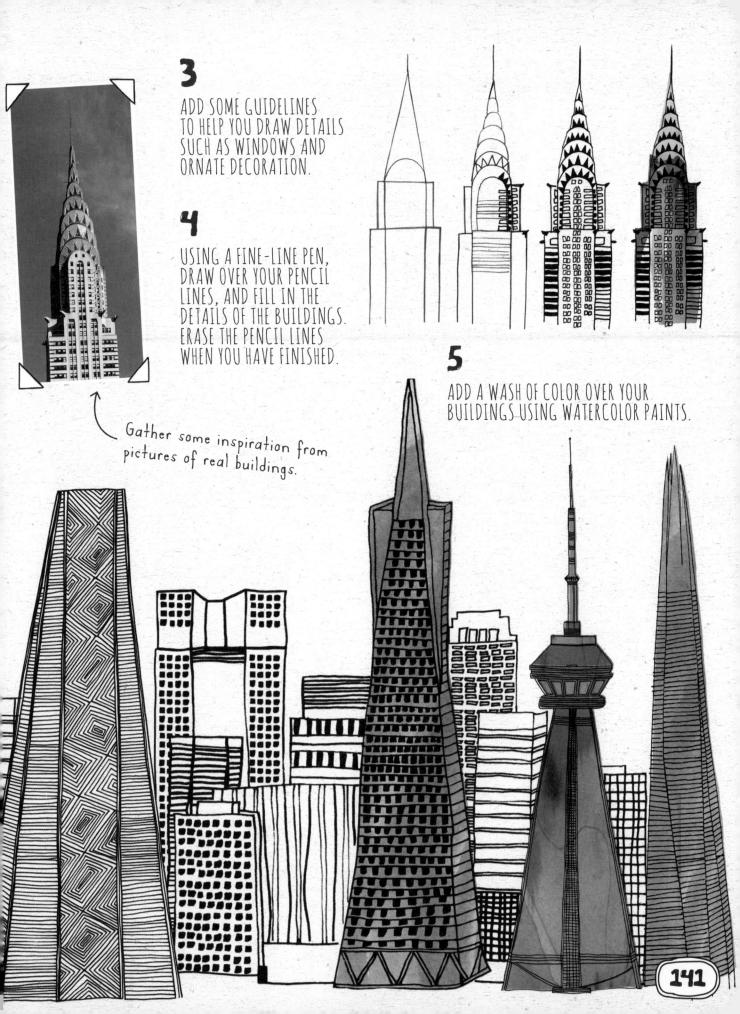

BASKETBALL PLAYER

You could use an image of a real basketball player to help you get the pose right.

USING A 2H PENCIL, ROUGHLY SKETCH A STICK FIGURE FOR YOUR BASKETBALL PLAYER. DRAW AN ARM POINTING IN THE AIR, AND MAKE ONE LEG MORE BENT THAN THE OTHER FOR A JUMPING POSE. EVEN AT THIS INITIAL STAGE, TRY AND DRAW A FIGURE THAT LOOKS LIKE IT'S IN MOTION.

26.131

14

SKETCH THE BASIC OUTLINE AND PROPORTIONS OF YOUR FIGURE, USING THE STICK LINES AS A GUIDE. NOTICE HOW THE MUSCLES BULGE OUT MORE ON THE LEG THAT'S BENT. WORK ON THE BODY PARTS, USING CURVED LINES FOR THE MUSCLE SHAPE ADD THE FINGERS, HAIR, AND FACIAL FEATURES. DRAW IN CLOTHING, THINKING ABOUT HOW THE POSE WILL AFFECT THE WAY THE CLOTHES HANG.

USING A HEAVIER PENCIL SUCH AS A 4B, REFINE YOUR LINEWORK EVEN MORE. SKETCH SERIES OF SLANTED LINES FOR THE SHADOWS, USING SUBTLE SHADING TO BRING OUT THE MUSCLE TONE. ADD DETAIL TO YOUR PLAYER'S SHOES AND DRAW A FEW MORE CREASES ON HIS CLOTHES. When drawing the basket,

use simple crosshatch strokes for the mesh part of the net. The top third of the basket is actually more of a zigzag shape—a little like a row of shark's teeth!

5

GO OVER YOUR LINEWORK WITH A BLACK PEN. USE A THICKER LINE FOR THE OUTSIDE OF HIS BODY, WITH A THINNER LINE FOR FINE DETAILS SUCH AS THE CREASES IN HIS CLOTHING. WHEN COLORING YOUR PICTURE, USE A RANGE OF TONES FOR EACH AREA, ADDING SUBTLE HIGHLIGHTS AND EXTRA SHADOWS TO CREATE DEPTH.

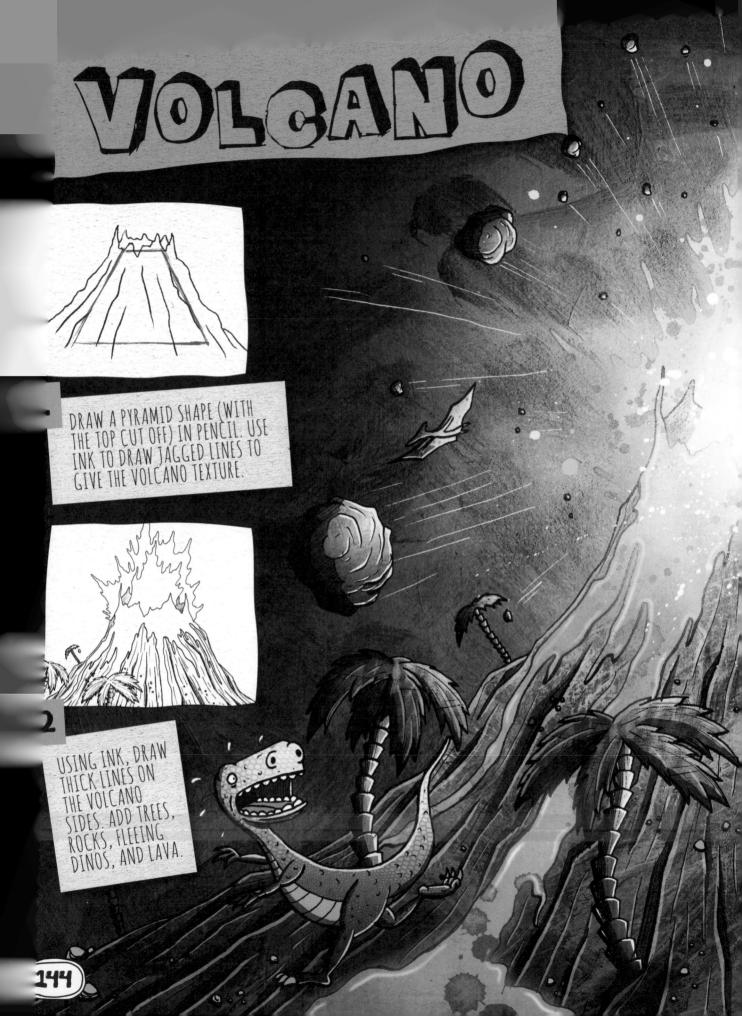

Flick light colors of paint around the mouth of the volcano to make it look even hotter.

0

PAINT DARK ORANGES AT THE BOTTOM OF THE LAVA, AND WORK UP TO THE BRIGHTER COLORS FOR THE LAVA ERUPTING.

PAINT THE REST OF YOUR PICTURE, ADDING SHADOWS AND HIGHLIGHTS FOR DRAMATIC EFFECT.

Make this rock really big so you get a sense of the danger up close.

3

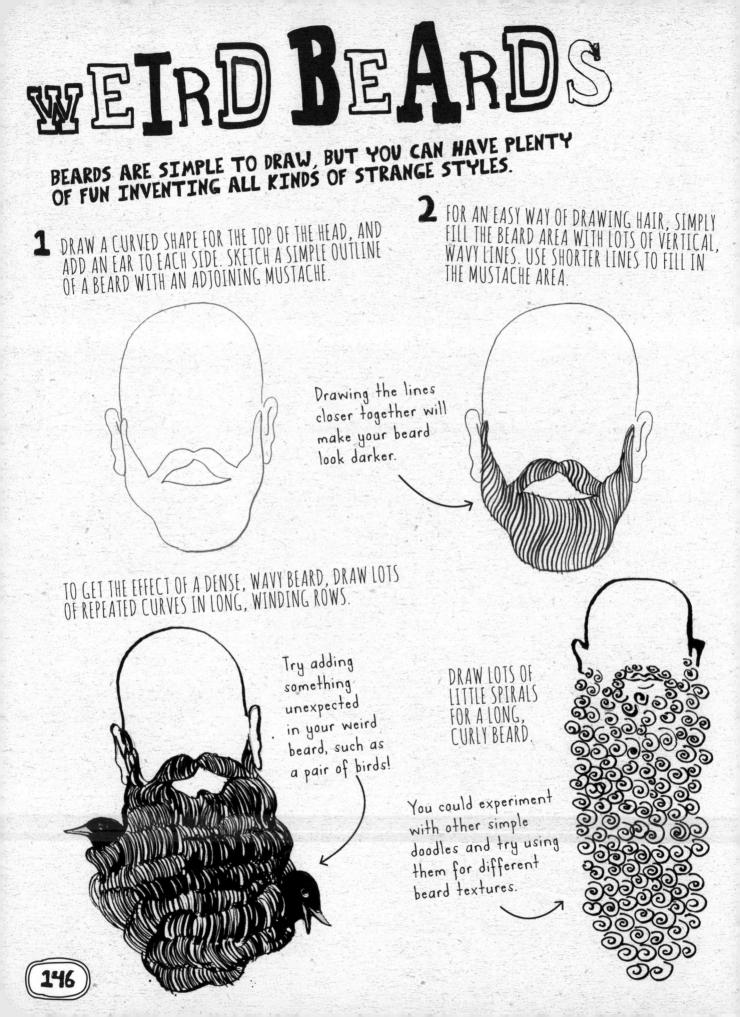

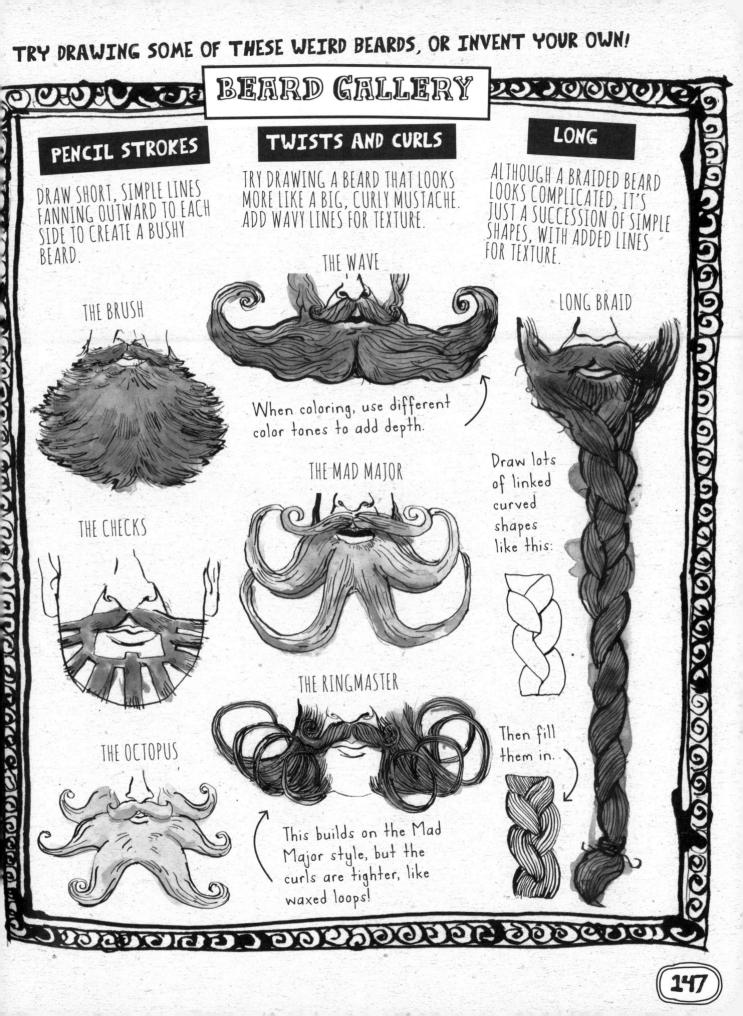

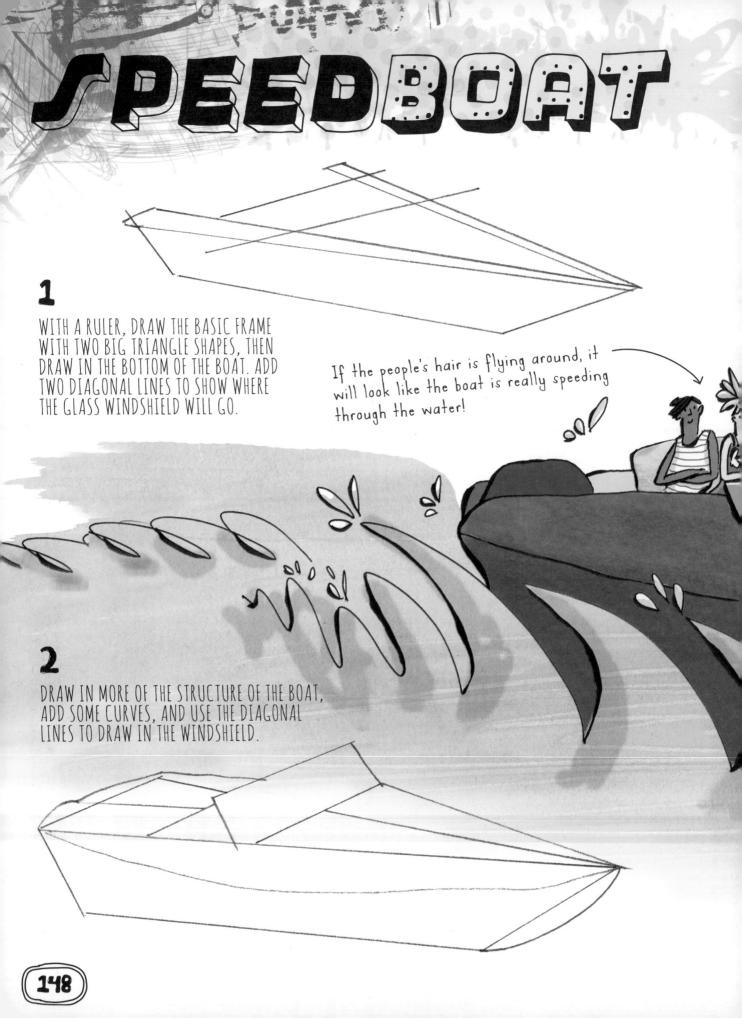

ERASE THE LINES YOU DON'T NEED, AND ADD SOME CURVES AND DETAILS. Roughly sketch in where the People Will sit in the speedboat, A Steering wheel, and motor.

0000

10

3

21

4

000

DRAW IN SOME SPIKY WAVES. THESE ARE SUPPOSED TO

LOOK LOOSE AND SPLASHY, SO DON'T WORRY ABOUT BEING TOO PRECISE. ADD IN THE PEOPLE'S FEATURES AND A REFLECTION LINE ON THE

WINDSHIELD.

00

20

FINISH BY COLORING THE PICTURE. BE PRECISE WITH THE COLOR OF THE BOAT AND LOOSE WHEN COLORING THE WAVES.

5

Add little splash marks loosely colored in to really give the sense of the boat's speed!

NPp

TRY DRAWING FRAMES FOR YOUR PICTURES USING SIMPLE SHAPES TO BUILD UP PATTERNS.

FOR A ZIGZAG PATTERN, DRAW TWO LONG PARALLEL LINES, THEN DRAW ZIGZAG LINES BETWEEN THEM. BUILD UP A COMPLEX PATTERN BY ADDING DETAIL AND SHADING LINES IN THE TRIANGLES YOU'VE CREATED.

THIS PATTERN IS SIMILAR TO THE ONE ABOVE, BUT THIS TIME, USE CONSECUTIVE CURVES AND REMOVE THE TOP LINE TO GIVE A DIFFERENT, ROUNDED STYLE. ADD DETAIL INSIDE THE CURVES FOR SOPHISTICATION.

FOR ANOTHER INTERESTING PATTERN, DIVIDE THE SPACE BETWEEN THE PARALLEL LINES INTO SMALL SQUARES. TRY DIFFERENT PATTERNS IN EACH ONE, OR REPEAT SOME OF THE DESIGNS TO BUILD UP A BIGGER PATTERN.

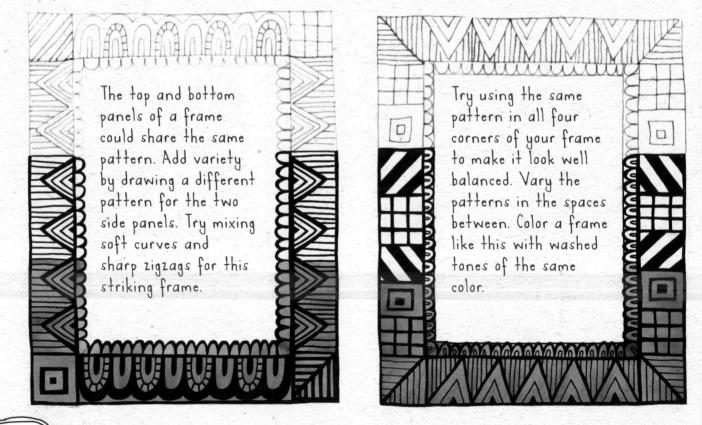

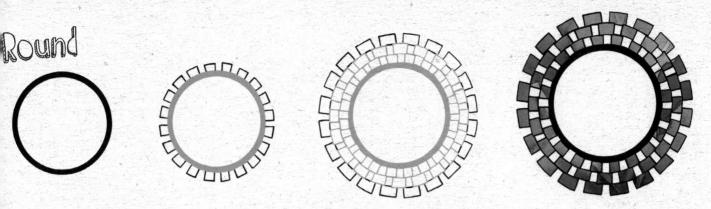

Start by drawing a thick circle. Add squares around the outside, leaving spaces in between. On the next layer, add squares, building on the spaces in the first layer. Do the same for the third layer. Mix different tones of watercolor paints to color the squares, leaving white space in between.

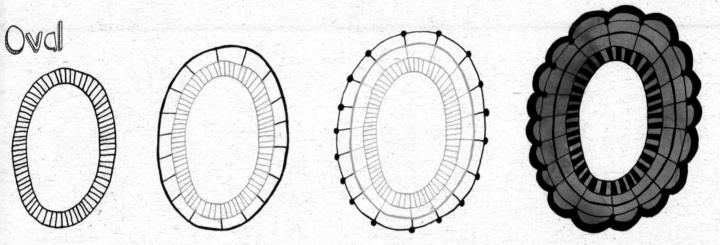

Draw an oval shape with a larger oval around the outside. Draw lines close together inside. Add larger ovals, and divide them up into equal sections, as shown. Add curves around the outside of the frame, looping from line to line. Color with watercolor paints and varying tones.

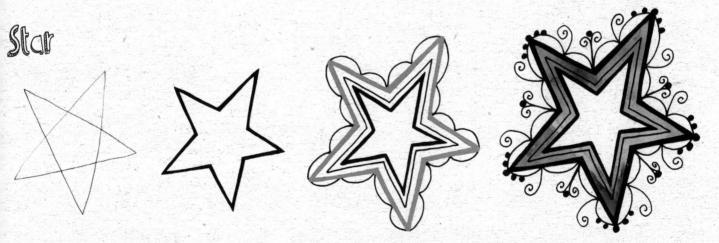

To make a star-shaped frame, draw two interlocking triangles, one on top of the other. Add larger stars around the outside. In light pencil, draw curves around the outside. Paint the frame. When it's dry, ink over the lines varying the thickness to make it interesting. Add pretty detail!

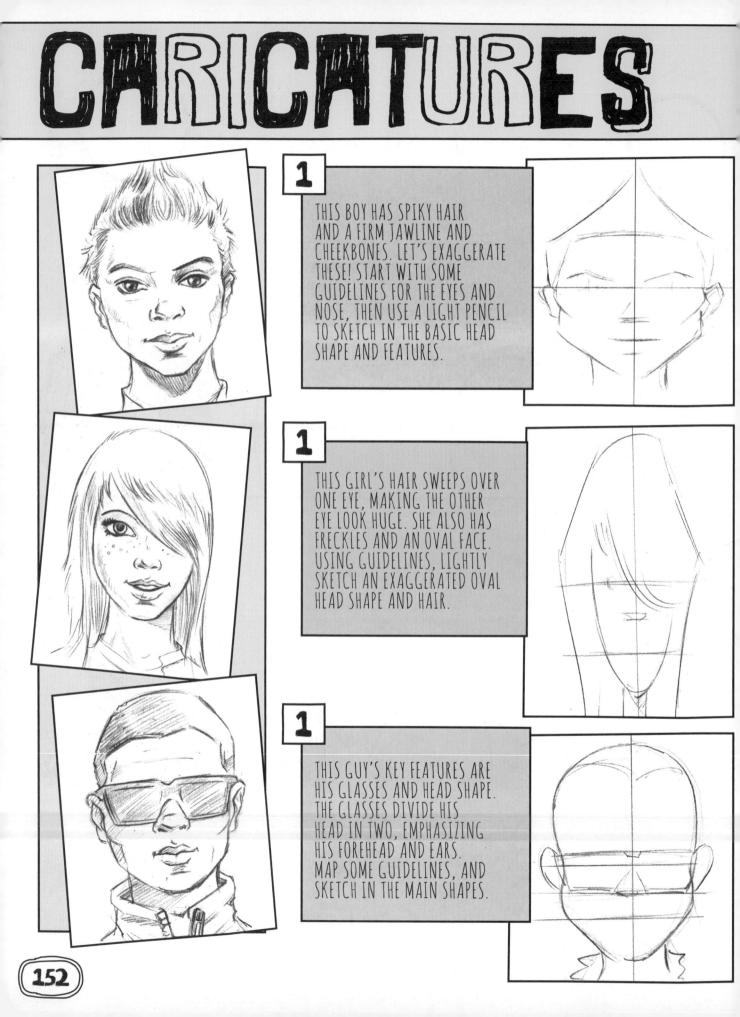

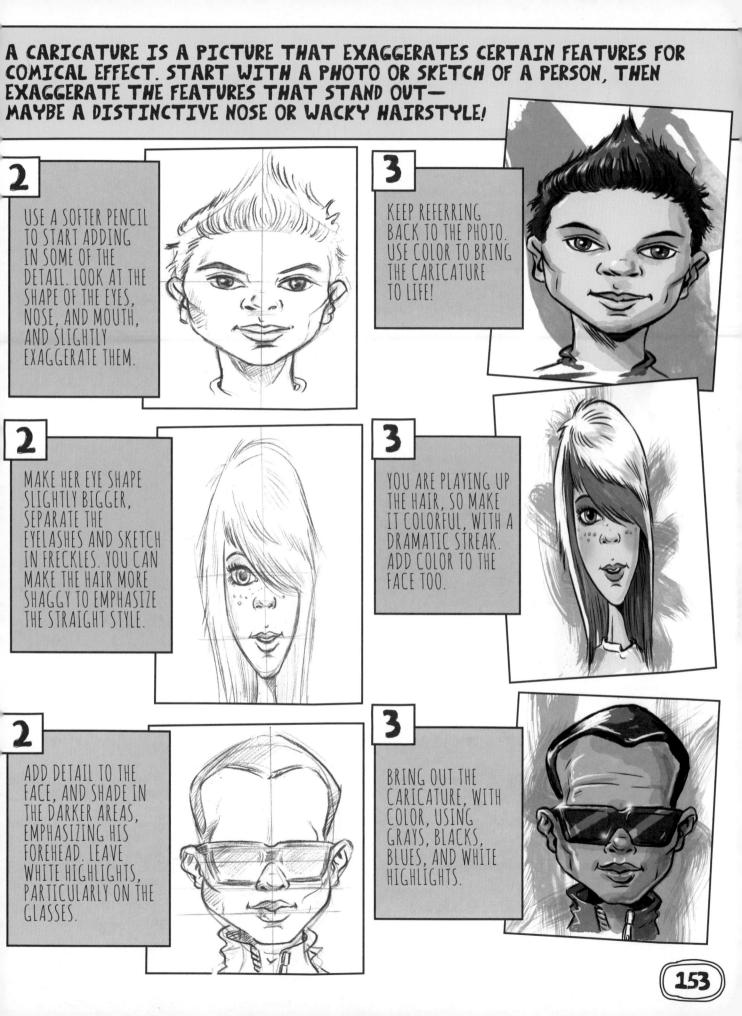

CR@C@DILE

1 SKETCH THE BASIC SHAPE OF THE CROCODILE'S BODY WITH A LIGHT, SHARP PENCIL. ADD ROUGH CIRCLE SHAPES FOR THE THREE LEGS YOU'LL SEE.

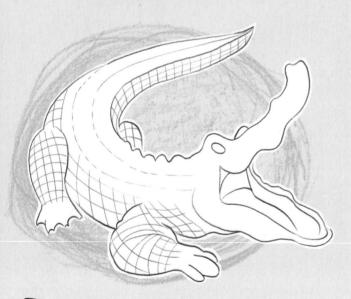

3 SKETCH THE OUTLINE OF THE CROCODILE. DRAW TWO LINES RUNNING PARALLEL ALONG HIS BACK. USING A GRID SYSTEM, DRAW A GUIDE FOR THE SCALES ON THE LIMBS AND BODY. **2** DRAW AN OVAL SHAPE FOR THE HEAD BEFORE ADDING IN THE OPEN MOUTH. SKETCH IN THE ROUGH DETAIL OF THE MOUTH, AND ADD SOME FEET FOR THE BEGINNING OF THE CLAWS.

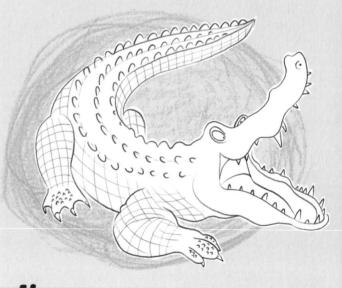

ADD THE EYES, CLAWS, TEETH, AND BACK SCALES, MAKING SURE THE SCALES FOLLOW THE CONTOUR OF THE BODY. MARK SMALL CURVES FOR SCALES ON THE FEET AND BACK.

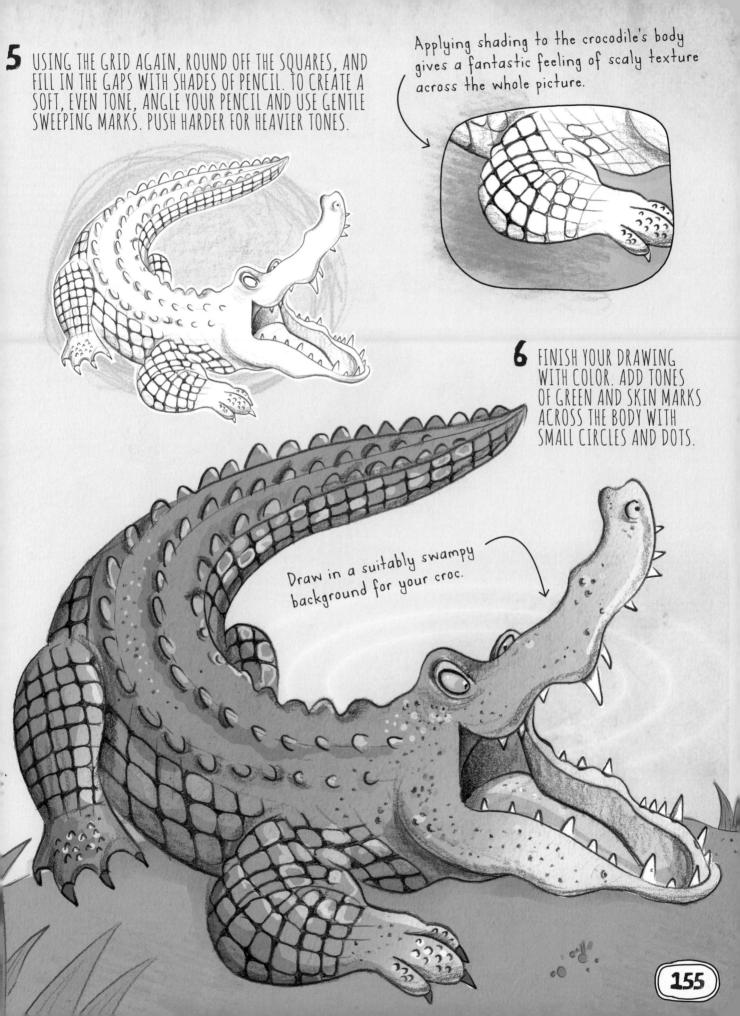

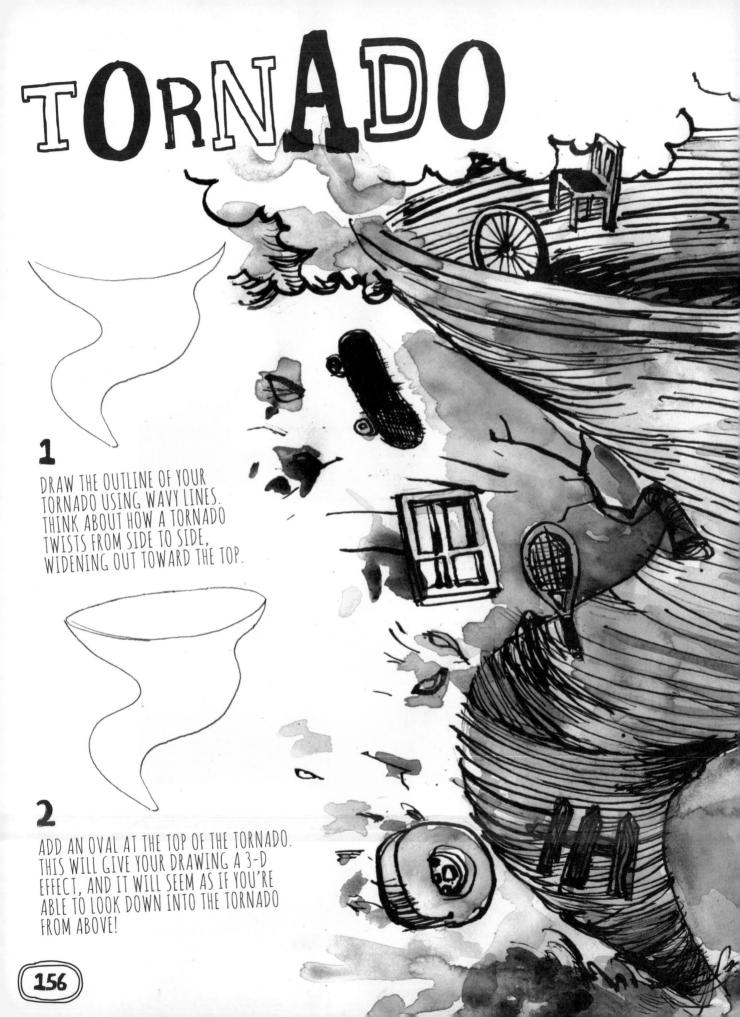

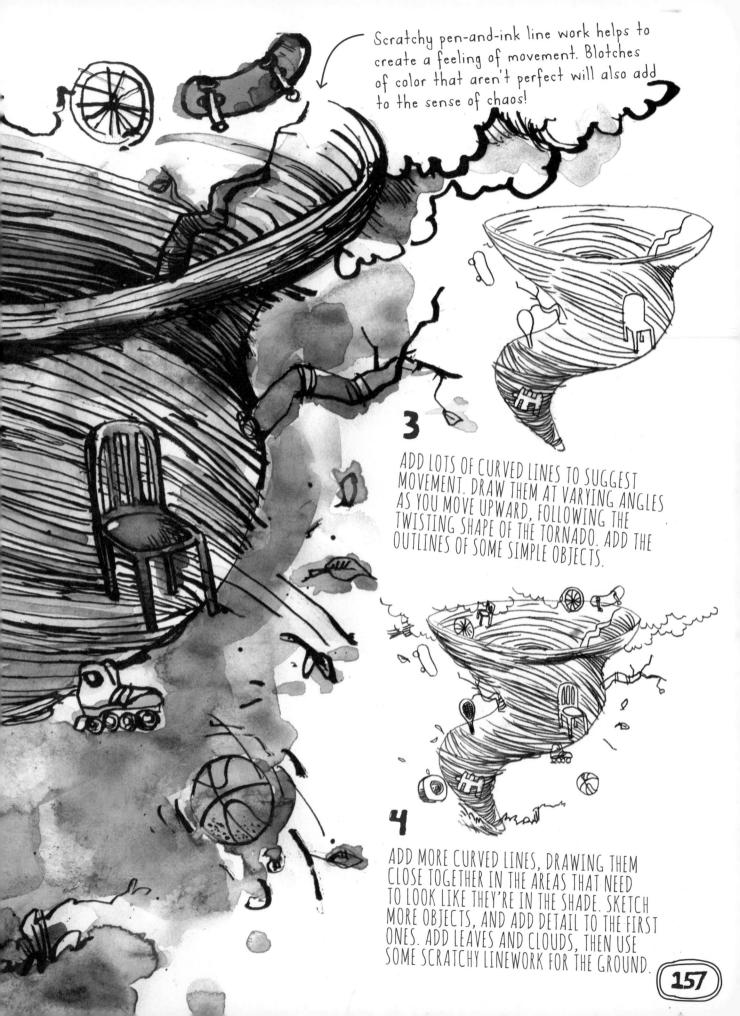

PIECE TOGETHER DIFFERENT IMAGINATIVE BODY PARTS TO CREATE A MOB OF MASHED-UP MONSTERS!

1 START WITH THE MONSTER'S BODY. USE A SIMPLE CIRCLE, BENDING THE LINES A LITTLE, THEN ADD MONSTER DETAIL ON TOP, SUCH AS SPIKES OR STRIPES.

FOR THE LEGS, TRY TENTACLES, LEGS WITH WEBBED FEET LIKE A BIRD, BIG HAIRY ONES WITH GIANT CLAWS, OR ANYTHING ELSE YOU CAN THINK OF. GO WILD!

SIMILARLY FOR THE HANDS, THERE ARE SO MANY POSSIBILITIES! TRY SIMPLE CLAWS, A BIG HAIRY HAND WITH SHARP NAILS, OR EVEN A CLAW LIKE A SEA CREATURE.

Attach the hands directly to the body, or draw long wavy lines for arms.

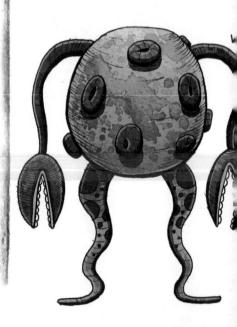

HASH-UP 4 5

FOR INTEREST, GIVE YOUR MONSTER SOMETHING OTHER THAN TWO EYES— TRY ONE LARGE ONE IN THE MIDDLE OF THE HEAD, PUT A FEW ON LITTLE STALKS, OR DRAW ON LOADS!

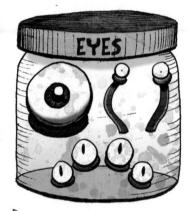

Draw a head with a similar texture to the body, so that it looks connected. THE MOUTH SHOULD BE QUITE BIG TO MAKE THE MONSTER LOOK SCARY. AND DON'T FORGET THE TEETH! THE SHARPER THE TEETH, THE SCARIER THE MONSTER!

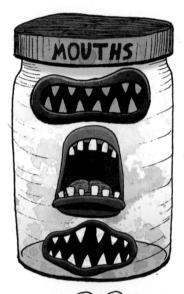

ADD MASSIVE HORNS COMING OUT OF THE SIDE OF THE MONSTER'S HEAD OR MAYBE SMALLER ONES ON THE FRONT. DON'T FORGET, YOU DON'T HAVE TO STOP AT JUST TWO!

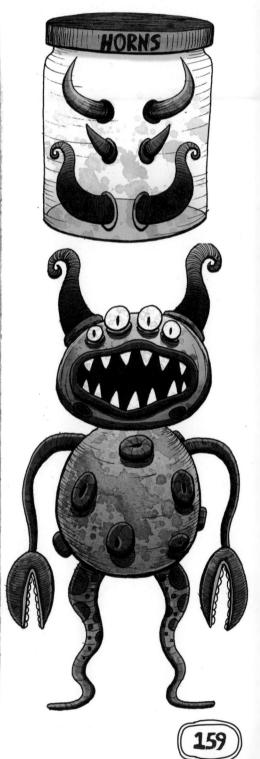

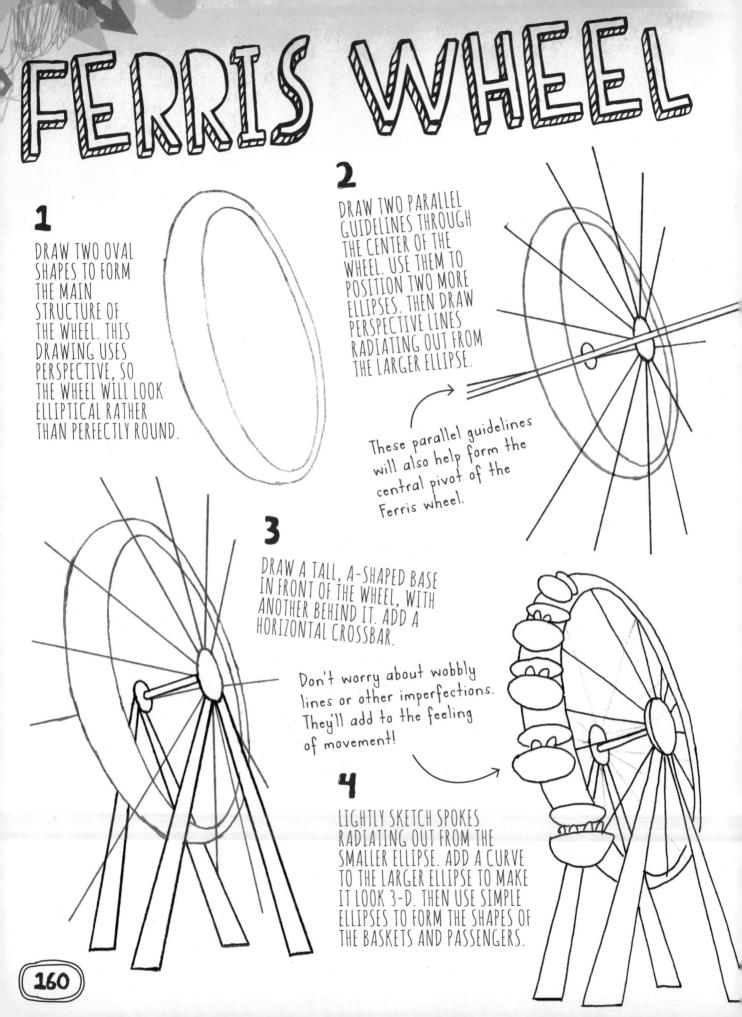

Add sets of curved motion lines around the outside. These will give the impression that the wheel is spinning around. ADD LOTS OF CIRCLES AND FOR THE LIGHTS, THEN IN A FEW HUMAN FIGURES. ELLIPSE DRAW LOW ANGLE, Y ONLY THEIR HEADS THAT ULD BE VISIBLE. COLOR YOUR. FERRIS WHEEL USING BRIGHT, CONTRASTING TONES. Try not to color

0

100

- Cor

20

od 00

200

000 000

000 500

161

0

80

0

0000

0

00

00

G

0

O

0

RODODODOCO

000000

 \cap

0

0

000

149

2

20

in each light fully. A small white arc shape will look like a highlight.

SCAREDY-CAT

DRAW AN EGG-SHAPED BODY, CONTINUING THE TOP CURVE TO FORM THE CAT'S REAR LEG. ADD SIMPLE SHAPES FOR THE FRONT LEGS AND TAIL. DRAW A CIRCLE FOR THE MOUTH AND A RECTANGLE FOR THE HEAD. For a more subtle fur texture, apply pressure at the start of each pencil stroke, easing off as your pencil flicks sharply upward.

2 DRAW ROUGH TRIANGULAR SHAPES FOR THE CAT'S CHEEKS AND WHISKERS, AND CIRCLES FOR ITS FEET, TOES, AND EYES. USE THE CURVED LINE RUNNING THROUGH THE FACE TO HELP YOU POSITION AN OPEN MOUTH.

Small details will help make your scaredy cat look even more afraid. Draw large ovals for its wide eyes, adding raised eyebrows just above the head. Make the mouth wide open, and use zigzags for the whiskers.

3 WORK ON THE FACIAL DETAILS, ADDING TEETH, WHISKERS, AND A TONGUE. DRAW IN THE TOES AND CLAWS. THEN

SKETCH LOTS OF PARALLEL LINES ALONG THE OUTLINE OF

THE CAT'S BODY TO SUGGEST FUR STANDING ON END!

A DRAW IN THE BODY FUR BY USING SWEEPING PENCIL STROKES IN AN UPWARD DIRECTION. USE SMALLER STROKES TO ADD SOME STRIPES.

5 NOW USE CONTRASTING COLORED PENCILS TO COLOR. THIS PICTURE USES GREEN AND BROWN TONES, WITH CERTAIN AREAS LEFT WHITE, SUCH AS THE EYES AND HIGHLIGHTS ON THE MOUTH AND PAWS. ADD MOVEMENT LINES TO ADD TO THE "SCAREDY-CAT" EFFECT!

1111

111/11/11

SYBORG

► DRAW A STICK FIGURE TO SHOW THE BASIC POSE AND PROPORTIONS. SKETCH A SLIGHT CURVE FOR THE BACK AND HORIZONTAL LINES FOR THE HIPS AND SHOULDERS. ADD ARMS AND LEGS AND AN OVAL SHAPE FOR THE HEAD.

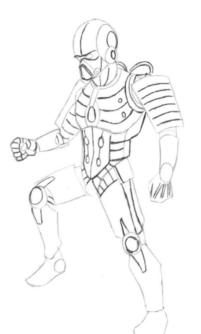

WORK ON THE ARMOR DETAIL. ADD CIRCULAR LIGHTS, AND DRAW CURVED LINES ON THE CHEST AND SHOULDER AREAS. CREATE A SCI-FI FEEL BY ADDING TUBING AND MORE ELABORATE KNEE JOINTS. ADD MORE DETAIL TO THE MASK AND HELMET.

ERASE THE STICK LINES.

DRAW THE CYBORG'S ARMOR BY

SKETCHING SHAPES THAT MIMIC

THE BODY PARTS UNDERNEATH,

THICKNESS. USE CIRCLES FOR THE WRIST, KNEE, AND ANKLE JOINTS.

BUT LARGER TO GIVE THE IMPRESSION OF WEIGHT AND TO FLESH OUT THE LIMBS, DRAW CYLINDERS AROUND THE STICK LINES, MAKING THE LINES CURVE OUTWARD TO SUGGEST BULGING MUSCLES. ADD IN THE CHEST MUSCLES, PLUS A CIRCLE TO SUGGEST A PUMPED-UP SHOULDER!

2

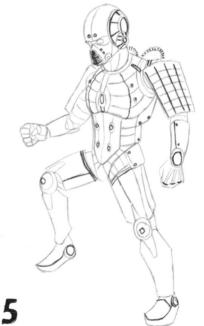

REFINE THE DETAIL FURTHER. DRAW RIVETS ON THE ARMOR, LINES ON THE MASK, AND A CRISSCROSS PATTERN ON THE SHOULDER PLATE. ADD LINES TO DIVIDE PARTS OF THE ARMOR INTO SMALLER SECTIONS, SUCH AS THE HELMET AND UPPER LEG AREAS.

6 PAINT YOUR CYBORG WITH COOL COLORS. TO MAKE THE CYBORG LOOK METALLIC, USE NARROW BANDS OF DIFFERENT TONES, ESPECIALLY FOR THE HIGHLIGHTS, TO SHOW LIGHT REFLECTING OFF A SHINY SURFACE.

Draw rocks using a mix of smooth and angular lines to form spiky peaks. Add plenty of shadows for dramatic contrast.

Add small, dark lines to the armor to suggest wear and tear.

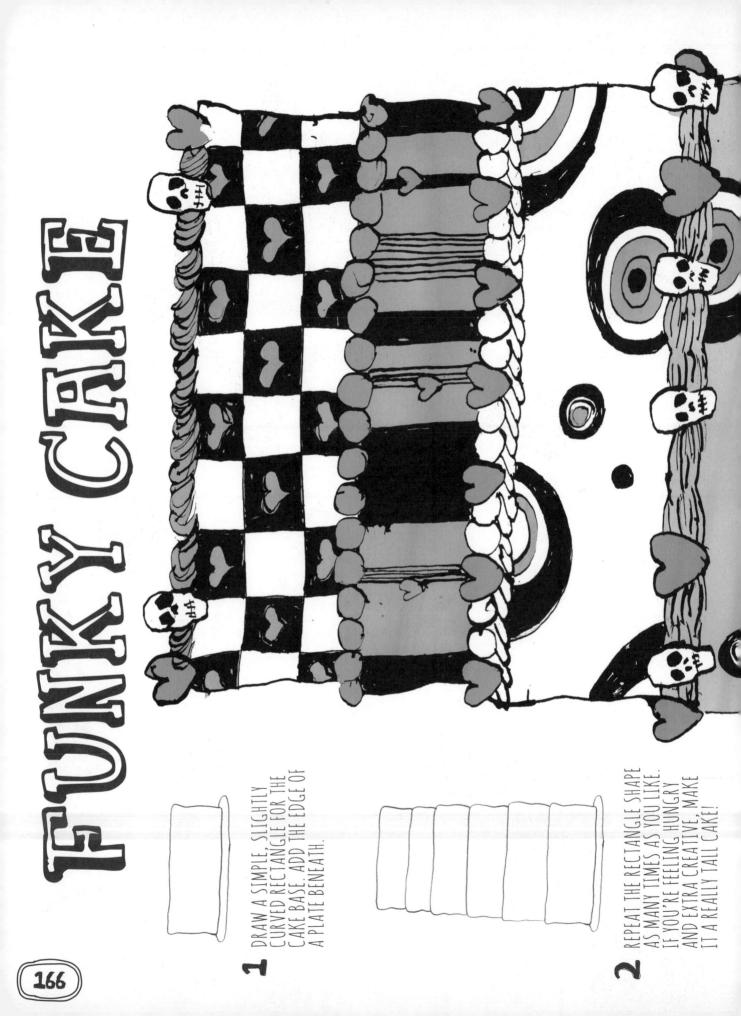

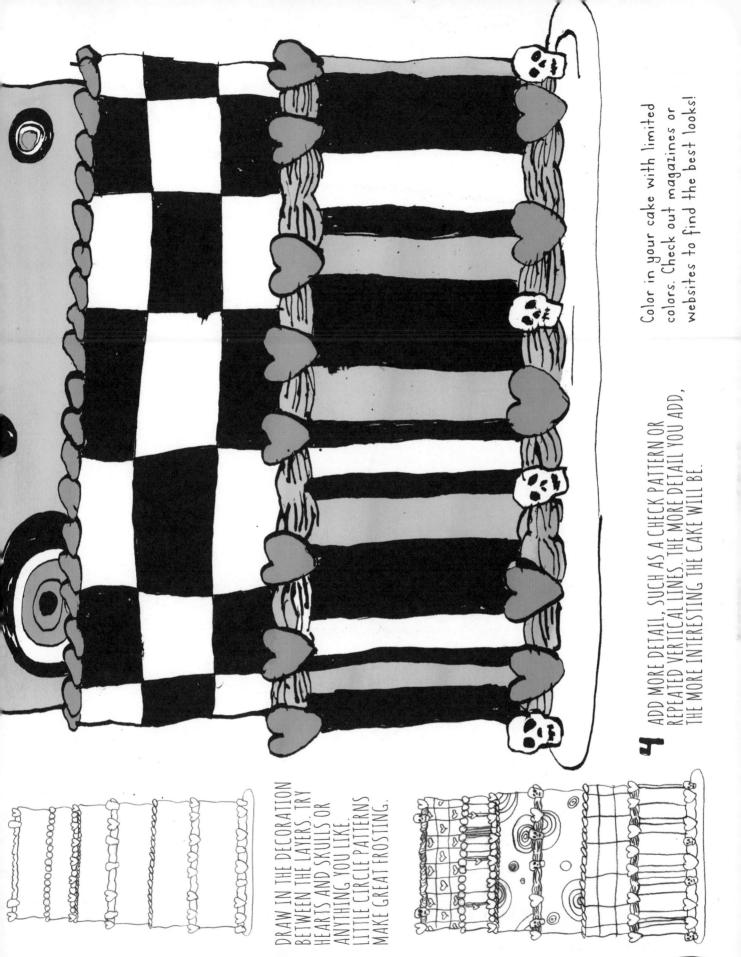

m

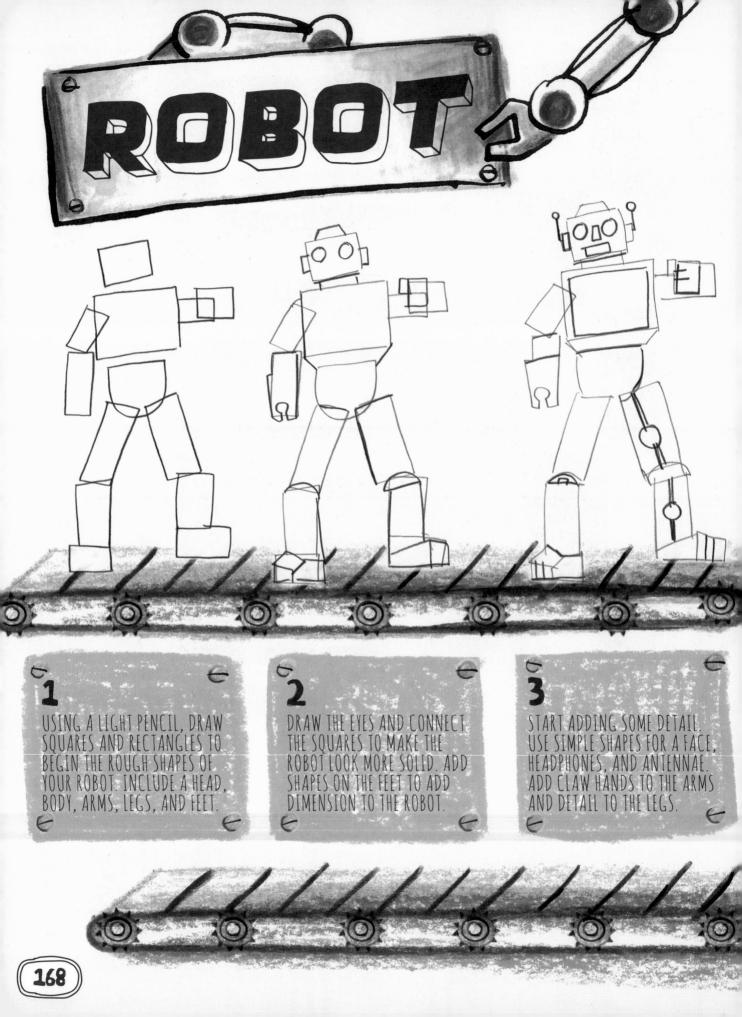

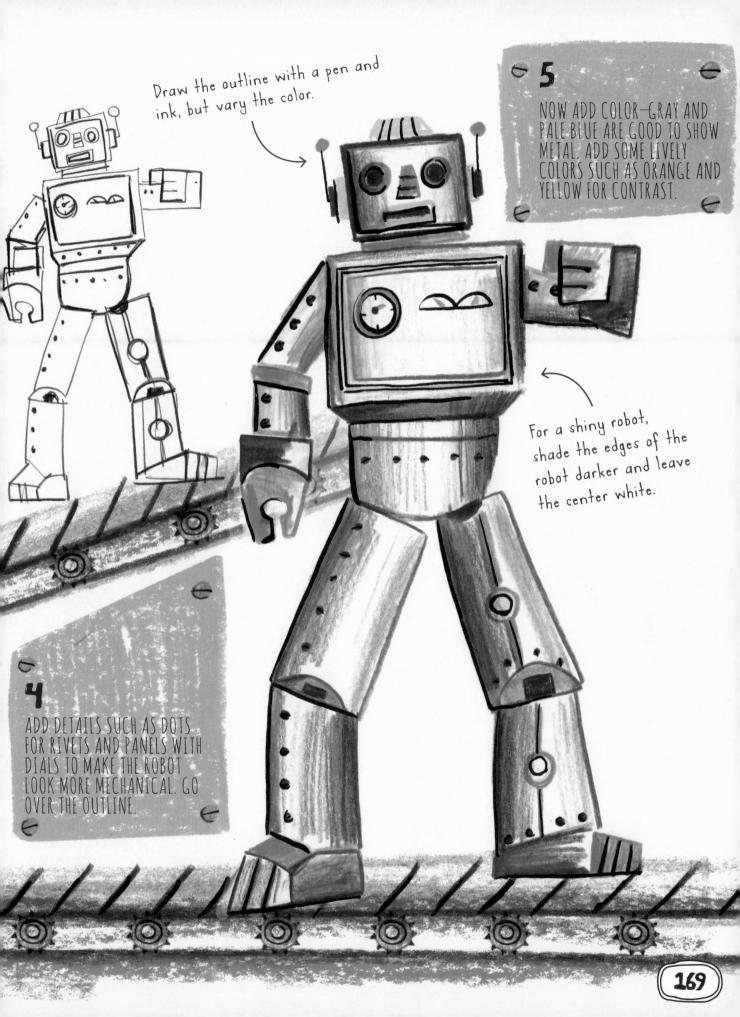

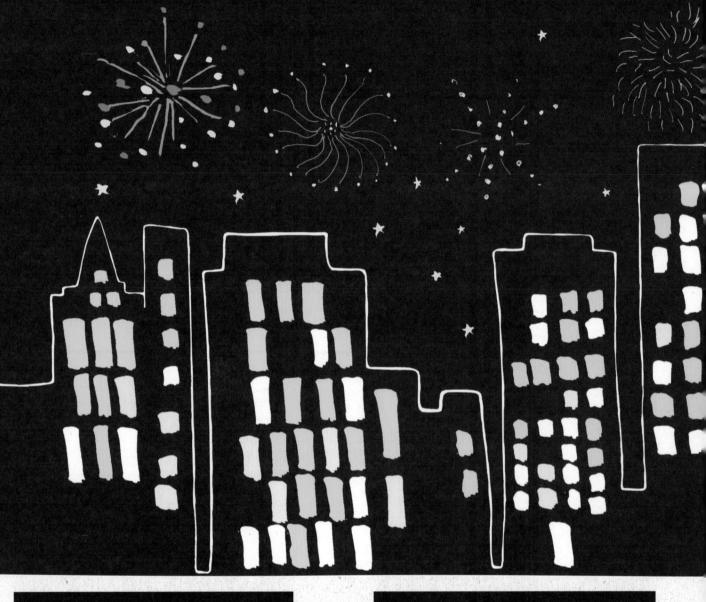

1 DRAW A BASIC CITY SKYLINE OF DIFFERENT-SHAPED BUILDINGS WITH WHITE CHALK OR PAINT ONTO A PIECE OF BLACK CARD STOCK OR PAPER, LIKE THIS.

170

2 DRAW SMALL WHITE AND YELLOW RECTANGLES TO LIGHT UP ALL THE BUILDINGS, AND MAKE YOUR CITY LOOK BRIGHT AND BUSY.

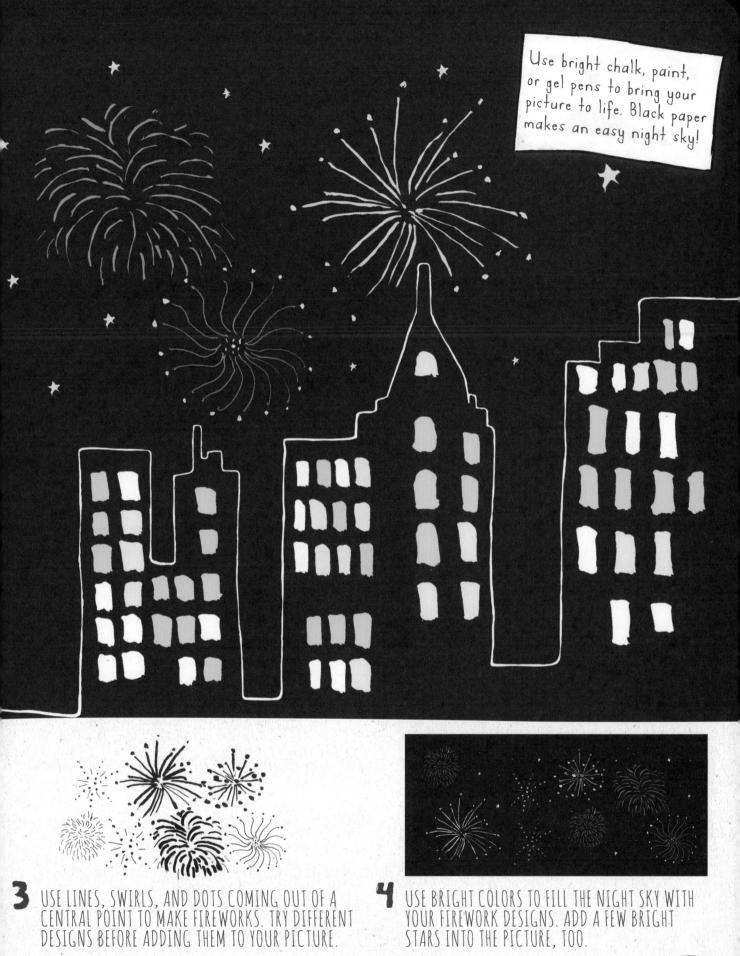

GARTOON CUTE ANIMALS

LEARN TO DRAW DIFFERENT FEATURES, THEN HAVE FUN PUTTING THEM TOGETHER TO CREATE YOUR OWN CUTE CARTOON ANIMALS.

AILS

HINK SHAGGY AND WAGGY OR THIN AND CURLY—TAILS CAN ADD A LOT OF CHARACTER TO YOUR ANIMALS!

PAWS HERE ARE SOME SIMPLE SHAPES YOU CAN USE FOR PAWS AND HOOFS. BIG PAWS RELATIVE TO A BODY CAN EMPHASIZE THE CARTOON FEEL.

NOSES

TRY AN UPSIDE-DOWN TRIANGLE FOR A NOSE AND SIMPLE LINES FOR A MOUTH. USE PENCIL STROKES FLICKING OUTWARD FOR WHISKERS.

EYES

EXPERIMENT WITH DIFFERENT-SHAPED EYELIDS—THE SLANT OF THE LINE CAN MAKE YOUR CHARACTER LOOK MEAN, CROSS, OR SAD. USE A SMALL CIRCLE FOR AN EYE GLINT.

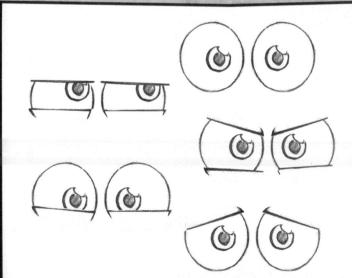

Add dark colors and shadows to give dimension to the cartoon figures.

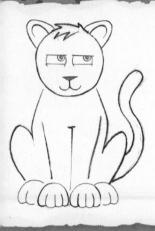

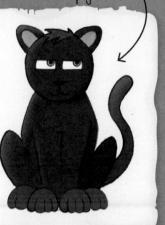

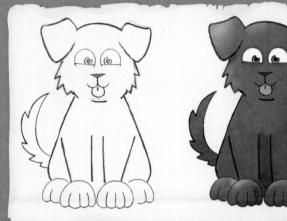

Cartoon characters are just that—cartoons! They don't need to look real, so you can use realistic colors, but try wacky ones, too!

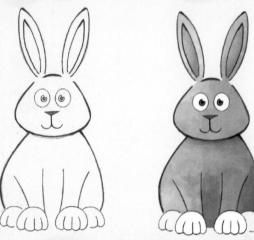

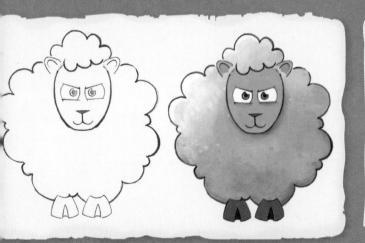

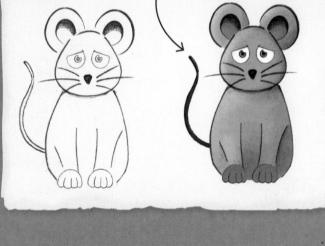

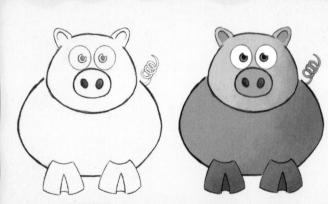

173

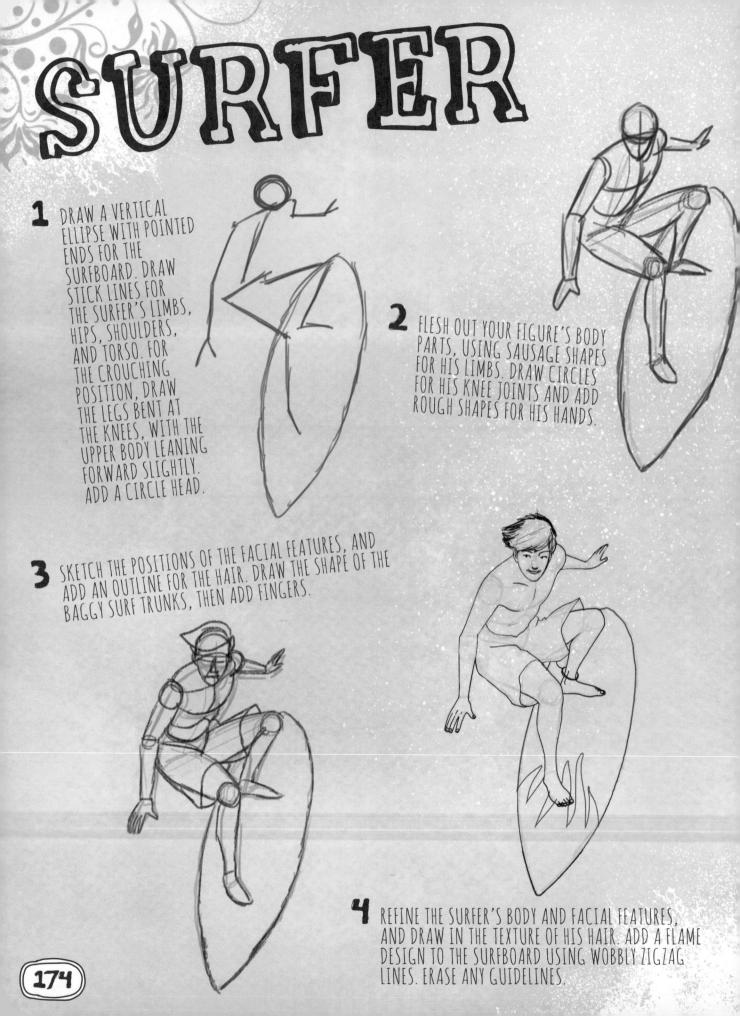

5 PAINT YOUR SURFER'S SKIN USING A FLAT BROWN COLOR. THEN USE PALER HUES ON TOP TO BRING OUT HIS MUSCLE TONE, WITH BANDS OF WHITE FOR HIGHLIGHTS. GIVE HIM A NECKLACE AND BRACELET, AND PAINT A FLOWERY DESIGN ON HIS SHORTS. COLOR THE FLAMES RED FOR DRAMATIC IMPACT.

Choose a simple but striking color scheme. Here, the red flames contrast well with the green of the surfer's shorts.

> Paint the background with a big brush. Use watercolor washes in different shades of blue, starting with a lighter tone first, before merging in slightly darker areas.

Add sea spray by dipping an old toothbrush in white paint. Then run your finger along the bristles to flick tiny dots of paint onto the picture.

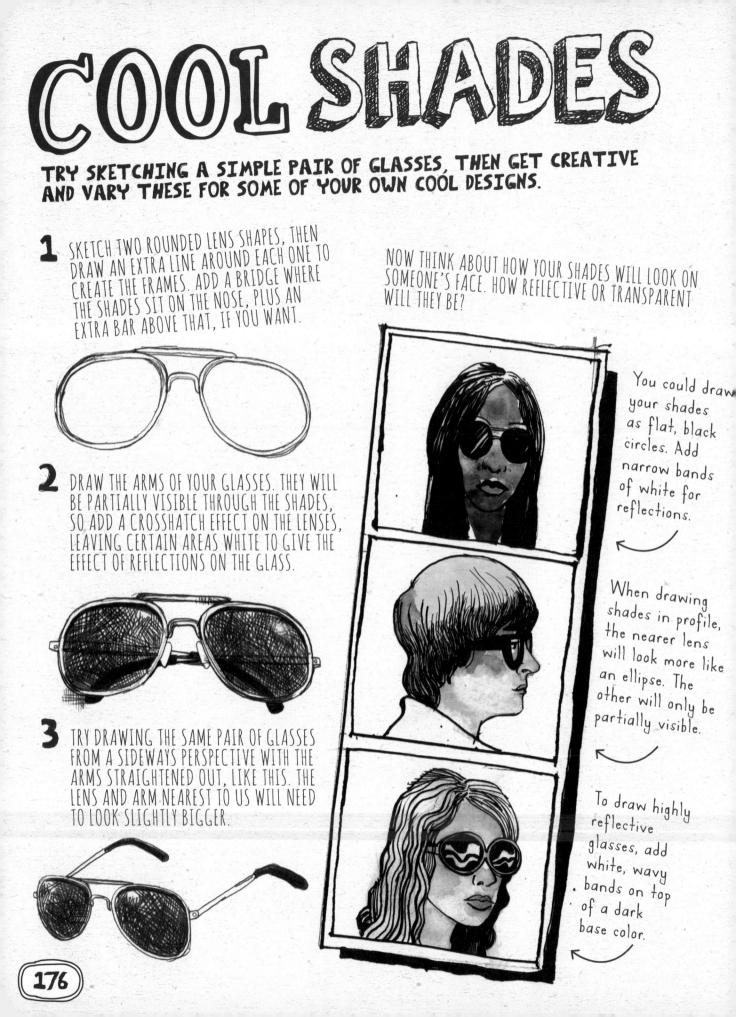

SHADES CAN BE PLAIN OR PATTERNED, AND CAN COME IN ALL KINDS OF SHAPES AND SIZES ...

STANDARD SHAPE

STANDARD FRAMES ARE BASICALLY SQUARES WITH CURVED EDGES. EXPERIMENT WITH DIFFERENT SHAPES, CHOOSING HEAVY BLACK FRAMES, OR EVEN ONES WITH AN UNUSUAL STRIPED EFFECT!

PATTERNED SHADES

A SIMPLE REPEATED MOTIF IS GOOD FOR DECORATING YOUR FRAMES, SUCH AS THESE THIN LINES. YOU COULD ALSO TRY GIVING YOUR FRAMES A MOTTLED PAINT EFFECT.

SHAPED FRAMES

PLAY AROUND WITH DIFFERENT Shapes and styles. From Pointy Edges to love hearts, they can be any shape you like.

STATEMENT SHADES

EVEN A BASIC STYLE OF FRAME CAN BE LIVENED UP BY ADDING QUIRKY DETAILS OR A REFLECTIVE PATTERN TO THE LENSES. SECRET AGENT

HALF-PATTERNED FRAMES

DIAMANTÉ BLING

STRIPY

• PATTERNED LENSES

OD

LOVE HEARTS

STARS

SKI CHIC

FRANKENSTEIN'S MONSTER

▲ DRAW BASIC GUIDE SHAPES FOR THE MONSTER'S HEAD, BODY, LEGS, AND HANDS.

POLISH THE OUTLINE OF THE MONSTER, AND DRAW SOME CLOTHES. ADD MORE DETAIL TO THE HANDS AND HEAD.

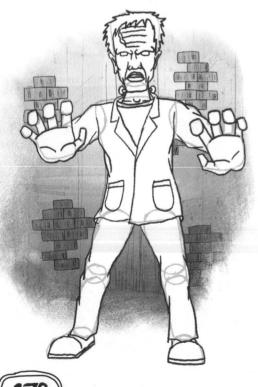

LISE SAUSAGE SHAPES TO BUILD UP HIS FEET AND LIMBS. ADD THE FINGERS, DRAWING SMALL CIRCLE AT THE END OF EACH ONE.

Praw sausage shapes for the ears and eyebrows, adding round and triangular shapes for the other facial features.

SHADE THE PARTS OF YOUR MONSTER THAT ARE IN SHADOW. USE MORE SHADING FOR THE CREASES IN HIS CLOTHES, AND ADD SOME TO HIS FACE TO EMPHASIZE HIS SCARY EYES!

Use a fine point for this shading technique. Make areas look darker with rows of horizontal or vertical lines.

5 WHEN COLORING YOUR MONSTER, MAKE HIS GREEN SKIN LIGHTER THAN THE OTHER COLORS IN ORDER TO DRAW OUR ATTENTION TO THE SCAREER PARTS OF HIS BODY. FOR THE CLOTHES, USE TONES THAT WORK WELL WITH GREEN, SUCH AS DARK BLUE AND PURPLE.

ATTA

Add highlights to your monster's hands and face. These light bands of color contrast dramatically with the black lines, emphasizing the scary effect.

111

Add a simple brick wall behind the monster, and use pale tones to help him stand out from the page.

1 al liter

TITLE

179

STARTING WITH A LIGHT PENCIL, DRAW CIRCLES FOR A SQUIRREL'S HEAD, LEG, AND NUT. SKETCH IN EARS, ARMS, LEGS, AND A BUSHY TAIL.

ADD THE NOSE, EYE, AND WHISKERS. BUILD THE Shape by smoothing out the curves. Erase Any guidelines.

> USE DIFFERENT TONES OF THE SAME COLOR TO SHADE IN THE FUR. THIS WILL CREATE THE EFFECT OF VOLUME. NOTICE WHERE THE FUR IS DARKER OR LIGHTER.

ANIMAL FUR Use short pencil strokes, mixing different tones of the main color. The direction of the strokes should follow the shape of the

> DRAW THE FOX'S SHAPE USING CIRCLES AND TRIANGLES. ADD A BEAN SHAPE FOR THE

BODY, THEN ADD THE

LEGS. NOTICE THE WAY THE BACK LEGS BEND.

animal.

TO DRAW A DEER, USE CIRCLES FOR THE HEAD AND KNEES, AND RECTANGLES FOR THE NECK, BODY, AND LEGS.

THE SHAPE OF A LETTER S.

USING THE SHAPES AS A GUIDE, SMOOTH AND SOFTEN THE OUTLINE OF THE SHAPE. ADD EARS, NOSE, AN EYE, MOUTH, AND TAIL

3 ERASE THE GUIDELINES AND ADD SOME COLOR BLEND DIFFERENT BROWN PENCILS TO CREATE THE FUR, AND ADD STROKES OF WHITE PAINT FOR THE DOTS. USE BLACK INK FOR THE FINAL DETAILS. AND HOOVES.

ASE ANY GUIDELINES, THEN USE COLORED PENCILS TO DRAW THE FUR, FOLLOWING THE DIRECTION OF THE FOX'S SHAPE. ADD THE EYES, NOSE, MOUTH, AND WHISKERS TO DRAW AROUND YOUR GUIDELINES TO THE FOX PERSONALITY. SMOOTH OUT THE FOX SHAPE. ADD DOTS FOR GIVE THE EYES AND NOSE. DRAW THE TAIL LIKE

Add mushrooms to create a colorful scene. Use a rounded triangle for the cap and a rectangle for the stalk. Draw circles for spots, then color it all in.

MOUNTAIN BIKE

DRAW A LARGE CIRCLE FOR THE BACK WHEEL. SKETCH A SIMPLE 'H' SHAPE LEANING BACKWARD NEXT TO IT. THIS FORMS THE BASIC SHAPE OF THE BIKE'S FRAME.

3 ADD SMALL ELLIPSES FOR THE SEAT AND HANDLEBARS, WITH LITTLE RECTANGLES TO MARK THE POSITIONS OF THE PEDAL. SKETCH ANOTHER CIRCLE FOR THE REAR CHAIN WHEEL. **2** DRAW THE FRONT WHEEL BY ADDING ANOTHER CIRCLE THE SAME SIZE AS THE FIRST ONE. SKETCH A SMALLER CIRCLE FOR THE CHAIN WHEEL, THEN ADD A DIAGONAL LINE FROM THE CENTER OF THIS WHEEL TO THE FRONT PART OF THE FRAME.

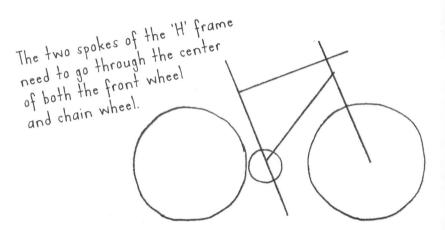

FOLLOWING YOUR GUIDES, DRAW TWO PARALLEL LINES FOR EACH PART OF THE BICYCLE FRAME. SKETCH A LARGER CIRCLE AROUND EACH WHEEL SHAPE, AND ADD SMALLER ONES FOR THE GEAR SYSTEM. DRAW SETS OF PARALLEL LINES FOR THE SPOKES.

> Use a ruler to draw the spokes for a professional-looking bike.

182

Don't worry if the spoke lines are incomplete. The faintness of the line work suggests that the spokes are very thin.

6 GO OVER YOUR LINE WORK IN PEN AND INK. CHOOSE A BRIGHT COLOR FOR THE FRAMEWORK TO CONTRAST WITH THE DARK TIRES. ADD MARKINGS TO THE FRAME FOR EXTRA VISUAL INTEREST.

5 ERASE ANY LINES THAT AREN'T

AND FRONT WHEEL.

NEEDED. REFINE THE SPIKY SHAPE OF THE CHAIN WHEEL, AND ADD OTHER DETAILS, SUCH AS THE WAVY BIKE CHAIN AND BRAKE CABLES AND PADS BETWEEN THE HANDLEBARS

Add a simple background in a contrasting tone to make your bike stand out from the page.

Try using a fine paintbrush and black India ink to add shadows and depth to your bike.

IT IS AMAZING HOW MANY PATTERNS YOU CAN INVENT USING THE HUMBLE LINE! DOODLE SOME LINES, AND SEE WHAT YOU COME UP WITH.

Lines and Stripes

SIMPLE HAND-DRAWN VERTICAL LINES CAN MAKE A SURPRISINGLY SOPHISTICATED DESIGN. TRY THIN AND THICK STYLES OF STRIPES AND THEN COMBINE THEM. HAVE A COUPLE OF DIFFERENT-SIZED PENS AND BRUSHES ON HAND TO FIND WHAT WORKS BEST.

Draw pinstripes with a fine pen or brush.

h A flat brush will make wide stripes.

The two styles combined look fab!

Use tonal colors of different widths.

Draw contrasting horizontal stripes.

Combine them to make a plaid pattern!

CHANGING THE DIRECTION, WIDTH AND COLOR OF THE LINES ADDS TO THE VARIETY OF PATTERNS YOU CAN ACHIEVE. OVERLAPPING COLORS CAN ADD TO THE PATTERN IN SURPRISING WAYS.

BUILDING UP CRISS-CROSS DIAGONALS IN DIFFERENT LINE WIDTHS CAN LOOK QUITE ORGANIC. TRY COMBINING TWO SIMPLE PATTERNS ON TOP OF EACH OTHER. TRY THIS WITH INK ON ABSORBENT PAPER TO GET A FUZZY EDGE TO THE LINES.

Mix up the width and direction.

Change the cornerto-corner direction.

Lay one pattern on top of the other.

Dotted lines help keep the zigzags symmetrical.

Experiment with thin and thick zigzags.

Alternate between zigzags in ink and paint.

Use your imagination to combine new patterns you have invented.

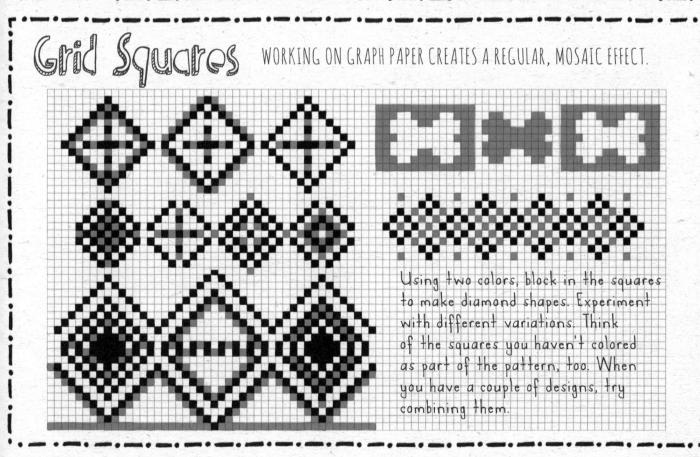

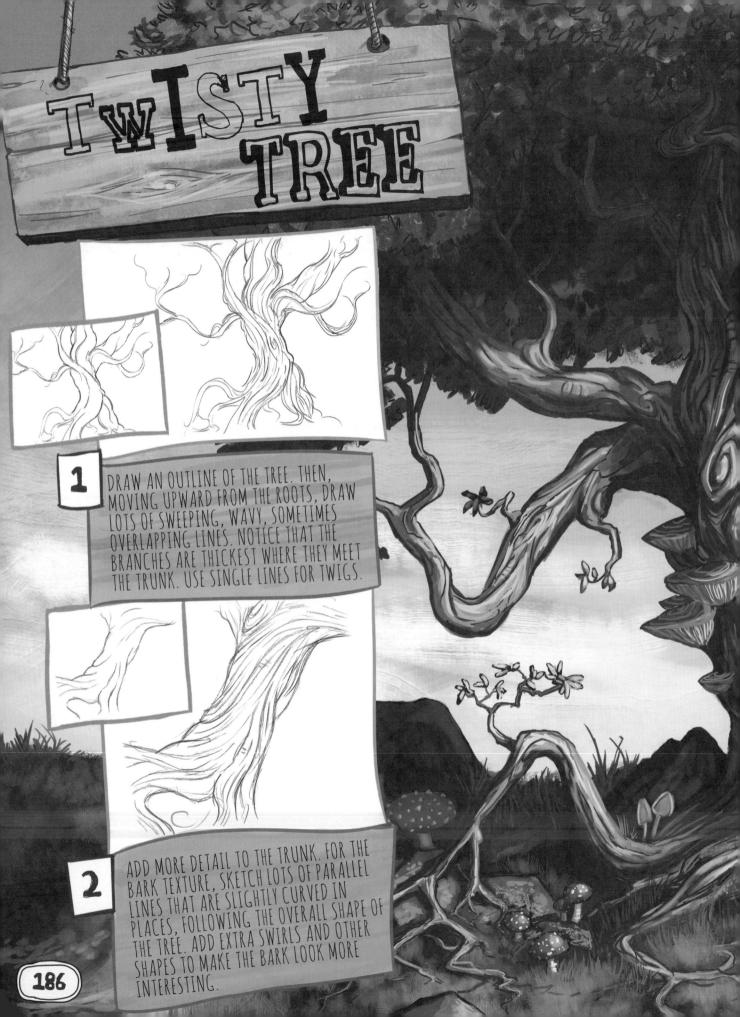

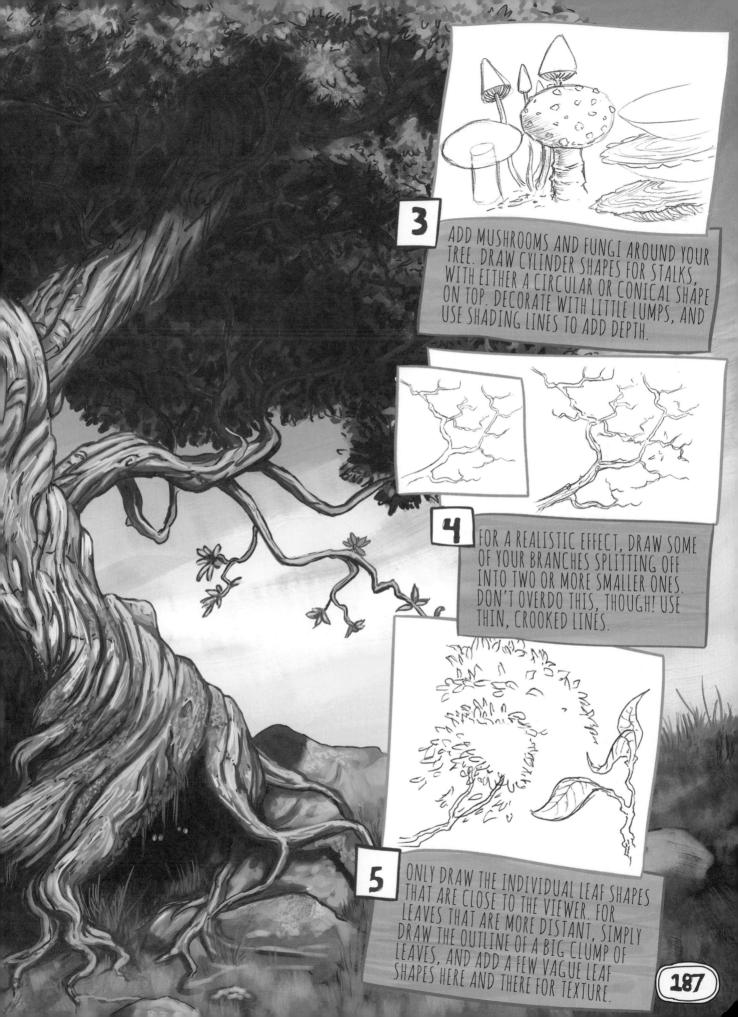

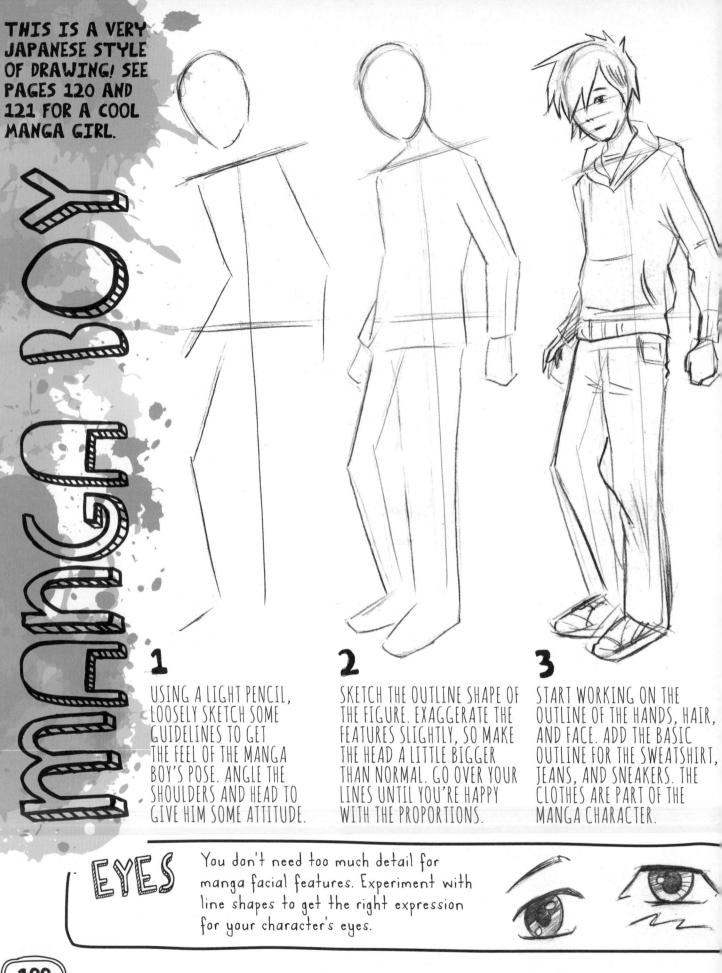

The hair covers a good portion of the face, so have only one eye clearly peeping through. HAIRSTYLES Manga hair is great fun to draw. Think cool and spiky! Work in the hair to give it a layered feel. USE A SOFT PENCIL TO K IN DETAIL. THINK W()R MANI ABOUT WHERE THE LIGH COMING FROM (TOP RIGHT HERE) TO ADD SHADOWS DON'T BE SCARED TO PUT IN LARGE BLACK AREAS. MANGA ILLUSTRATIONS ARE ALLY COLORED ON A COMPUTER, 111 BUT YOU CAN USE THICK MARKER

PENS TO MIMIC THE GOOD FLAT COLORS THAT YOU SEE IN BOOKS AND ANIMATION.

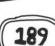

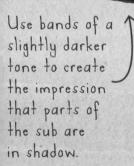

5 GO OVER YOUR LINE WORK IN PEN AND INK, THEN COLOR YOUR SUB. USE A WASH FOR THE BODY, THEN BUILD UP A ROUGHER TEXTURE ON TOP WITH THE SIDE OF A PENCIL. USE A BLUISH TONE FOR THE WINDOWS, WITH A CONTRASTING COLOR FOR THE REST OF THE METALWORK. YELLOW MAKES IT LOOK GOLDEN!

ELLIPSES AND

ED LINES TO CREATE

THE BASIC SHAPE OF A

DIVING BELL.

2

ON

Use a watery blue wash for the sea, and add green coral shapes in a variety of different tones.

191

ADD DETAIL BY DOUBLING UP

JUST DRAWN. USE LONG,

CURVED SHAPES FOR THE

MECHANICAL GRABBERS.

THE LINE WORK YOU'VE

1- 1 1 1

3 NOW BEGIN ADDING DETAIL. DRAW THE HAIRLINE LOW ON THE BROW, HEAVY EYEBROWS, A POINTY NOSE, EARS, A DOWN-TURNED MOUTH. ADD RIPPED EDGES TO THE CLOTHES, AND START FLESHING OUT THE BODY AND CLUB. **Y** USE SLUDGY GREEN WATERCOLOR PENCILS AND DRAW YOUR OUTLINE IN BROWN. ADD FINISHING TOUCHES, SUCH AS TUFTS OF HAIR, WITH PEN AND INK.

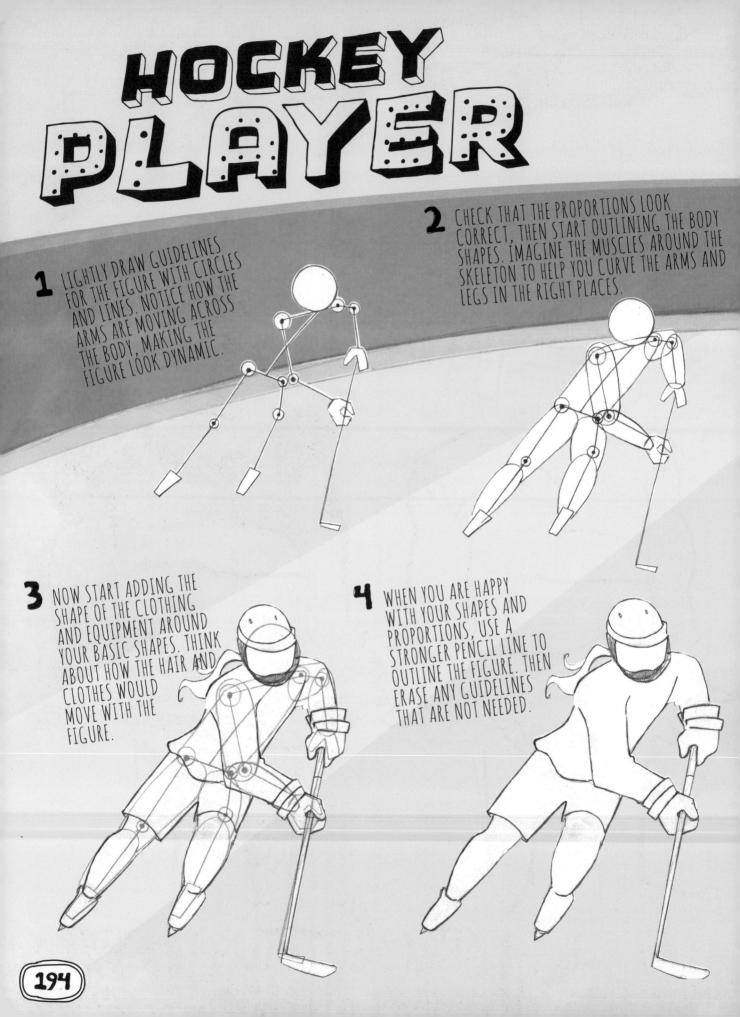

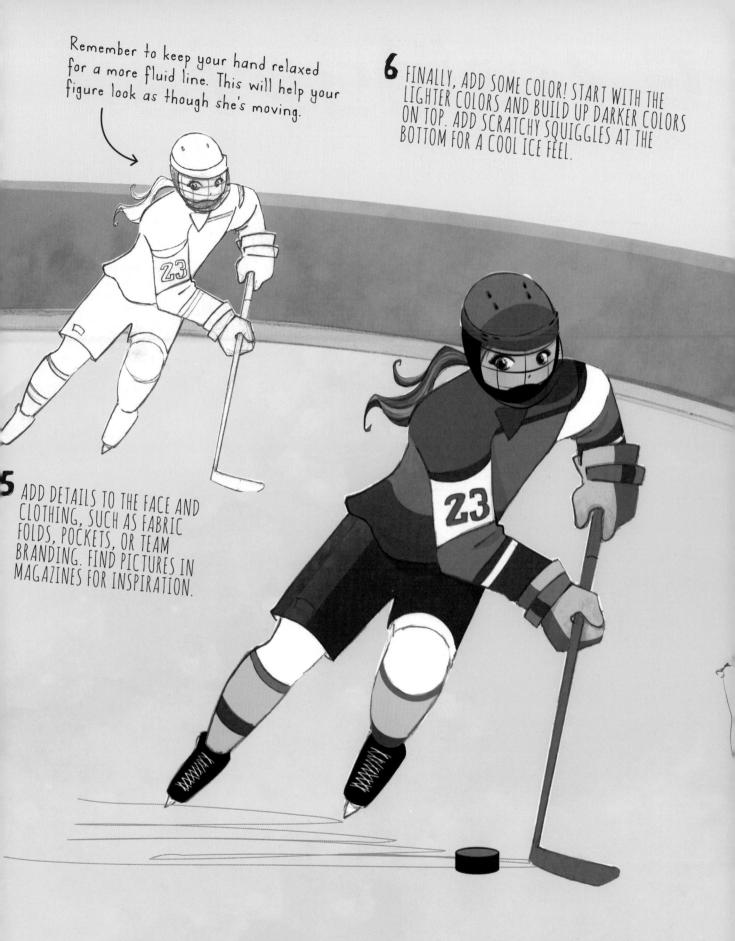

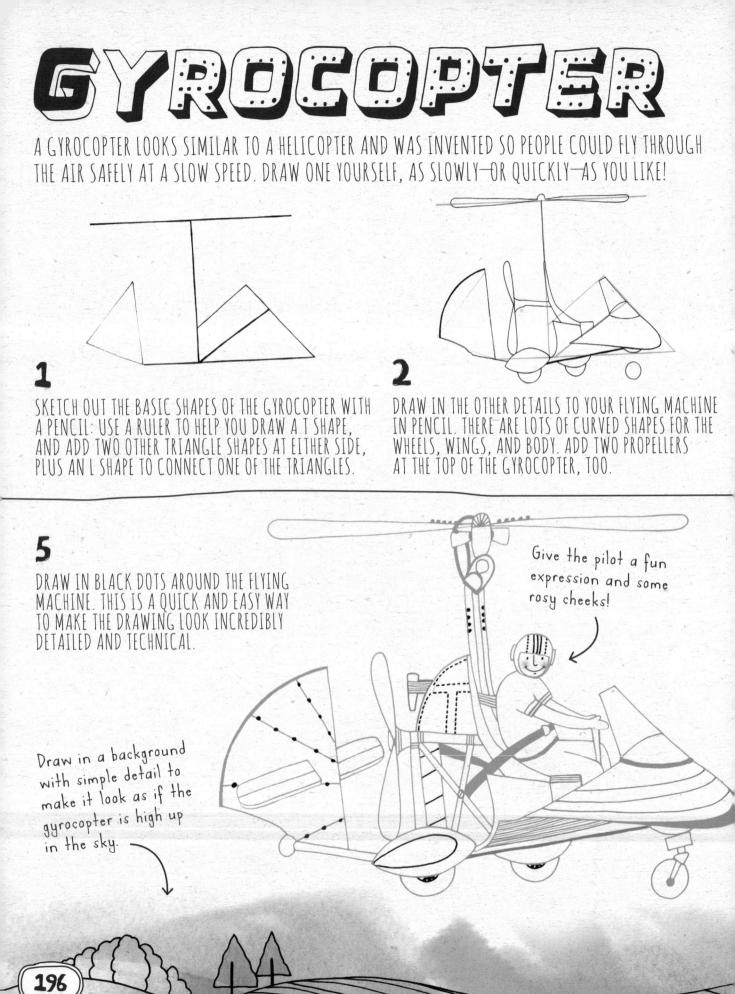

ADD DETAIL TO THE GYROCOPTER TO MAKE IT LOOK REAL. DRAW IN THE PILOT, THEN DRAW IN THE SAFETY BELT AND THE MECHANISM THAT RUNS THE TOP PROPELLER.

3

ADD MORE DETAIL IN STAGES. BUILD UP THE FINER TECHNICAL BITS, SUCH AS THE LINES ON THE WINGS AND THE PARTS AROUND THE PROPELLERS.

4

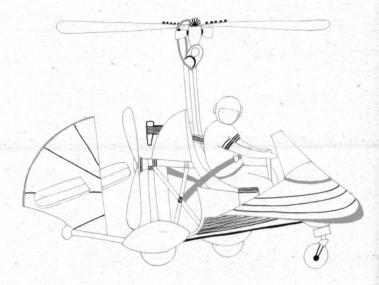

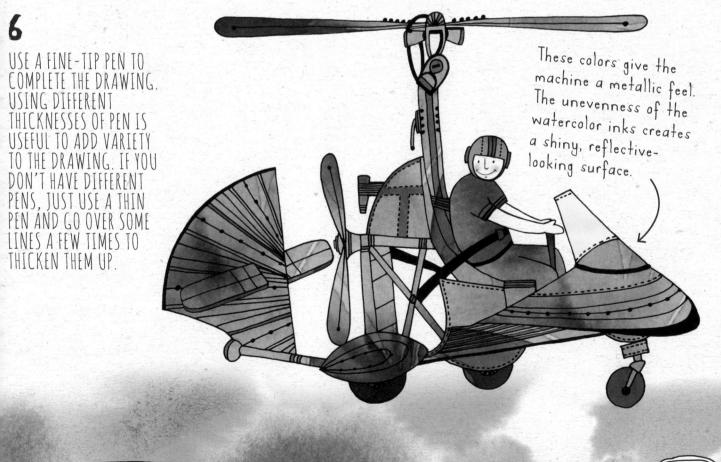

DRAGON

Try adding a castle to the background. Build up your design by joining basic shapes together, such as boxes, cones, and cylinders.

DRAW A DRAGON'S SPINE CURVING FROM THE TIP OF A TAIL TO THE BASE OF THE SKULL. DRAW A ROUGH SHAPE FOR THE HEAD AND EYE, THEN ADD ANOTHER LINE TO CREATE THE BODY. ADD ROUGH STICK LINES FOR THE ARMS, LEGS, AND WINGS. 2 FLESH OUT THE DRAGON'S BODY PARTS. REFINE THE HEAD AND DRAW CURVED SHAPES TO CREATE THE ARMS AND LEGS. ADD SOME SPIKES TO THE BACK, AND DRAW HORNS ON THE HEAD. USE SLIGHTLY CURVED LINES FOR THE OUTLINE OF THE NEAR WING

5 YOU CAN ADD EVEN MORE DETAIL TO THE DRAGON'S BODY BY USING LAYERS OF OPAQUE PAINT. START WITH A BASE COLOR, MAKING THE GAPS BETWEEN THE SCALES EXTRA DARK, THEN PAINT THE HIGHLIGHTS ON TOP. USE IMAGES OF REAL ANIMALS AS REFERERENCE, SUCH AS CROCODILES OR OTHER REPTILES.

> The bright flames will light up the dragon's face, so use warmer colors to add highlights to its scales.

Choose muted reds and purples to create an ominous-looking sky. Use thick paint for the clouds, and blend the colors and shapes into each other to create texture.

ERASE YOUR GUIDELINES, INCLUDING THE AREA OF THE BODY BEHIND THE WING. ADD MORE SURFACE DETAIL, SUCH AS BODY SCALES AND WING BONES. ADD DETAIL TO THE HEAD, DRAWING TEETH, NOSTRILS, AND A TONGUE. FOCUS ON THE FINER DETAIL. DRAW SMALLER SPINES ON THE TAIL, ADD SCALES TO THE BACK LEGS, AND USE SHORT LINES TO GIVE THE SCALES AND HORNS SOME TEXTURE. ADD THE DRAGON'S SHARP TALONS, AND USE SWIRLY LINES FOR ITS FIERY BREATH.]

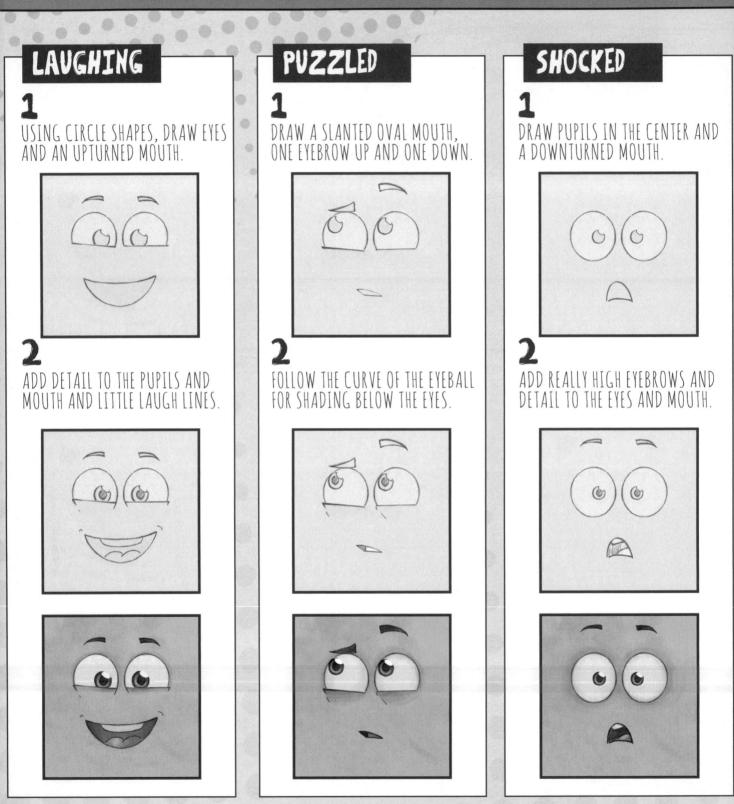

SMALL CHANGES IN SHAPE CAN MAKE A BIG DIFFERENCE WHEN YOU ARE DRAWING CARTOON EXPRESSIONS. ALL YOU NEED IS CIRCLES, HALF CIRCLES, AND LINES.

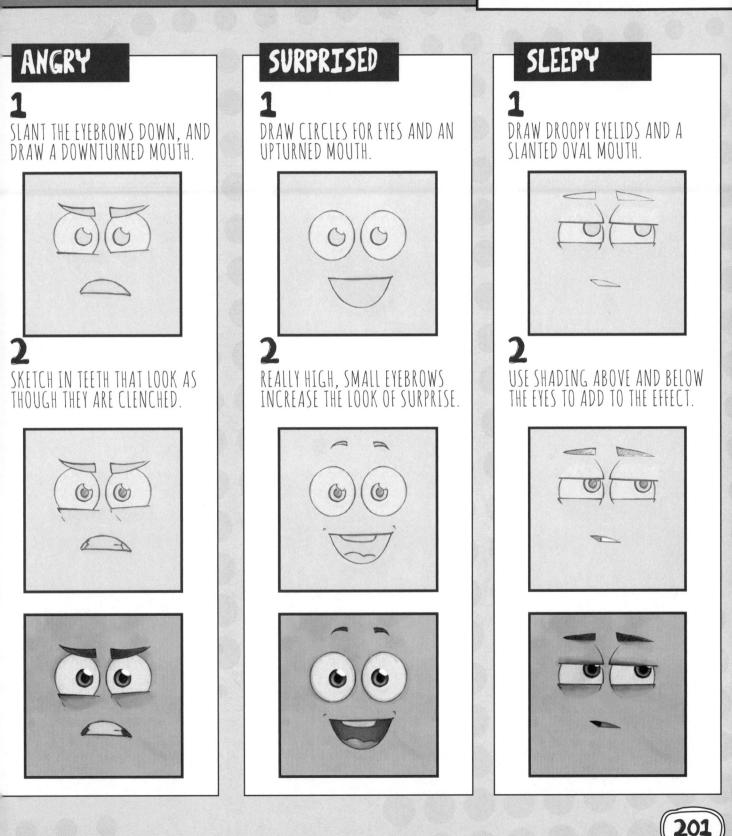

SUDBSSEDUS

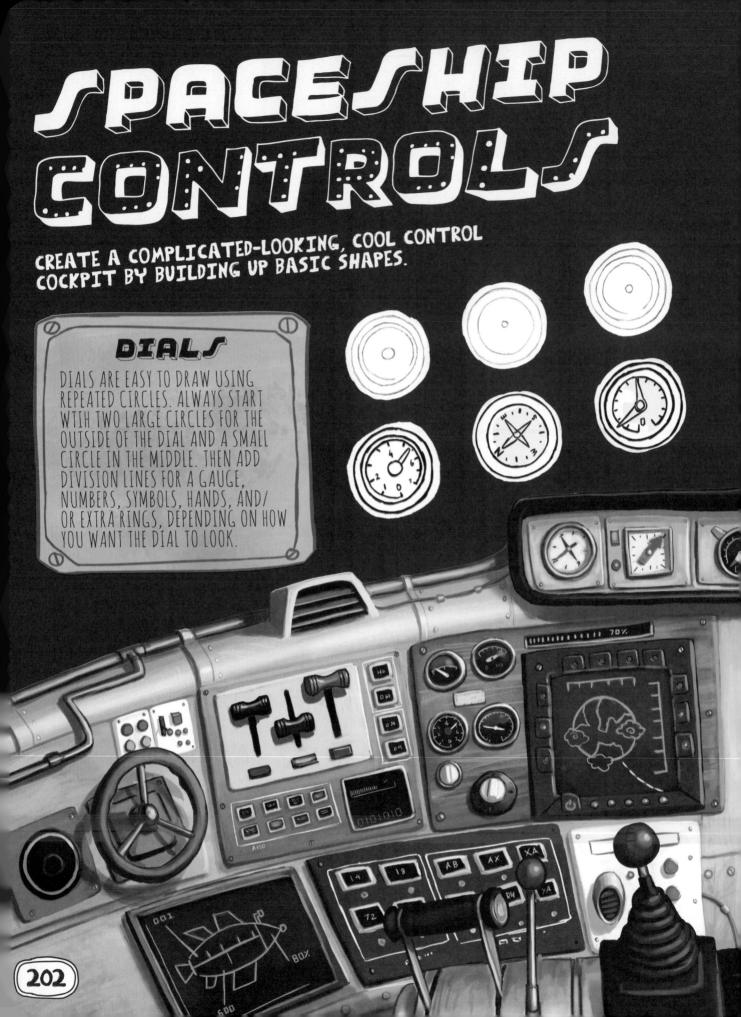

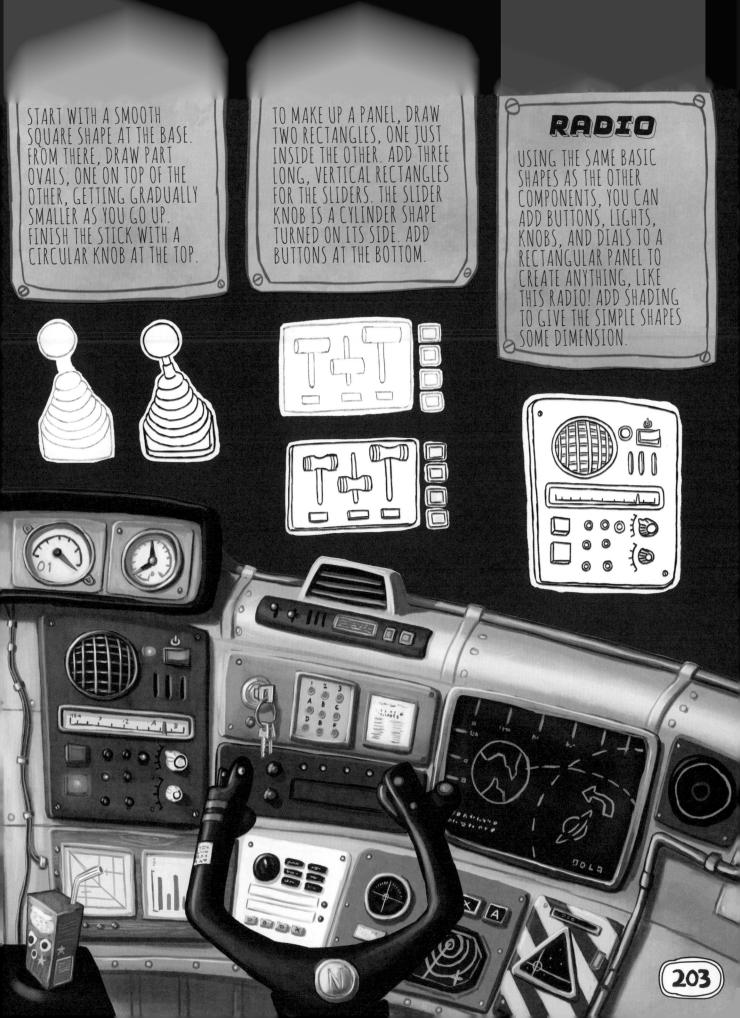

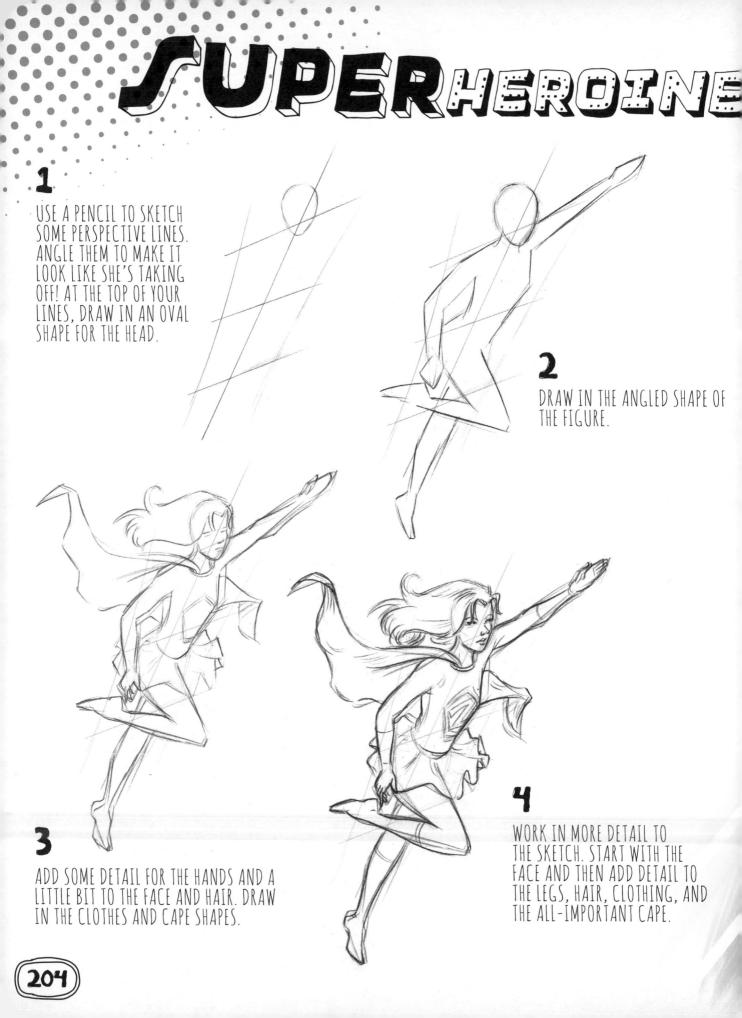

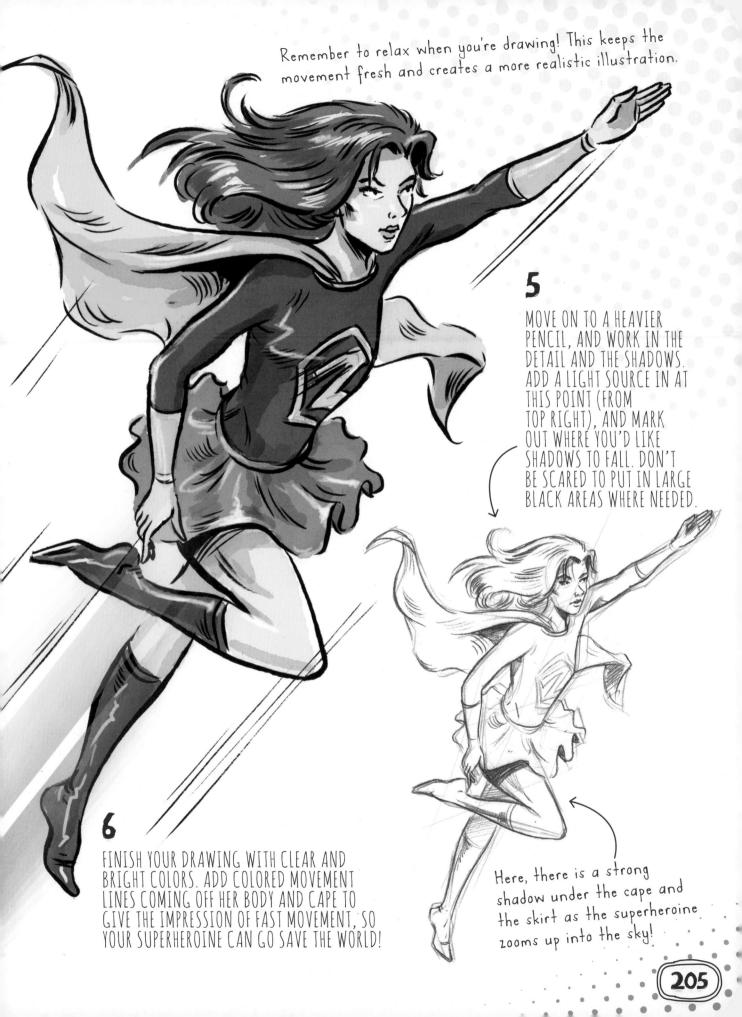

ANIMAL PATTERNS INSPIRE DESIGNS EVERYWHERE YOU LOOK! THEY'RE USED ON EVERYTHING FROM BOOKS AND BEDDING TO CLOTHING AND ACCESSORIES. USING REFERENCE PHOTOS, LEARN TO DRAW THE BASIC SHAPES FIRST, SUCH AS LEOPARD SPOTS AND ZEBRA STRIPES. EXPERIMENT WITH REALISTIC TONES BUT ALSO PUNCHY FASHION COLORS. THEN TRY TRANSFERRING YOUR FAVORITE PATTERNS TO DRAWINGS OF OTHER OBJECTS.

DISTORT YOUR PICTURES USING THIS CLEVER TECHNIQUE.

START WITH THE NORMAL PICTURE FIRST. FOR A FISH, DRAW AN EGG SHAPE. ADD A CURVE FOR THE FACE, THEN DRAW AN EYE AND MOUTH.

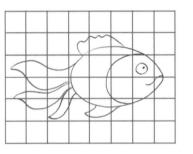

USING A RULER, DRAW A RECTANGLE AROUND YOUR FISH. DIVIDE THE SHAPE INTO SMALL SQUARES, MAKING SURE THEY'RE ALL THE SAME SIZE.

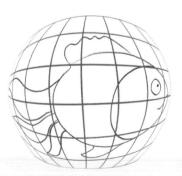

SKETCH A CIRCLE. ADD CURVED HORIZONTAL AND VERTICAL LINES TO GIVE YOU THE SAME NUMBER OF BOXES AS THE ORIGINAL GRID. COMPARE AND COPY CORRESPONDING SQUARES TO HELP YOU DRAW A DISTORTED SHAPE OF THE ORIGINAL.

SKETCH THE FINS AND TAIL. USE CURVY LINES FOR THE TAIL TO MAKE IT LOOK AS IF THE FISH IS SWISHING AROUND IN THE WATER.

6

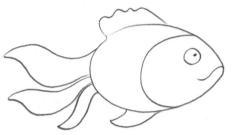

ADD LINES TO THE FINS AND TAIL, PLUS SOME SHADING TO THE OUTLINE AND EYE AREA. USE SMALL 'C' SHAPES FOR THE SCALES.

Use different shades of blue to give the impression of movement in the water. Add curved white shapes to create highlights and to make the bowl look 3-D!

3

ERASE YOUR GUIDELINES, AND DRAW A BOWL, SAND AND PLANTS. THEN COLOR YOUR PICTURE!

5

CAT LOOKING THROUGH A FISHBOWL!

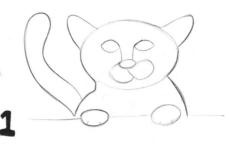

START WITH THE NORMAL PICTURE AGAIN. DRAW AN OVAL FOR THE CAT'S FACE. ADD SIMPLE SHAPES FOR ITS FACE, EARS, PAWS, AND TAIL.

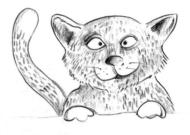

DRAW STROKES FOR THE CAT'S FUR. SHADE INSIDE THE EARS AND NOSE, AND AROUND THE EYES. DRAW DOTS FOR PUPILS AND LINES FOR WHISKERS.

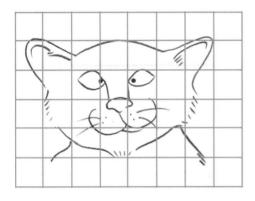

DRAW A RECTANGLE AROUND YOUR PICTURE, AS BEFORE. USING A RULER FOR ACCURACY, DIVIDE UP THE SHAPE INTO A GRID OF SMALL SQUARE SHAPES.

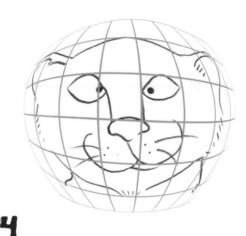

DRAW A CIRCLE. DIVIDE UP THE AREA WITH CURVED LINES AS BEFORE, UNTIL YOU HAVE THE SAME NUMBER OF BOXES AS YOUR RECTANGULAR GRID. COMPARE CORRESPONDING SQUARES, AND DRAW IN YOUR DISTORTED CAT SHAPE, BIT BY BIT.

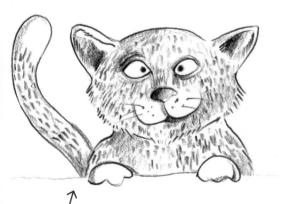

Here is the cat before he is distorted.

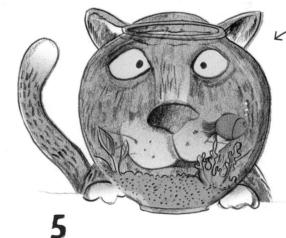

Give the distorted cat face a slightly bluish tinge to give the effect of looking through water!

DRAW THE FISHBOWL AS BEFORE. USE TRACING PAPER TO COPY THE FACE OF YOUR DISTORTED CAT INTO THE BOWL. THEN, TRACE OR COPY THE ORIGINAL PICTURE TO DRAW HIS EARS ABOVE THE BOWL, AND PAWS AND TAIL NEXT TO IT. NOW COLOR THIS CURIOUS CAT IN!

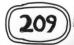

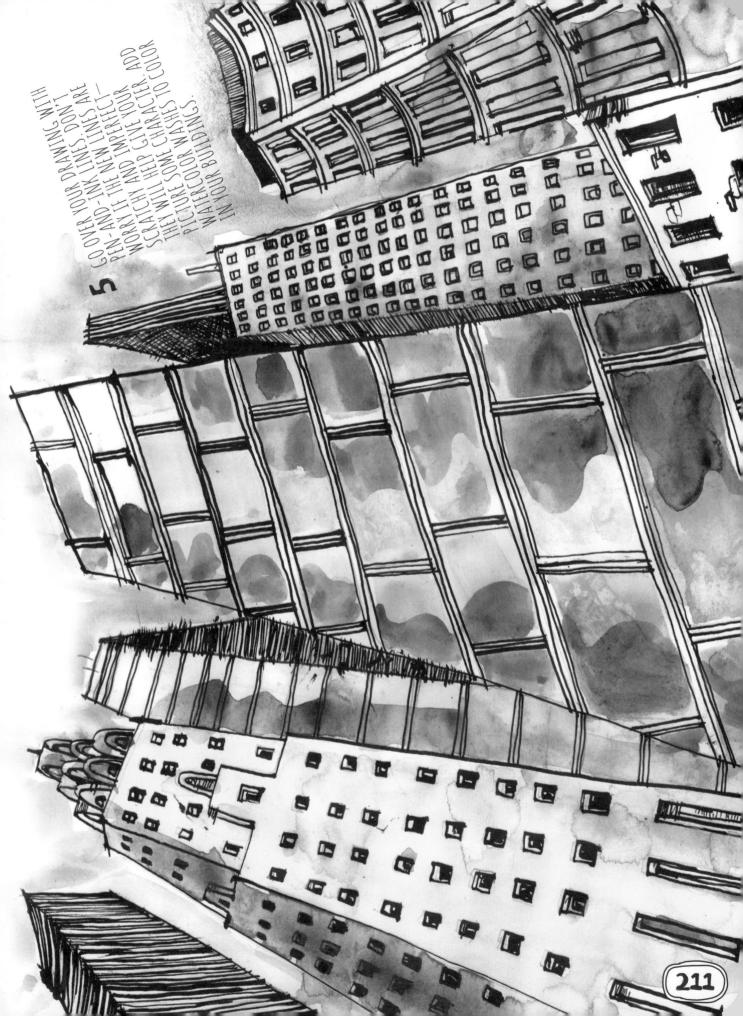

FRENCH CAFÉ

THIS CHIC FRENCH CAFÉ MIGHT LOOK A LITTLE COMPLICATED TO DRAW, BUT EACH OBJECT IN THE PICTURE IS ACTUALLY MADE UP OF RELATIVELY SIMPLE SHAPES. PRACTICE SKETCHING EACH ELEMENT ON ITS OWN, THEN BRING EVERYTHING TOGETHER TO CREATE A PERFECT PARISIAN SCENE!

Make the café look farther away than the people by positioning the building halfway up the page. Use a thick pencil outline for the building, picking out certain shapes in pen and ink.

For the umbrella, sketch a simple triangle, then draw a curved triangular shape on either side. Add curved lines beneath each segment. Draw a circle on top, then sketch the pole. Add more shapes to make the umbrella look 3-D.

Sketch a big ellipse for the table top, then add a vertical line running through the center of two much smaller ellipses. Draw swirly supports on one side first before sketching their mirror image on the other.

To draw an elegant café chair, sketch an ellipse, adding another line at the bottom to make it look 3-D. Draw two curved shapes for the back. Add a big U shape beneath the ellipse, then use more elegant curves for the legs.

Use different-sized ellipses and curved shapes to draw an ornate teapot and cup. Add swirly patterns to the sides to give them some old-fashioned charm!

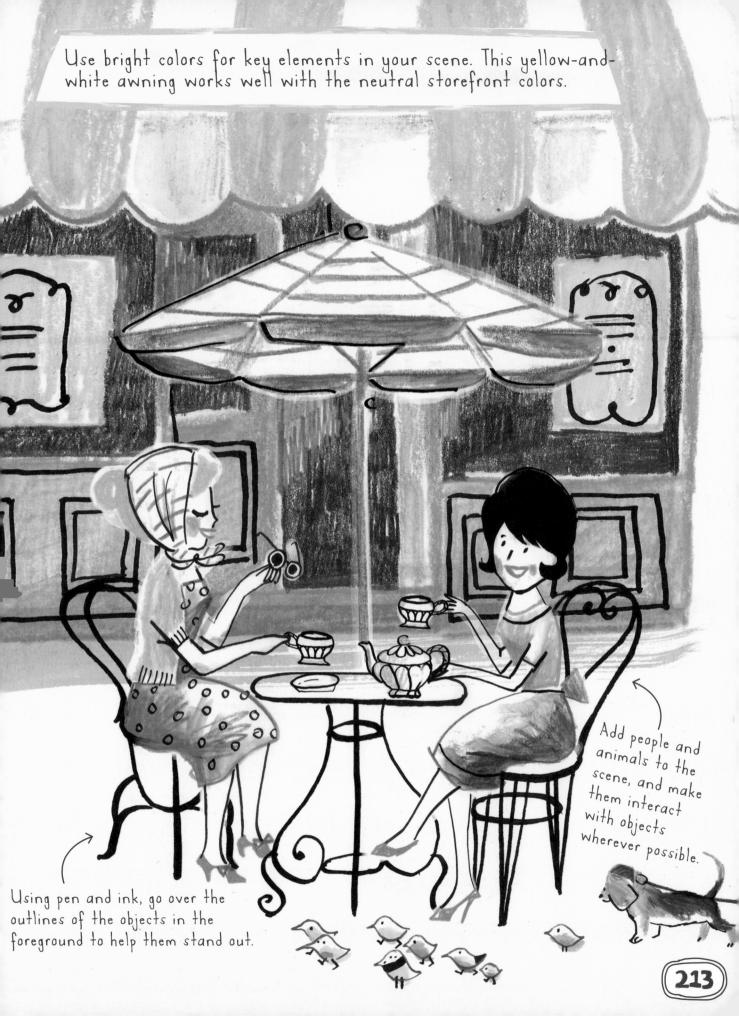

OPTICAL ILLUSIONS CAN MAKE PEOPLE SEE THINGS THAT AREN'T THERE. LEARN TO DRAW THEM TO TRICK YOUR FRIENDS AND FAMILY!

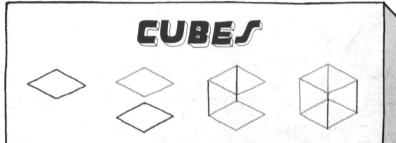

Draw a flattened diamond for the top of the cube, then exactly the same for the base. Draw vertical lines to link the corners together.

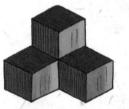

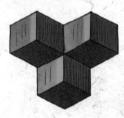

Add shading to some sides of the cube, like this. This helps gives them a 3-D look.

Draw a lot of cubes together to get the optical illusion. Are the cubes the right way up or upside down? Or maybe you see them flip back and forth!

Draw a simple outline of a face looking to the right, using only one smooth line.

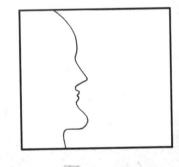

Then draw or trace the same face again, facing the first.

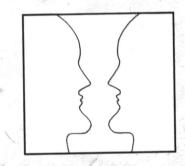

Darken the gap between the two faces. Some people will see the dark vase, and some people will see the faces!

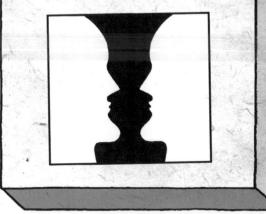

Impossible triangle

IF YOU LOOK CLOSELY, THIS TRIANGLE COULDN'T ACTUALLY EXIST. FOLLOW THE STEPS CAREFULLY TO CREATE ANOTHER TRICK OF THE EYES!

Start with a simple triangle.

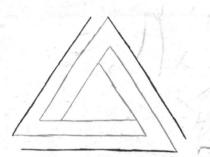

From the end of the last lines, draw three more parallel lines. Your impossible triangle should now be taking shape.

At the three points, extend the lines slightly, like this.

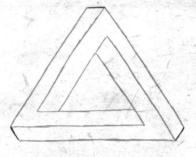

To create the illusion, link the last three lines to the rest of the triangle.

From the end of these new lines, draw parallel lines following the original triangle's sides.

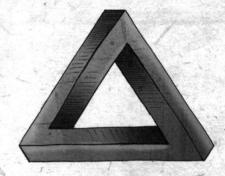

Color your image. Be careful with the shading, and you'll get the amazing effect!

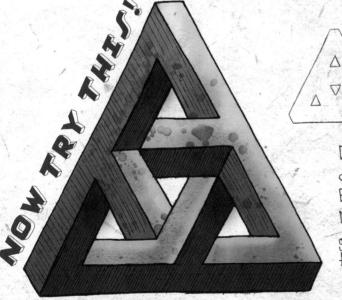

Draw a simple triangle with the three tips cut off. Then draw four small triangles inside. Extend lines from each point of each triangle. Now draw in the last lines, filling in all the gaps. Then add some shading and your impossible triangle is complete and an awesome illusion!

DRAW THE DANCER'S JEANS, USING THE GUIDES TO HELP YOU. KEEP THE LINE WORK LOOSE, AND ROUND OFF WHERE THE LEFT KNEE IS BENT. DRAW THE SHAPE OF THE ARMS.

2

SKETCH THE SHIRT AND AN ELLIPSE AT THE BOTTOM OF THE PANT. ADD A SEMICIRCLE FOR THE CAP WITH AN ELLIPSE FOR THE BRIM. DRAW A FOOT BEHIND THE BENT LEG.

SILHOUETTES

To draw cool silhouettes of streetdancers, find photos of dancers in different poses. Then simply trace over their outlines and color them in.

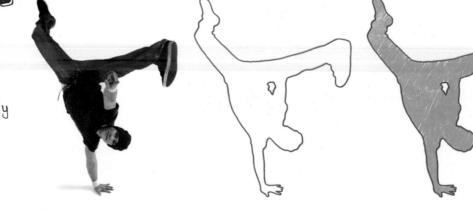

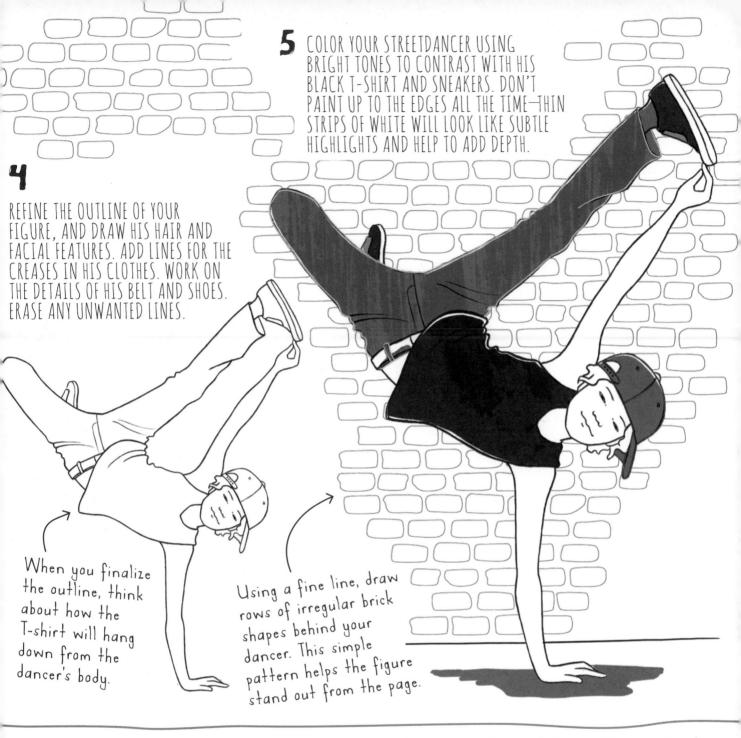

Keep your color work loose, allowing streaks of white to show through. These skewed lines help create a feeling of movement.

CREEPY MANSION

DRAW A SET OF ROUGH RECTANGLE SHAPES FOR THE MAIN PART OF THE BUILDING. USE TRIANGLES FOR THE ROOF AND TURRETS AND A SEMI-CIRCLE FOR THE DOMED TOWER.

ADD SIMPLE LINES TO YOUR SKETCH TO DEFINE THE BUILDING. ADD SMALL TRIANGULAR POINTS TO THE ROOF AND TURRETS TO MAKE THEM LOOK SHARP. DRAW A BASIC DOOR AND BALCONY, TOO. Jack & 1 Christ

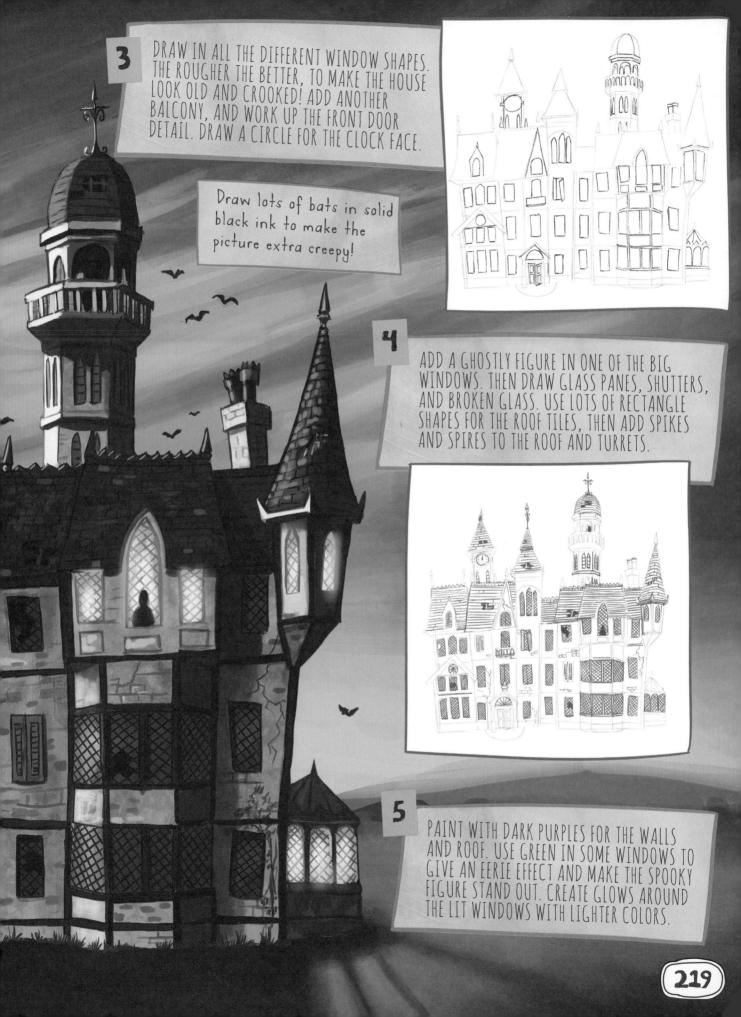

EX •

D

airplane	80-1
aliens	
animals 12-13, 18-19, 24-	5, 32-3,
52-3, 64-5, 74-5, 82-3	, 102-3,
124-5, 154-5, 162-3, 172-3	, 180-1,
	198-9
비행 이 소문이 이야지 않는 것이 많이 많이 많이 많이 없다.	

в	
basketball player	
beards	
belts	
bridge	
buildings	, 118-19, 140-1,
170-1,	218-19, 210-11
bullet train	
burger	

C	
café	
cake	
candy machine	
caricatures	
cartoons	
expressions	
ca†	
color wheel	
crayons	
chalk	
crayons chalk oil	
wax	
crocodile	
crosshatching	8. 34. 104
cyborg	

dessert	
dinosaur	
distortion	
diver	
dog	
dragon	
drum kit	

editing software	9
and the second	
elephant	
	b
explosions	

fashion	
boys	
girls	
Ferris wheel	
fishbowl	
frames	
Frankenstein	

9

giraffe face	52-3
grizzly bear	
guidelines8, 1	
16, 20, 24, 30, 31, 38, 39, 4	0, 47,
50, 52, 68, 71, 72, 73, 74, 7	5, 76,
82, 84, 92, 95, 101, 106, 120	, 128,
141, 152, 160, 174, 180), 181,
18	8, 194
gyrocopter	.196-7

H

hairstyles
hats
haunted house 118-19, 218-19
hedgehog12-13
highlights
40, 41, 55, 62, 65, 78, 93, 131,
135, 143, 145, 153, 163, 165, 175,
179, 199, 208, 217
hockey player
horizon line 9, 38
hot-air balloons

1

inks.....b, 7, 14, 15, 18, 21, 34, 39, 43, 51, 56, 57, 68, 69, 77, 81, 91, 98, 99, 103, 104, 105, 108, 123, 144, 151, 157, 169, 181, 183, 184, 185, 191, 193, 197, 211, 212, 213, 219

] jetpack	126-7
L light sources8, 13,	
line designs	92, 96, 205

M manga girl......120-1

mankeys	Q	. T
monsters	quad bike	T. rex
motorcycle		T-shirts
mountain bike	R	techniques 8-9
moustaches	racing car20-1	tornado
	robot	
N	rock star	+roll
ninja		
<u> U</u>		u ·
0	S	UFO
optical illusions	shadows	
	32, 34, 37, 41, 43, 66, 78, 93, 96,	V
P		vanishing point9, 38, 72, 90
paints	145, 165, 178, 183, 189, 191, 205	
	shark	
	skateboarder	W
watercolor 6, 7, 15, 39, 53, 61, 77,		watercolor pencils 6, 41, 83, 91,
85, 97, 117, 139, 141, 151, 175, 211		129, 193
paper typesb		woodland animals
patterns	J . I	1
animal		-1
circular		이 지금 방법을 하는 것은 것이 같은 것이 같이 있는 것이 같이 같이 있는 것이 없는 것이 없다. 것이 없는 것이 없는
	controls	
	speech bubbles	
	speedboat	
24-5	spy car90-1	
	Statue of Liberty 40-1	
	street art104-5	
	streetdancer	
highlighter 7	stunt rider	
	submarine	
	sunglasses176-7	
	superhero	
	superheroine 204-5	
pirate ship		
pizza 108-9	symmetry	
pizza	90, 185	
pop star		
portraits10-11, 22-3, 78-9		
proportions 8, 9, 14, 32, 46, 92,		
96, 116, 142, 164, 188, 192		
,,,,,,,		

RBOUT THE ARTISTS TALENTED ARTISTS FROM AROUND THE WORLD HAVE CONTRIBUTED THEIR SKILLS AND ILLUSTRATIONS TO THIS BOOK!

TOM MCGRATH always wanted to be an artist. He likes to use a mixture of pencil, pen, and the computer to finish his drawings. Tom now works as a freelance illustrator to support his addiction to ginger cookies.

SI ([ARK is an illustrator and animator. He grew up in the countryside but now lives in London, England. He started drawing at a very early age and has pretty much been drawing every day since then. Si is obsessed with drawing trees and cities, as well as finding strange textures to scan into his drawings!

YASUKO YASUKO has developed a graphic illustration style, mixing ink work, brushstrokes, and digital textures. She loves Japanese fashion, and sometimes makes her own clothes. Yasuko lives and works in Paris and loves to spend time drawing in the Louvre art museum.

PAULA FRANCO

is a children's book illustrator and graphic designer from Argentina. She loves to spend her spare time wandering around libraries.

LUCIANO LOIANO got an MA in Illustration in Barcelona, Spain, and now lives in that same city. He works as a professional illustrator on books, newspapers, and magazines.

ALEX HEDWORTH works as an illustrator and is currently studying for an MA. Originally from Newcastle, England, he now lives in London. He has been drawing for as long as he can remember—his first drawings were copies of comic books!

MADDY MCCLELLAN lives in Sussex, England, and works as an illustrator and printmaker. She has illustrated many children's books, including some that she has written herself. She is happiest drawing with a lively, inky line in her studio in the yard, visited by an assortment of animals.

STEVE HORROCKS was born in Merseyside, England. He now lives in California with his wife, where he works at a major feature animation studio and continues to pursue his passion for creating art on a personal level, too.

DAVID SHEPHARD is a children's book illustrator and designer. He lives in the shadow of a Norman castle in Sussex, England, with his wife, children, and several pets. He loves drawing people and faces and works best in his attic, where his family slides his dinners under the door! STEVE STONE is an illustrator from the Northeast of England who loves to capture the character of animals. He gets lots of help from his orange cat, Vincent van Mog.

JULIE INGHAM is an illustrator and designer who lives and works by the sea in West Sussex, England. Her favorite things to draw are skyscrapers and all things decorative!

ACKNOWLEDGEMENTS

ILLUSTRATED BY Si Clark, Paula Franco, Alex Hedworth, Steve Horrocks, Julie Ingham, Luciano Lozano, Maddy McClellan, Tom McGrath, David Shephard, Steve Stone, and Yasuko Yasuko

DESIGNED BY Belinda Webster at Picnic Design, Clare Phillips, and Rachael Fisher

EDITED BY Laura Baker, Cathy Jones, Moray Laing, and Jason Loborik

PRODUCTION BY Richard Wheeler

PHOTOGRAPHS FROM Shutterstock, Inc.

mm

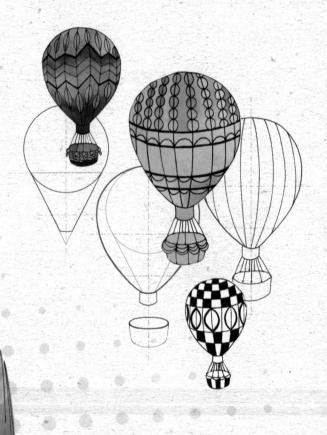